CLARK
STUDIES
IN THE
VISUAL
ARTS

THE LURE
OF THE OBJECT

Edited by Stephen Melville

Sterling and Francine Clark Art Institute
Williamstown, Massachusetts

Distributed by Yale University Press, New Haven and London

This publication is based on the proceedings of the Clark Conference "The Lure of the Object," held 30 April–1 May 2004 at the Sterling and Francine Clark Art Institute, Williamstown, Massachusetts. For information on programs and publications at the Clark, visit *www.clarkart.edu.*

© 2005 Sterling and Francine Clark Art Institute

Curtis R. Scott, *Director of Publications*
David Edge, *Graphic Design and Production Manager*
Diane Gottardi, *Layout*
Mary Christian, *Copy Editor*

Printed by the Studley Press, Dalton, Massachusetts
Distributed by Yale University Press, New Haven and London

ISBN (Clark) 0-931102-61-8
ISBN (Yale) 0-300-10337-9

Printed and bound in the United States of America
10 9 8 7 6 5 4 3 2 1

Title page and divider page illustration: George Henry Seeley, *The Firefly* (detail), 1907. Photogravure from *Camera Work,* October 1907. Sterling and Francine Clark Art Institute, Williamstown, Massachusetts

Library of Congress Cataloging-in-Publication Data

The lure of the object / edited by Stephen Melville.
 p. cm. — (Clark studies in the visual arts)
 Based on the proceedings of a conference held Apr. 30–May 1, 2004
at the Sterling and Francine Clark Art Institute, Williamstown, Mass.
Includes bibliographical references.
 ISBN 0-931102-61-8 (Clark : pbk. : alk. paper) — ISBN 0-300-10337-9 (Yale)
 1. Masterpiece, Artistic—Congresses. I. Melville, Stephen W. II. Sterling and Francine Clark Art Institute. III. Series.

N72.5.L87 2005
709—dc22

2005049791

Contents

Introduction

Stephen Melville

What are you doing when you make—or try to make—a conference? That's one question when you ask it early on, another when it obsessively recurs during the sleepless nights immediately preceding the thing, if only because it's no longer about ideas but about something in inexorable motion.

Here's how at least a version of an answer looks now: You start out with a notion of something you hope is worth getting at—in the present instance, a long-standing sense of the poverty of the ideas of objectivity that animate current art history, and perhaps current intellectual life more broadly—and some sense of how it might matter to get at those things—in this case, a desire that the conference itself be "objective," in the sense of not abstract but fully freighted with objects, finding its way to its questions crucially through them. You then try to find a reasonable way of phrasing the general question so that you can lay out some plausible version of its parts, the conference's discrete sessions, and set about seeing whom you can draw in. As the responses accumulate, you find the initial thought returned to you rephrased and so find yourself reconstruing its parts—persons and papers moving to places you had not plotted for them, the places themselves moving and changing shape. Somewhere along the line you discover yourself saying things like, "Well, it's called 'The Lure of the Object,' but it's really more like 'Aspects of the Lure of the Object,'" and wondering if that's good enough.

Then papers and abstracts start showing up and you are, first of all, relieved that people seem to be talking more or less about what you had hoped they'd talk about, and then somewhat pleased that the older layers of the conference have also shown up, vertically threaded through the panels, dispersed and recurrent, like a loose pattern of knots that roughly pull the sequence of sessions into a loose grid. Some of these threads are perhaps worth noting. There is, for example, photography—variously, a way of making objects, a medium perhaps; a way of rendering objects, perhaps exerting a particular claim on our sense of objectivity; a condition to which our disciplinary objects are notably submitted, a shape of their availability and circulation and fate; and, at moments at least, a name for an age we take to be peculiarly, perhaps also vanishingly, our own. This thread runs alongside, and offers a kind of interpretation of, another thread that has no equally direct name

but that reflects the various ways in which for art the question of "the object" finds particular purchase or explicitness in various strands of distinctly modern art: Minimalist "objecthood" lurks around the edges of the conference, while Dada and Surrealism have a more straightforward presence, and they have it at least in part because of how they are so closely intertwined with a third thread laid down early on in thinking about the conference—psychoanalysis with its strong proposal of objects as everywhere worked by the vicissitudes of desire, its modalities of attachment and detachment, insistence and loss.

And then there's a third moment in one's reading of these things: the discovery of what comes as a surprise, what has sensibly shown up without ever having appeared as a thread around which the initial thought might have been organized. Sculpture is, I think, like that in this conference, and noticing its presence makes the knotted threads of the matrix feel more like an actual net, weighted now with something it may have caught. What exactly might be caught in the net's haul and whether any of it is worth keeping remains, of course, a question, but it does feel time to pull it in and see.

Some of this perhaps helps in rereading the conference's title. It was no doubt partly meant to be serviceably neutral: "objects" are in some way the thing we are all—art historians, curators, conservators, students of material culture—willing to say we depend on and work with, and the term seems to pick out those things well enough and without prejudice to the particular ways we do that work. Of course, it turns out not to be neutral, and from among those who declined our invitation to participate there were moments of real abruptness: "I don't work on objects," or, from an artist, "I don't make objects." It's hard in those moments not to want to pick a fight of some kind, to retort, "Of course you do," or, "If you don't do that, what exactly do you do?" But of course what's being rejected in such remarks is not the fact of objects but a particular shape of the world or the discipline or of art-making, a shadow that is itself perhaps a dimension of the topic.

"The Lure of the Object" is even more clearly than it was at the outset not "The Lure of the Image"—photography, for example, for the most part doesn't figure that way; "representation" does not emerge as a leading issue; and if the questions and papers open to some degree toward questions of material culture, they do not open particularly strongly into visual studies or visual culture. For the most part, it's a specifically art historical orientation to objects that remains in question. And it's also not "The Lure of the Thing"—it's devoid of the particular philosophic and quasi-theological overtones that might seem to come with that phrase ("things

in themselves," things as figures, or more, of worldly entanglement), and there's not much trace of the questions that tend to arise along these lines—questions of, for example, things and their names, *les mots et les choses*. Oddly for me, I seem to have fostered an event in which this is probably the only time Martin Heidegger's name will appear.

When we were trying to choose an image for the conference flyer and program, I was very drawn to the Clark's *Temptation of St. Anthony* after Bosch—all those be-thinged quasi-humans fishing for others of their strange kind, weirdly caged and netted, lure and lurer, trapped and trapper, repeatedly conflated. But in the end we found our way to the better image. Seeley's photograph—I've been stubborn in my refusal to know anything about it—evidently presents us with both itself and an object, setting up complex equivalences between its own photographic presence and that of the object proffered within it, between that object's foreground brilliance and backlight partially blocked by the woman who offers it, between our gaze at the photograph and its "firefly" object as well as between us and the subject who holds that object, between our gaze at the photograph and her gaze toward us, between her look and the look of light, and so on. That there is something there, where the proffered light is, is indubitably part of the photograph's ordinary objectivity, but there's certainly room to doubt that it is or was a firefly—I find myself inclined to take the picture's title as a first step toward the allegorizing the photograph invites and that I am inclined to refuse, probably because I don't like the uneasy trading with time and transience that seems at work here. Certainly whatever sense we make of the point of light in this way is strongly inflected by its rhyme with her eyes and, in the full photograph, the diadem she also wears (cropped, I should say, in part because of my fear of wandering too far into Elvish in what was, at the time, still very much the year of the Lord of the Rings—an ambivalent mark of my resistance both to the photograph's claims and to the inevitable entrapment of those claims in the toils of history and its shifting contexts). There's tricky trafficking here, a slippery play of contexts and values, a staging of the magic by which an ordinary object is diverted toward a moment of special experience that at once claims a certain showing of the object and enacts its dissolution. The same game seems to be played out again between the rim and void of the large bowl or basket from which the object has perhaps been plucked, into which it might be returned, by which it is certainly framed, and that seems to me to assert its inner darkness as the underlying condition for the exchanges and transformations the photograph sets up both within itself and between us and it.

You can, I suppose, love this photograph. You can be put off by its mawkish mystifications. Either way, the simple effort to describe it will lead you back and forth through the various registers the conference's panels have tried to separate out for discrete exploration. I imagine—with no particular reason—that had Seeley organized these two days he might well have entitled them "The Lure of the Work of Art." He'd have had, I think, no reason to worry about how far that lure might or might not fall apart into aspects not fully reassemblable into his work, because that conference could, in effect, only be an attempt to extend the photograph's salient silence. The "objectivity" this conference aims at is, I think, made to a high degree of joints and passages, continuities and discontinuities, and so does not go apart from a work of articulation that may leave it permanently entangled in its own aspects.

PART ONE

COMMERCE AND CONTEXT

The Lure of Leonardo

John Brewer

In the summer of 1920 the *New York World* reported that Sir Joseph Duveen, the self-avowed most powerful art dealer in the world, had dismissed as a copy or fake a recently imported work that claimed to be the original *La Belle Ferronière* by Leonardo da Vinci (fig. 1). He poured scorn on the French expert who had authenticated the picture, and he asserted that the true, original *La Belle Ferronière* was in the Louvre in Paris (fig. 2). The owners of the picture, Andree and Harry Hahn of Junction City, Kansas, sued Duveen in the New York courts for slander of title, claiming that Duveen's remarks not only made it impossible for them to complete a sale that was already being negotiated with the Kansas City Art Institute, but to sell the picture at all.

The case of *Hahn v. Duveen* initiated nearly a decade of litigation. In 1923 the parties (at Duveen's expense) shipped the Hahn picture to Paris, where it was placed alongside the *Belle Ferronière* in the Louvre. A team of experts, including Bernard Berenson, Roger Fry, the directors of the National Gallery in London and the Rijksmuseum, and others were interrogated by American lawyers about the two pictures and broadly affirmed that the Hahn picture was either a fake or a copy and that the Louvre picture was a genuine Leonardo. After many delays, the case came to trial on 5 February 1929 in the Supreme Court of New York state. After twenty-eight days of hearing chiefly expert testimony, the jury, which included two real estate men, an accountant, a shirt manufacturer, a women's wear manufacturer, and a hotel clerk, was unable to reach a verdict, though nine jurors were for Hahn and only three were for Duveen. After further legal wrangling, the case was settled out of court and Duveen paid the Hahns sixty thousand dollars.[1]

Obviously the case is interesting to historians for many reasons, but here I want to focus on the contradictory processes by which different sorts of value were created in the Old Master art market in the early twentieth century. Specifically, I want to examine how the story of Old Master art was marketed in America and how the legitimation of such an art market and the works that circulated within it was marked by contradictions that the Hahns were able to exploit in their struggle with Duveen. *Hahn v. Duveen* was, of course, about the status of two particular works of art, especially of the painting owned by the Hahns, but it was also about who gave value to works of art that were fetishized as bearers of the highest values

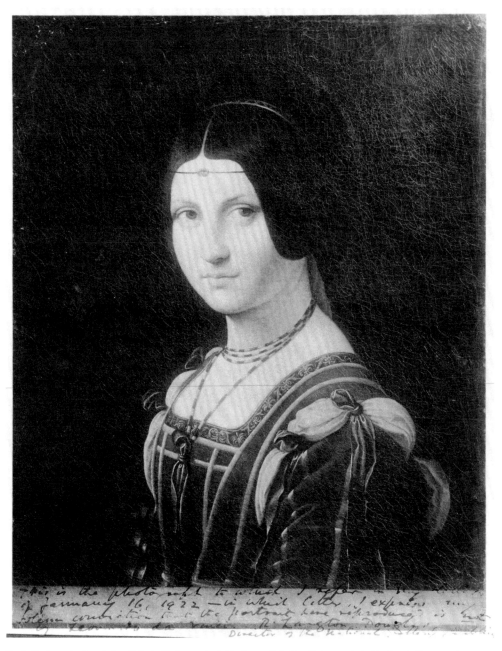

Fig. 1. Photograph of a painting attributed to Leonardo da Vinci—an attribution that was rejected by Joseph Duveen, who was later sued by the painting's owner. The inscription on the photograph is by R. Langton Douglas, director of the National Gallery of Art, Dublin, who testified in the case on Duveen's behalf. Duveen Archive, Sterling and Francine Clark Art Institute, Williamstown, Mass.

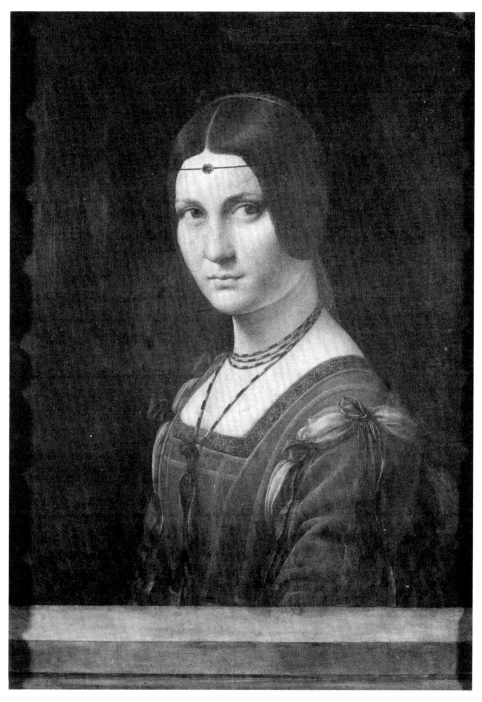

Fig. 2. Leonardo da Vinci (Italian, 1452–1519), *Portrait of a Woman (La Belle Ferronière)*, c. 1500. Oil on panel, 24 ⅜ × 17 ⅜ in. (62 × 44 cm). Musée du Louvre, Paris

of civilization, and how they did it. At the center of this story stands Joseph Duveen, the focus of a complex set of relations between a larger public, wealthy collectors, and experts with special knowledge.[2]

One of the most obvious features of the Hahn case is the astonishing amount of publicity it excited. The events in Paris in 1923 and New York six years later were covered not only by many American newspapers and journals—with the *Kansas City Star* and the *St. Louis Post-Dispatch* devoting headlines to the case—but also by the British, French, and Italian press. In 1923 the French press had a field day over the experts at the Louvre. In 1929 the Duveen London office reported that fourteen English provincial newspapers "averaging 20 to 40 lines" covered the beginnings of the trial. Both pictures were repeatedly reproduced in the press, and the *Illustrated London News* ran a four-page spread on the Two Belles and the experts.[3]

Such publicity was only one example, but it marked the apotheosis of the extraordinary attention paid by the press to the Old Master boom in North America. Never have so many private transactions—the selling and buying of Old Master art—taken place so publicly. Before 1913 the bulk of the European art transferred into the hands of American millionaires such as Frick, Huntington, Altman, or Morgan was not on display, but even before the opening of individual donor museums or the consignment of large collections to public museums, there was extensive press coverage in the daily newspapers and in a swiftly proliferating number of magazines about the influx of European cultural artifacts into American collections.

In her recent book *The Melancholy of Masterpieces* Flaminia Gennari Santori has shown how an American public was bombarded with information and news about the new art market.[4] As she points out, this reportage was framed in a particular way. The boom was portrayed as a consequence of a distinctive American, entrepreneurial style of collecting carried out by businessmen (the many female collectors, including Isabella Stewart Gardner, were generally overlooked) who were able to outbid and outwit European owners and collectors, transferring their vast private wealth to public, philanthropic use. This was depicted as a very American phenomenon; there was no suggestion, for example, that these collectors might be aping the manners and lifestyles of European aristocracies and merchant elites.

Accounts of the market emphasized the vigorous competition among collectors and the fabulous prices they paid, and they engaged in a sort of global accounting in which the number of works by major artists in the United States and the rest of the world were tallied up. Santori quotes a report of 1909: "America now has 70 of the 650 known works of Rembrandt. It has 50 copies of Franz Hals, as

against only 4 in Germany, and 7 of the Delft painter Vermeer's pictures to our [England's] 7."[5] Numerous examples of this sort of art count can be found. When individual pictures were discussed, their date, provenance, or aesthetic value were overlooked for the story of their owner and recent history in the marketplace. Thus some of the so-called "gems" of the Altman collection given to the Metropolitan museum were described as follows: "Mantegna, Madonna. This was the auction room sensation of 1912, its price being forced to $150,000 at the Weber sale in Hamburg. . . . The Crucifixion by Fra Giovanni Angelico da Fiesole. It is doubtful if another work by Fra Angelico will ever leave Europe, for all the known examples are in public collections. . . . Old Woman cutting her nails, by Rembrandt. Mr. Altman bought it at the Rudolph Kann sale in Paris in 1907, after rigorous competition with other well-known collectors."[6] The reason why paintings were reproduced in the press was almost always because of their recent arrival in the United States or their sale on the art market.

The effect of this publicity was to offer some legitimacy to the robber barons who had been heavily criticized in the progressive press, to depict private collecting as a patriotic and civic act, to see this collecting as a distinctively American phenomenon based on skilled business practice, and to excite a vicarious sense of participation and ownership in the imported art, even while it remained in (very rich) private hands. It encouraged a notion of rich men's stewardship of a cultural heritage that was becoming American. At the same time, as Santori points out, the ambiguities of the market were embodied not in the art dealer (a commendable commercial American type), but in the new body of experts whose arcane skills could be used to manipulate the market. As she explains, experts were viewed suspiciously because although they were necessary to authenticate works, they were also in a position to deceive collectors and the public.[7] They were the gatekeepers between commerce and transcendence, or the alchemists who transmuted art into gold. They determined the authenticity of the art object and thereby transformed it into a commodity. The volatility of the market—shifts in prices and fashions—were blamed on the experts. Changes in attribution were viewed not as a sign of progress, greater knowledge, or expertise, but as proof of the inexactitude and arbitrariness of connoisseurial opinion. The fact that almost none of these experts were American (the great exception, of course, being Berenson) made them even more suspect.

Where did Duveen fit in this publicity machine that depicted a heroic, distinctively American collector, conscious of his private interests and mindful of the public good? Unlike many other art dealers of the time, Duveen did not shun

publicity; he positively encouraged it. He provided photos—dealers were often the only people with images of the works of art—to be reproduced in magazines and newspapers; he cultivated a special relationship with the *New York Times*, where he was often featured in its headlines; and he aggressively supported the vision of American collectors in their determined and rightful pursuit of the greatest art in the world, even if it commanded the highest prices.[8]

Indeed he strongly identified himself with the rich clients he served. Working with monopoly capitalists, he publicly portrayed himself as the monopolist of great Old Master art. He liked to project an image of total power, one that concealed the compromises and collaborations he made with other dealers. He was famously ruthless in his pursuit of monopoly, not only talking up his own pictures, but also denigrating those of rivals.[9] Hahn's connection to Knoedler's—Duveen's greatest competitor, who helped secure a certificate of authentication for Hahn's Leonardo—cannot have endeared him to the dealer.

Even as he copied their business practices, Duveen persistently maintained the fiction to his clients that price was not important—that it only mattered to have the best—even while the publicity about the market emphasized spectacular prices. He played on the idea that what was being bought had a certain transcendental value that was humanly universal, eternal, unbounded, and beyond the quotidian, a value whose commercial worth was determined by the fact that it wasn't commercial but an expression of the human spirit. You cared about attribution because you wanted to be sure you were buying a Leonardo. But you bought a Leonardo because it was agreed to be one of the highest forms of human expression. You were buying something mysterious, wonderful, and intangible. What was being sold was a certain sort of elevated experience between the (private) viewer/collector and the art object. One critic describing Berenson's views said, "According to him, a work of art is a kind of reservoir of energy discharging itself into our previous nervous system, exciting us and putting us in the state of mind the artist wishes to express; for a moment we feel like Michelangelo, or to be more exact, the artist through his picture enters our body and plays on it like a musical instrument. Muscular ideas of strength, laziness, violence, and voluptuousness flow through us . . . we share the existence of these supermen . . . we find we are in a heroic world." The power of the collector lay in magnanimously making this experience available to a larger public.

This sort of experience was, at least in the eyes of someone like Duveen and thereby in those of his collector clients, attached to a small class of objects— Old Masters by artists in Vasari's *Lives;* a group of English eighteenth-century

painters, primarily Reynolds, Romney, and Gainsborough; a couple of Dutch artists, notably Rembrandt and Hals; and a few others such as Velázquez and El Greco. The precise list of artists is less important than the fact that they constituted a canon and that the canon was the market. They did not, of course, comprise the only art market by the 1920s, but in the larger public they were viewed as the supreme art market and the pinnacle of taste. It was a market first and foremost for artists. The art object's allure rose from its expression of the genius of the artist. The key sign of a picture's worth was therefore the hand of the master. Publicly, at least, the assumption was that there were three types of art on the Old Master market: originals (bearing the sole hand of the master), copies (acknowledged), and fakes (works of deception). Experts were aware of a more complex picture connected to workshop practice and collaborative or divided labor, but there was a constant pressure on them to push works into a positional relationship to "the original."

Where, then, does Leonardo fit into the story? Clearly he belongs to the canon, but he was not often found in the marketplace. Louis Levy, Duveen's lawyer, remarked that finding a Leonardo on the open market was a bit like discovering a new planet. To my knowledge, the first undisputed Leonardo purchased by an American buyer was the artist's earliest surviving portrait, *Ginevra de' Benci,* bought by Paul Mellon in 1967 and given to the National Gallery of Art in Washington.

But Leonardo had another sort of visibility, for the artist's work had a particular association with forgery and copying. The father of modern connoisseurship, Giovanni Morelli, bequeathed a supposed Leonardo to Donna Laura Minghetti, the wife of a close friend. Bernard Berenson authenticated the work, and it was sold to an American collector, Theodore Davis, only to be exposed as a fake by a Milanese restorer.[10] In 1909 Wilhelm von Bode purchased for the Kaiser-Friedrich museum a "Leonardo" wax bust that also turned out to be a fake.[11] And the most sensational Leonardo story of all, the theft of the *Mona Lisa* from the Louvre in 1911 by an Italian painter-decorator and its recovery two years later in Florence, led a whole series of owners to claim that their version of the Mona Lisa was the original, and the recovered work a copy. (Incidentally, the thief, Vincenzo Peruggia, approached Duveen in 1912, but was dismissed as a fraud).[12] In short, of all of the canonical artists, Leonardo probably had the greatest scarcity value on the market, but there was also a sense that his work, though deeply desirable, was dangerously surrounded by the risks of fakery and fraud.

Bearing all this in mind, we can now understand the positions taken by the Hahns in their case against Duveen. They used several different tactics. They por-

trayed the struggle with Duveen as a conflict between the little man and the rich mo-
nopolist (bear in mind that Hahn was a midwestern car dealer), and they set out to
expose Duveen's monopolistic tactics. They claimed the Hahn Leonardo—the
American Leonardo, as it was often called—to be not the possession of wealthy col-
lectors or a coastal elite, but the object of the whole nation; they sought to appropriate
the picture to the American arts of science and commonsense empiricism. All of these
factors were rallied to overpower the almost universal expert opinion that the Hahn
picture was a poor copy. In these efforts the Hahns were able to command the sup-
port of a number of fellow travelers—contemporary American art groups fed up
with the attention given to foreign Old Master art, dealers in other art markets, and
midwestern boosters who wanted to put Kansas on the cultural map.

For Harry Hahn the entire case was one of deception, a peculiar intrusion
of the aesthetic into the commercial, an emasculation of business acumen by the
apologists for art. As he put it:

> [T]he art expert ... left his philosophies and obscure studies and be-
> came a man of the world. If ... his aesthetic interests were looked upon
> with suspicion because of their uncertainty and arbitrary nature, they
> were welcomed in the game of artistic trading. They gave refinement
> and an aura of scholarship to what might have been mistaken for raw
> greed. They provided just what was needed to keep rich businessmen
> from acting and thinking as businessmen. They made business suspicion
> appear vulgar and shameful. More important still, they made the ele-
> ment of fact, which is the prime element of business operations, seem
> inconsequential in the matter of art where its place was taken by more
> ethereal concerns.[13]

Duveen's counterattack against the Hahns played into his critics' hands.
First he wielded all his power to destroy the credibility of the Hahns and their pic-
ture. It was an exercise in overkill, a massive deployment of art historical expertise,
the key resource in his system for exciting desire for Old Masters. Then he began
an aggressive campaign, both in the trial itself and in the press, to explain the prin-
ciples of connoisseurship. The entire case, then, focused on what the presiding
judge, William Harman Black, called "a battle between experts."[14]

The Hahns' lawyers were remarkably adept at undermining the credibil-
ity and reputation of Duveen's experts. In Paris, and later during the New York

trial, they revealed the covert business connections between the supposedly impartial Duveen experts and the dealer's firm. (This particularly distressed Bernard Berenson.) The entire business of connoisseurship was exposed as snobbish, European, elitist, and highly subjective and intuitive, a matter of cultural capital rather than technical knowledge. In this they were helped by the experts themselves. Thus Sir Martin Conway, justifying his rejection of the Hahn picture, testified, "I simply look at the Hahn picture and the impression produced on my mind is that it is not by Leonardo." Maurice Brockwell said, "[I]t is a question of psychology, not of the magnifying glass; it is the mind of the great master that we see, the spiritual content, the psychological correlations." Berenson spoke of a "sixth sense . . . difficult to find the vocabulary to express oneself." He also spoke of the importance of "accumulated experience upon which your spirit acts almost unconsciously." Robert Langton Douglas described his use of "constructive imagination."[15]

This may have gone down well with Duveen's clients in the dark shadows and warm lights of the dealer's showroom, but looked pretty shabby in the harsh light of a New York courtroom. Judge Black, who had a lawyerly sense of hard evidence and a strong commitment to proof on the basis of facts, was withering, both in the court and in his written opinion, about Duveen's experts. "It required," he remarked, "some mental agility to follow some of the experts from their positive testimony on the stand to the diametrically opposite views they had expressed in their books long before." "Beware experts," said Black to the jury, "because a man claims to be an expert does not make him one. . . . I have profound respect for critics whose conclusions rest upon facts . . . the opinions of any other kinds of experts are as sounding brass and tinkling cymbals. Some of them expound their theories largely by vocal expression and gesture; others wander into a zone of speculation founded upon nothing more tangible than 'psychological correlation.' I do not say that this is as absurd as it sounds to the layman, but it is too introspective and subjective to be the basis of any opinion a jury can pin its faith upon."[16]

Black's reference to diametrically opposite views alluded to what was deemed the weakest part of Duveen's case, namely the fact that many of his experts had once publicly acknowledged that they did not see the Louvre's *Belle Ferronière* as a work by Leonardo. The history of the attribution of the Louvre picture is complex, but for our purposes it is enough to know that received wisdom in the early twentieth century was that the work was either of the Milanese school or the work of Leonardo's pupil Boltraffio.[17] Yet nearly all of Duveen's experts, with only one doubter, confirmed that the Louvre picture was by Leonardo. (Conversely, when Harry Hahn suggested

in Paris that he did not want to say that the Louvre picture was a copy but was perhaps another version by the hand of the master, he was quickly muzzled by his lawyers.) The firm attribution, exposed in court as a sharp change of mind, fed the accusation that the experts were kowtowing to the wishes of Duveen. And though there is no evidence of Duveen's direct intervention, it is hard to explain the change in expert opinion, which then later shifted back to its earlier position, except as a defensive response to the public attack on connoisseurship.

The written testimony from Paris and the oral testimony in New York exposed the fragile and divided state of the world of art expertise. Berenson and Douglas claimed that they were "professional art counsel," but there was no sense of belonging to a professional group with a career path, qualifications, institutional grounding, and accepted standards of conduct and competence. When Levy drew up a list of questions asking about the qualifications of the Paris experts, he was told that most would not answer because they found such questions impertinent and ungentlemanly.[18] Even when the witnesses agreed with one another over the Hahn picture, they could not resist disparaging one another, questioning the skills of colleagues in a way that played into the hands of Hahn's lawyers. This simply mirrored the many personal and critical disagreements by which this art world was riven. As Douglas commented during the trial, "Experts fight like cats and dogs."[19] Expertise was still viewed as a highly personal skill, not a collective discipline.

Against this view, the Hahn case stressed democratic grounds for attribution based on scientific inquiry. As *Time* put it, Mrs. Hahn's experts "were relying on history, measurements, concrete evidence, rather than esthetic considerations,"[20] on the analysis of pigments and the use of X-rays and the painstaking recovery of the picture's provenance. Whereas today such resources are seen as tools to aid what is ultimately a connoisseurial judgment, in 1929 Duveen's experts—with the exception of a professor of chemistry who had volunteered his services—went out of their way to condemn scientific evidence and the knowledge of history when compared to "a highly trained eye." Although he eventually called an X-ray expert to counter the Hahns' expert, Duveen did not want to use X-radiography to support his case because, as he said, "I do not believe in it."[21]

The struggle between the Hahns and Duveen ended in an unsatisfactory stalemate. Duveen later conceded he was much distressed by the case, and he seems to have courted publicity thereafter through visible and uncontroversial acts of philanthropy rather than bruising and spectacular litigation. Berenson, as his wife explained to Duveen, felt horribly wounded and exposed.[22] The case, written up

in Harry Hahn's *The Rape of La Belle,* published in 1946, remained a key piece of evidence for a populist conspiratorial view of the art world and can be found on Web sites today.[23] The Hahns gained financially and in an agreement that Duveen would not make any more comments on the picture, but the power of Duveen and the experts meant that the American Belle remained unsold. Subsequent attempts up to the present to sell the picture have foundered, not least because of the reluctance of experts to give a public opinion on the status of the work. The Hahn family continues to speak of an art market conspiracy.

What is striking to me about this case study is how overdetermined the meanings of the art object were. So much was riding on both the Hahn and Louvre pictures. The Hahn picture became an indictment of the whole Old Master system and had to be expelled from it, both as a copy or fake and by casting it into an attribution limbo so that it could not be sold. The Louvre picture, in turn, had to be realigned as a definite Leonardo to shore up the system of connoisseurship, even when there were good grounds for qualifying its attribution. Of course the Hahns had a strong material incentive to sell their picture (and were not above ruses that would have flattered Duveen), but the longer the fight went on, the more preoccupied they became with the larger issues and values that were at stake. Duveen, in turn, was paying a price for his success in promoting the collecting of Old Master art as a public good. For all the attention paid to both the Hahn and Louvre pictures, one cannot but come away with a sense that the works of art were much less important than the freight they were asked to bear as both objects and icons.

1. There are several brief accounts of the case. Much the best is Andrew Decker, "The Multimillion-Dollar Belle," *Art News* (summer 1985): 87–97. See also Colin Simpson, *The Partnership: The Secret Association of Bernard Berenson and Joseph Duveen* (London: Bodley Head, 1987), 241–43; Harry Hahn, *The Rape of La Belle* (Kansas City: Frank Glenn, 1946).

2. The standard biography of Duveen is S. N. Behrman, *Duveen: The Most Spectacular Art Dealer of All Time* (New York: Little Book Room, 2003), first published in 1952. But see Meryle Secrest, *Duveen: A Life in Art* (New York: Knopf, 2004), which had not yet appeared when this essay was written.

3. Press coverage of *Hahn v. Duveen* is best followed in the Duveen Archive, Sterling and Francine Clark Art Institute, Williamstown, Mass., Bay XXII, items 2–7, which are scrapbooks of press clippings on the case, and in the Duveen Archive, Getty Research Center, Los Angeles, series 2B, Records of Law Suits, Microfilm box 304, reels 159–60. The item about the British press is "Commercial Cable

from London, 13 Feb. 1929." See also *Illustrated London News,* 2 Mar. 1929.

4. Flaminia Gennari Santori, *The Melancholy of Masterpieces: Old Master Paintings in America 1900–1914* (Milan: Five Continents, 2003), esp. chaps. 1–2.

5. Ibid., 44.

6. Ibid., 55.

7. Ibid., 129–32.

8. Ibid., 16–17, 127–28

9. Behrman, *Duveen,* 5.

10. Sybille Pantazzi, "The Donna Laura Minghetti Leonardo: An International Mystification," *English Miscellany* 16 (1965): 321–48.

11. Simpson, *The Partnership,* 141–42; Mark Jones, ed., *Fake? The Art of Deception* (London: British Museum Publications, 1990), 303–5.

12. Donald Sassoon, *Becoming Mona Lisa* (New York: Harcourt, 2001), 173–87, 199–203.

13. Hahn, *The Rape of La Belle,* 18.

14. Opinion, Judge J. Black, *Hahn v. Duveen,* Supreme Court of New York, 133 Misc. 871; 234 NYS 185; 1929 N.Y. Misc. (LEXIS 756, 13 Apr. 1929).

15. Hahn, *Rape of La Belle,* 103; Duveen Archive, Getty, Deposition of Sir Charles Holmes, 15 Sept. 1923; *New York Times,* 4, 18 Sept. 1923; 20, 21, 27, 28 Feb. 1929.

16. Opinion, Judge J. Black, *Hahn v. Duveen.*

17. For a history of the attributions see Pietro C. Marani, *Leonardo da Vinci: The Complete Paintings,* appendixes added by Pietro C. Marani and Edoardo Villata (New York: Harry N. Abrams, 2003), 178–82.

18. Duveen Archive, Getty, Stanchfield to Joseph Duveen, 28 July [1922]; Duveen Bros. Paris to Duveen Bros. New York, 26 May 1922.

19. See, among many news reports, *St. Louis Post-Dispatch,* 22 Feb. 1929.

20. *Time,* 18 Feb. 1929.

21. Duveen Archive, Getty, Joseph Duveen to Louis Levy, 8 Feb. 1929.

22. Ibid., Mrs. B. B. to Paris, 10 Feb. 1929.

23. See, for example, *www.fakesinmuseums.com* (viewed June 2003).

Dan Graham Inc. and the Fetish of Self-Property

Emily Apter

> We might say that, since the original moment of the "appropriation" or
> *prise de possession*, man—not only the man who has been deprived of
> property, expropriated if you like, but above all the man who *appropri-*
> *ates* something as his "own," who says "this is mine" or "I own this"—
> was running after a lure: that of actually *enjoying* what he *possesses*.[1]

In psychoanalytic theory, objectification—the breakdown of embodied totality
into erotogenic zones and partial objects that Lacan associated with the *corps
morcelé*—has often functioned as a universal model of subject formation and ex-
istential negation. Accordingly, analysis of something like the "lure of the object"
has been inextricable from narratives of the loss of the subject. Identification with
the object (of desire), leading to the ego's mime of the other's other, or camouflage
as other, presupposes an evacuation of the subject, its disappearance into the maw
of objectification. This problem of subjective loss continues to haunt us, but now
it is increasingly framed in terms of a radical self-depropriation induced by ad-
vances in biotechnology and internet literacy. The "lure of the object" in the
contemporary scene might thus be associated with some of the strange forms of
self-objectification that result when the "human" is divested of distinct attributes
of personhood. At this moment in history, it would seem, fetishism, instead of
connoting perverse object attachments intended to ward off castration anxiety,
finds a new role as theoretical placeholder for what happens when the enjoyment
of ownership—what the French notary refers to as *la jouissance des biens* (the verb
jouir connoting bliss as well as the Lacanian notion of the real, as that which is ex-
cessive to representation)—bleeds into anxieties around self-possession (definable
as a Faustian dilemma of selling oneself in order to consume more things).

In this essay I want to re-examine fetishism—a topic of long-standing criti-
cal engagement—as a theoretical construct relevant to interpreting the conceptualist
framing of art as subjective property. The term *subjective property* connotes the pro-
prietary drive that gives form to late capitalist possessive individualism.[2] It points to
a cluster of ideas in libertarian political theory encompassing voluntarism, the right
to self-disposal, wage labor, the limits of contract, self-ownership (as individual

autonomy), and property in the person (qualified as proprietorship of one's own person or capacities).[3] It extends to matters of copyright in the age of the human genome—starkly illustrated by the questions: "Do I own myself in the face of corporate patents on genetic signatures? Do I control a singular human essence transferable to none? It signals complex debates over what is proper to the proper name (the issue of proprietary rights to internet name domains). It refers to the fetishization of that x-factor called the "human" as that which cannot be wholly desubjectivated. And it connotes, in a general way, the economism of art and the aesthetic ironies attendant on works that capitalize on market value as conceptual strategy. Andy Warhol presciently distinguished between "art art" and "business art" (art that supports itself, doesn't go out of business) and, like Dan Graham in the sixties, he treated commodity fetishism as aesthetic currency, simultaneously elevating and debasing the value of artistic signature. In what follows, I want to consider early projects by Warhol and Graham that set the terms for rethinking fetishism as an extreme form of self-objectification that transforms the subject into the object of a "perverse" proprietary drive.

The proprietary drive, as I am defining it, applies not only to the subject's relation to private property (the desire of a human for possession of a thing), but also, in the broadest ontological sense, to the process by which a subject becomes propertied; that is, constituted as subject, by virtue of the possession of things. According to the Lockean definition, man comes to property through the labor of his human hand: "Though the earth and all inferior creatures be common to all men, yet every man has a property in his own person; this nobody has any right to but himself. The labor of his body and the work of his hands, we may say, are properly his. Whatsoever then he removes out of the state that nature has provided and left it in, he has mixed his labor with, and joined to it something that is his own, and thereby makes it his property."[4] Locke expounded this idea of property in *The Second Treatise of Government,* written in 1690, midpoint between his return from his exile in Holland and his acceptance of a post as commissioner with the Board of Trade and Plantations, created by the earl of Shaftesbury. These biographical details support a definition of the Lockean possession *qua* fetish as a *locus amoenus* conjoining the burnished, gleaming domestic artifacts of Dutch still lifes, with the spoils of American slavery, products made by disenfranchised hands that could never declare their labor. Locke's idea of property thus cannot be historically dissociated from enslaved objects, from the most brutal form of dehumanization. The shadow of slavery haunts Locke's proto-libertarian concept of "property in the

person," canonized in the dictum "every Man has a *Property* in his own *Person. This no Body has any Right to but himself.*" Even though this proposition rests on an implicit assumption that slavery and servitude abrogate the rights ascribed to property in the person, it nonetheless, as Attracta Ingram has noted, "embraces the claim of slavery that people can be the object of private property rules."[5]

Once people are the object of private property rules, the fundamental weirdness of the relationship between people and things comes into view. The strangeness of consumerism as an attempt to bind material property to the person and expand the ego's perimeter, or compensate for its lack, becomes apparent. The proprietary drive, when unleashed on the subject as object, seems thus to spring from the need to mitigate egoic deficiency. On this point, of course, the classic literature on fetishism becomes relevant. The early annals of psychiatry and criminology are replete with case histories written by Jean-Martin Charcot, Valentin Magnan, Alfred Binet, J. Avalon, Albert Charpentier, Gustave Macé, Richard von Krafft-Ebing, Gaetan Gatian de Clérambault, Freud, and Havelock Ellis, in which the fetishist's pleasure is defined by acts of bounty hunting and conquest. The shoe, the trinket, and the lock of hair all are embedded in scenarios in which acts of purloining, plundering, stashing, and hoarding are especially meaningful. These scenarios are read with great subtlety as efforts to insert the lost object back into the subject. Curiously, such efforts depend on "castrating," if you will, the object by negating it, taking it out of circulation, subjecting it to extreme privatization.

Freud and Marx are eerily complementary in the way in which they deploy theories of object castration in explicating the psychology of proprietorship. Consider, for example, how Freud's support-belt fetishist comports himself in the famous 1927 essay. Freud referred to this case by exemplifying how the fetish can become a vehicle for both disavowing and affirming castration.

> This was so in the case of a man whose fetish was an athletic support-belt which could also be worn as bathing drawers. This piece of clothing covered up the genitals entirely and concealed the distinction between them. Analysis showed that it could signify that women were castrated and that they were not castrated; and it also allowed of the hypothesis that men were castrated, for all these possibilities could equally well be concealed under the belt—the earliest rudiment of this in his childhood had been the fig-leaf on a statue. In other instances the divided attitude shows itself in what the fetishist does with his fetish, whether

in reality or in his imagination. To point out that he reveres his fetish is not the whole story; in many cases he treats it in a way which is obviously equivalent to a representation of castration. This happens if he has developed a strong identification with his father and plays the part of the latter; for it is to him that as a child he ascribed the woman's castration. Affection and hostility in the treatment of the fetish—which run parallel with the disavowal and acknowledgment of castration—are mixed in unequal proportions in different cases, so that the one or the other is more clearly recognizable. We seem here to approach an understanding, even if a distant one, of the behaviour of the *"coupeur de nattes."* In him the need to carry out the castration which he disavows has come to the front.[6]

What is particularly fascinating about this passage is the way it shows how fetishism becomes the key to denaturalizing property ownership, prompting such questions as: How does property come to belong to the subject? How is the subject propertied? How is the human's relation to "the thing" crucially mediated by fetishism?

Freud's support-belt fetishist helps provide answers to these questions insofar as he treats the fetish in a way that is equivalent to castrating it. In the behavior of people who cut off women's plaits of hair Freud sees revealed "the need to carry out the castration which he disavows." Freud's fetishist thus approximates a kind of psychic castrato who attempts to overcome castration anxiety by submitting the object to his will, subjecting it to capricious displays of emotion (tenderness and hostility). It is just this attitude of whimsy and caprice that Marx ascribed to his prototype of the despot-proprietor in "Human Requirements and Division of Labour Under the Rule of Private Property" (included in the third volume of *The Economic and Philosophical Manuscripts of 1844*):

Private property does not know how to change crude need into *human* need. Its *idealism* is *fantasy, caprice,* and *whim;* and no eunuch flatters his despot more basely or uses more despicable means to stimulate his dulled capacity for pleasure in order to sneak a favour for himself than does the industrial eunuch—the producer—in order to sneak for himself a few pieces of silver, in order to charm the golden birds out of the pockets of his dearly beloved neighbors in Christ. He puts himself at the service of the other's most depraved fancies, plays the pimp

between him and his need, excites in him morbid appetites, lies in wait
for each of his weaknesses—all so that he can then demand the cash
for this service of love. [7]

Here one can draw parallels between Freud's suspensory-belt castrato and
Marx's image of the "industrial eunuch," the castrated factotum of the property
owner. Marx's proprietor, "serviced" by the producer of commodities (or pimp of
the fetish), may be seen through Freud's lens as "executing castration," enacting a
buried memory of castration on the object, which in turn endows the object with
its status as private property. As the object is abused or worshiped, it yields the en-
joyment of possession.

For Marx, the castration of the object occurs when it is purloined or ex-
tracted from the hands of the other: "Every person speculates on creating a *new*
need in another, so as to drive him to fresh sacrifice, to place him in new depen-
dence and to seduce him into a new mode of *enjoyment* and therefore economic
ruin. Each tries to establish over the other an *alien* power, so as thereby to find sat-
isfaction of his own selfish need. . . . Every new product represents a new *potentiality*
of swindling and mutual plundering."[8]

The classic Marxist interpretation of private property as the material sum-
mary expression of alienated labor takes on another meaning when read
psychoanalytically. It defines the proprietary drive as coextensive with a divestiture
drive, itself discernible as the satisfaction derived from taking the object away from
someone else, wounding the other by inflicting a lack or hole marking where the
thing once was.[9] By this logic of antinomian reconciliation, one might read the
museal, hoarding instincts of the Dutch collector, whose pronk still lifes record the
"embarrassment of riches" not as refutation of, but a confirmation of Pierre-Joseph
Proudhon's dictum that "property is theft." (La propriété, c'est le vol).[10] Conceived
in these terms, the proprietary drive leads to a process of bulking up the self by di-
minishing the other's stores. What better way to achieve that goal than by establishing
the self as master-fetish, a piece of supremely valuable property that gathers into
itself the value of the commodity? Such [self]-"possession obsession" is, of course,
synonymous in contemporary art history with the name of Andy Warhol.[11]

Fetishism of every kind is so ubiquitous in Warhol's art and life that on
first examination, it might seem almost meaningless; a tautology synonymous with
Warhol himself, or at least with his aesthetic and performative compulsions. Fetishism
emerges as the common denominator and preferred symptom of all of Warhol's

trademark subjects (bananas, shoes), death fetishes (electric chairs, crashed car bodies), love of camp accoutrements, (wigs, sequined dresses), and bibelot collecting (hoarded fanzines and stockpiles of unopened Fiestaware). In this context it is difficult to distinguish clearly between Andy Warhol as fetish-hallowed icon of the art world and Andy Warhol the fetishist. How can one draw the line between the Warhol signature as critical frame for product branding (Campbell's, Brillo, the *Marilyns* and *Jackies*), and the Warhol effect as a baptismal font of art-house industrial strength names: Candy Darling, Viva, Ondine, Billy Name? Throughout Warhol's oeuvre, the fetish for naming and the naming of fetishism remain intertwined. Thus a passion for Hollywood stars spawns an obsession with designer clothes, which connects to a fixation on fashion designers (Halston, et al.), which leads to a generalized commodity fetishism of designer labels, which blends into Warhol's mystique as the art market equivalent of a designer label.

The fetish, after all, is a particular kind of symbol, both arbitrary (shoe, glove, hat—what's the difference if they produce a sexual charge?) and singular (a treasured votive object, a cornucopia of favorite things—or, in Warhol's case, myriad favorite things: Old Masters, religious icons, French posters, Art Deco furniture, Steuben glass, Native American art, cookie jars, expensive jewelry, Kenny Sharf and Keith Haring paintings, etc.). As the engine of erotic force fields, guiding material objects into alignment with the magnetic pull of diffuse attractions and emotional cravings, fetishism assigns affect to objects of base materialism, to the shapes of meaningless matter. Given the wide compass of Warhol's field of desire, it is no accident that fetishism is everywhere and nowhere: everywhere insofar as Warhol transformed the most ordinary consumer artifacts into cult objects, and nowhere are they too penile, too obvious as phallic symbols to function effectively as desirable fetishes (the early shoe advertisements, the bananas, toes, and paintbrushes). A really good sexual fetish is a Freudian thing that is invested with the social and erotic power of the phallus without having to resort to overt resemblance to a penis. The best fetish inspires awe in its devotee by alluding to rather than referencing the memory of a traumatic wound in the psychic body of the subject. Hieratic and remote, cold and cruel (grinding memory, like the point of a stiletto heel), wielding the redoubtable moral authority of a Kantian categorical imperative, the power fetish suborns the fetishist to its will with a pitiless, "take no prisoners" imperiousness.

No critic has been able to avoid the presence of commodity fetishism in Warhol. Thierry de Duve noted: "It is only with late modernism, that of Warhol

for instance, that the economic conditions of art practice, understood until then to be contingent and external to art properly speaking, became its subject, its substance and its form."[12] He was referring, of course, to Warhol's notorious championship of business art, which took as a given the work's commodity status and market circulation. The trace of the artist's hand, authenticated and personalized through facture, gave way in Warhol's art to the Taylorized surface finish of photo silk screens (with the artisanal faintly hinted at by what he called "surface incidents"). Indeed, for many critics, this promotion of surface and, along with it, thematic superficiality, represented not only the triumph of mass reproduction over artisanal modes of production (or, to use Marx's formula, of exchange value over use value), but also the triumph of pop art's cultural narcissism (the viewer refracted in the gleam of the high-gloss surface) over the moralizing, redemptive humanism of high art.

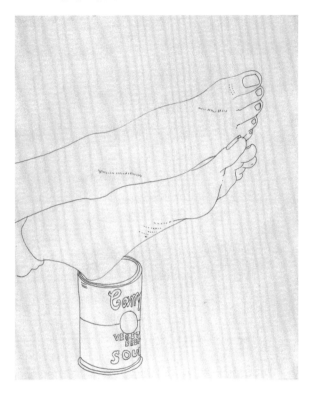

Fig. 1. Andy Warhol (American, 1928–1987), *Feet and Campbell's Soup Can*, 1955–57. Ballpoint ink on manila paper, 17 × 13 ⅞ in (43.2 × 35.2 cm). The Andy Warhol Museum, Pittsburgh

And yet there emerges a specificity to Warhol's fetishism that makes fetishism in Warhol's art more than just a means of describing everything he had a hand in, and that is the powerful way he conjugated sexual and commodity fetishism. For when commodity fetishism is joined to sexual fetishism, a different kind of object emerges. In Warhol's hands, Brillo boxes, collectively arrayed, reveal America's insatiable hunger for consumer goods—capitalism as desiring machine. A Campbell's soup can, generic and seeming to inspire little ardor, becomes an exciting sex toy when fondled by a bare foot (fig. 1). The vivification of inert objects, the sexual life of things, the "thingification" of the human, each iteration reveals the principle of controvertibility at the heart of the original Marxian formula in *Capital* whereby social relations mime object relations and commodities acquire the anthropomorphic qualities of people.[13]

Warhol explored the relationship between humanness and thingness in early erotic drawings that confound distinctions among part objects and body parts. Whereas Locke and Marx located the fetish in a middling position between thing and hand, Warhol made a fetish of all manner of body parts. His foot-penis or penis-*poitrine* function as mutant symbolic forms comparable to the classical fragments celebrated by fin-de-siècle decadence (on the order of Rilke's "Archaic Torso of Apollo"). Like the uncanny join between angel wings and back muscles in religious tableaux, or the connection of animal to human in classical mythological paintings, Warhol's goat foot, cloven hoof, or animal paw, thrusting its way between two legs, conjures up mythological man-beasts: the centaur, satyr, or sphinx. The "third leg" or tail, blurring taxonomies of species-being, is suggestive of evolutionary anomaly, transgenic fantasy, or human devolution. Warhol's visualization of bodies is uncivilized (in the strong sense of that term) insofar as it places the human on a non-hierarchical continuum between live thing and human meat.

The mobile semiosis between thing and living subject is clearly in evidence in Warhol's famous shoe pictures, particularly those belonging to the collection *A la Recherche du Shoe Perdu* (fig. 2). The Proustian allusion substitutes the lost shoe for lost time, underscoring the function of the shoe as memorial site, imprinting an absent human form, mummifying the press of the foot—the instep, weight, and gait of the body. The cast-off shoe, historically commemorating missing persons, also works as a time capsule storing palpable residues of human odor

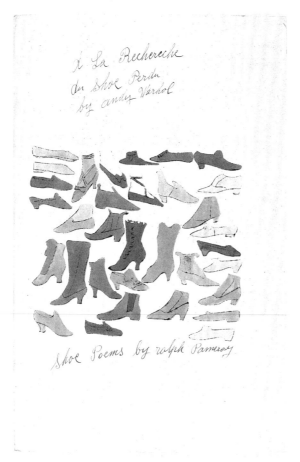

Fig. 2. Andy Warhol, Cover of *A la Recherche du Shoe Perdu*, 1955. Offset lithography, watercolor, and pen on paper, 13 ¾ × 9 ¾ in. (34.9 × 24.8 cm). The Estate of Andy Warhol. © The Andy Warhol Foundation for the Visual Arts / Artists Rights Society (ARS), New York

and musky distillations of impacted dirt and wear. Illustrating the animating power of the primitivist fetish, Warhol's shoes also typify how objects in his collections function as gangplanks connecting the human to the inhuman or the undead to the mortuary. Consider the shock of seeing an encased exhibition of Warhol's personal pharmaceuticals. Moisturizers and acne creams embalm a haptic memory of the artist's troubled complexion.

Warhol fulfilled Jean Baudrillard's claim "What you really collect is always yourself."[14] By treating himself as collectable property Warhol brought self-fetishism to the art of connoisseurship. His noteworthy covetousness for strange and beautiful things, from lowly craft to significant masterpieces, could be explained as the desire to possess objects that gave material justification to the expression of his "having an eye." According to associates, it was impossible to anticipate what the Warholian eye would shine upon with favor; the choice of object was serially reproduced, but the grounds of its selection were apparently without rhyme or reason.[15] The Sotheby's Arcade Auctions imposed a logic of lots onto this sea of things—jewelry, furniture, decorations and paintings; Art Nouveau and Art Deco; European and American paintings, drawings, photographs, and prints. Perhaps it is this logic that leads, ultimately, to the stray affinities binding the objects into a collection. Scrutinizing individual items at random—an Old Master painting, *Encounter Between a Rooster and a Ferret,* by Johann Heinrich Roos; *Crowning of Psyche by Cupid,* a nineteenth-century French school painting; harem scenes from the archive of colonial kitsch; a Norman Rockwell *Portrait of Jackie Kennedy; The Amazon,* a figurative head by Joseph Stella; a snub-nosed "Monster" by Francis Picabia; a painted cast-iron stove figure of Washington; a Canada goose decoy; an Egyptian revival painted armchair with gilt masks of Hathor, raised on legs formed as walking lions; a *poubelle* by Arman; a Claes Oldenburg project titled *Shrimps on Fork;* Tom Wesselmann's *Drawing for Most Beautiful Foot* (1968). It becomes apparent that a methodical weirdness governs Warhol's taste. Americana meets the *informe;* pop icons dance with sentimental souvenirs; baroque decor complements the one-liner surreal; small things of great value harmonize with big things of no value. There is an elective affinity, a principle of natural selection, a fetish family resemblance that makes itself felt, even when eluding precise articulation.

Snapshots of Warhol's home reveal an overall fetishism of the *intérieur* worthy of the pathological collectomaniacs indexed in the annals of fin-de-siècle psychiatry or consonant with Walter Benjamin's evocation of Second Empire rooms draped in antimacassars and wall hangings. According to Stuart Pivar, a pizza man

in polychromed plaster competed successfully for a pedestal in Warhol's private museum with masterpieces like *Theseus Slaying the Centaur.*

Warhol collected like an obsessional bounty hunter, falling prey to seizures of mimetic desire ("Whatever Henry [Geldzahler] buys I want the same or one just like it"), sniffing the air of the salesroom as if it were the purest oxygen of capital, haggling over prices like a Balzacian miser, and indexing his consumerism to a principle of self-inflation ("If I buy it, it goes up in value").[16]

This flippant phrase "If I buy it, it goes up in value" is particularly rich for my purposes, for it reveals how Warhol saw his own self-property as the guarantor of a return on his investment. Since Duchamp, artists have been fully wise to how artistic signature, the premier authenticating mark of artistic product, can transform ordinary objects into works of significant aesthetic and monetary value. But what Warhol figured out was that the function of signature extends beyond attribution to the act of acquiring a material object and infusing it with possessive individualism. By mingling his own name value with the object, he allowed market interactions with the object to qualify as art (fig. 3).

Property of the person, in its fetishistic function, took a different turn among artists working in Warhol's wake. Where Warhol directed the proprietary drive to the inflationary arc of signature (and duly profited), artists such as Vito Acconci, Bruce Nauman, and Dan Graham experimented with anticonsumerist strategies of embodied dispossession. Their early work embraced visual austerity—a love of typewriter print and grubby Xerox—that could be read as part of the purge of art values, specifically of abstract expressionism's saturated color fields, Warhol's commercial product extravaganza, or minimalism's hyper-elegance. In *Room Piece* (fig. 4) Acconci filled the Gain Ground Gallery in New

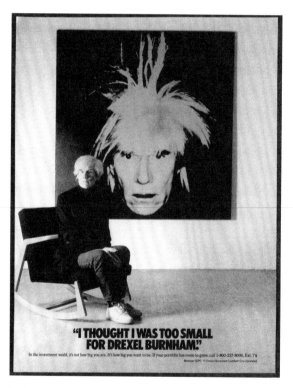

Fig. 3. Bruce White, *Drexel Burnham Advertisement*, 1986. Poster. Founding Collection, The Andy Warhol Museum, Pittsburgh

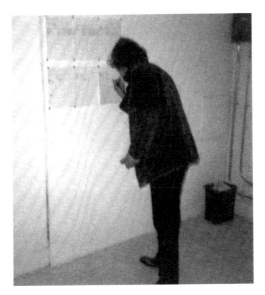

Fig. 4. Vito Acconci (American, born 1940), *Room Piece*, 1970. Activity/installation, home furnishings, house wares, cardboard boxes, and note sheets, 5 × 3 × 10 ft. (152.4 × 91.4 × 304.8 cm). Gain Ground Gallery, New York. Photo courtesy of Acconci Studio

York with boxes of personal effects and pieces of furniture, thus performing an act of self-deprivatization that paradoxically allowed for a privatization of the public sphere, as if the artist were annexing the gallery space to his own living room. In other pieces produced during 1970, Acconci shifted theme, from property ownership as a by-product of private/public site specificity, to the problem of self-property, as that which eludes ownership, seeping away from its bedrock status as predicate of the simple phrase "I make art."[17] *Rubbing Piece* (fig. 5), for example, shows the artist worrying one part of his body (the left forearm) with the other (the right hand), as if to show how the attempt to "work on" the self by the self, should *sensu stricto* enable the artist to sign himself as artwork, thus owning and being the product of his own labor. *Trademarks* (fig. 6), a kindred piece from 1970, featured close-ups of bite marks made by the artist on areas of his own body that he could reach with his mouth. "Turning in on myself. . . . (grouping of parts according to the way one part is produced by another—my leg bears the mark of my teeth: my

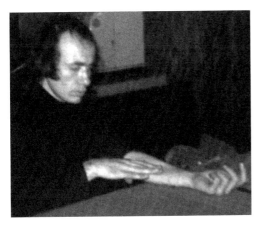

Fig. 5. Vito Acconci, *Rubbing Piece*, 1970. One-hour performance at Max's Kansas City, New York. Photo courtesy of Acconci Studio

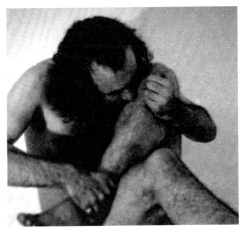

Fig. 6. Vito Acconci, *Trademarks*, 1970. Activity. Photo courtesy of Acconci Studio

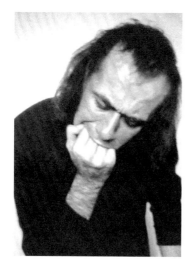

Fig. 7. Vito Acconci, *Adaptation Study (Hand and Mouth)*, 1970. Still from a Super-8, black-and-white silent film. Photo courtesy of Acconci Studio

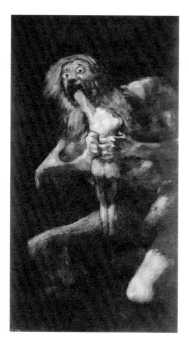

Fig. 8. Francisco de Goya (Spanish, 1746–1828), *Saturn Devouring One of His Sons*, 1820–23. Fresco transferred to canvas, 57 1/8 × 32 5/8 in. (146 × 83 cm). Museo del Prado, Madrid

leg is derived from my mouth)" Acconci wrote, thereby establishing a regime of acephalic (mouth replaces brain) self-possession in a semiotic field of intracorporeal relations.[18] Acconci's anthropophagic trademarking recurs in *Adaptation Study* (fig. 7) in which the artist ingests his own hand. The work recalls Goya's famous *Saturn Devouring One of His Sons* (fig. 8) (used by Jacques Lacan as the cover image of Seminar IV on "object relations"), except that where, in Goya's image, the bloodied, phallic stump pointing into Saturn's maw is of an "other" (albeit flesh-and-blood kin), in Acconci's piece, the "other" being eaten is self. This legendary self-cannibalism illustrates Etienne Balibar's characterization of *legitimate* (as opposed to exploitative) appropriation as "the movement of life that descends into things or assimilates them."[19] When the "thing" is a piece of one's own person, this formulation registers as a glorious life-infusion of the anatomical part object that dissolves barriers between self and own, proper and propriety, and the ontological stakes of "to have" and "to be." As Acconci aggressively attacks parts of his anatomy with another part of his anatomy in these early action pieces, he recalls the fetishist who castrates his property the better to possess it. Automutilation and the abject humility of public self-offering are thus resignified as unalienated labor and self-ownership.

Acconci's *Trademarks,* as other work of this period by avant-garde artists equally obsessed with the subject as object, replaced the aesthetics of self-reflexivity with cybernetic models of the subject as an information input-output loop or locus of social feedback.[20] Dan Graham, perhaps the premier theorist of the group, in his 1969 essay "Subject Matter" launched a post-minimalist program that proposed subjective property as the key to a new understanding of medium. For Graham, Bruce Nauman's topologically skewed and folded strips of cloth-backed latex (fig. 9) or Richard Serra's rubber sheets of 1967–68 (particularly the sculpture *To Lift* [or

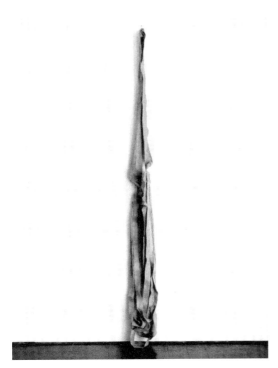

Fig. 9. Bruce Nauman (American, born 1941), *Untitled,* 1965–66. Paint and latex rubber over burlap, approx. 96 × 21 × 4 in. (243.8 × 53.3 × 10.2 cm). The Menil Collection, Houston. Gift of Gerard Junior Foundation

Fig. 10. Bruce Nauman, *Flesh to White to Black to Flesh,* 1968. Video still. Reproduced in Dan Graham, *Articles* (Eindhoven: Van Abbemuseum, 1978), 66

Slight of Hand]) could be read as an index of the human trace and as a site of "verb action" applied to a material. "In this view," he wrote, "the object is defined as processual and dematerialized (built out of information). *The material has been lifted.*"[21] "Lifted" may be taken in a double sense to mean both liftoff (the flight of structure into information or process) and subjective theft (the object "lifts" or steals subjective substance from the artist, binding it to materials). We begin to see here how property of the person—the residue of the hand of labor—almost seems to come off onto the art object, allowing some measure of "self" to be owned as an "other property" belonging to the art object.

In the same vein, Graham wrote of Bruce Nauman's 1968 video pieces (fig. 10): "The body in-formation is the medium; the body in-formation is the message for the presence of . . . *Nauman himself.* There is no longer the necessity of a material (other than the artist's body) for the mediation."[22] In this instance, the medium is the message, not just in body, but also in name. The name "Nauman," hovering homonymically between "now-man" or the German *neue Mann* qualifies as nominalist subjective property. Graham would use nominalist self-property to great effect in many of his own early forays into magazine art. For a project called *Detumescence* (fig. 11)—in which the artist walked a fine line between his role as buyer

DETUMESCENCE

I had in mind a page, describing in clinical language the typical emotional and physiological aspects of post-climax in the sexual experience of the human male. It was noted that no description exists anywhere in the literature, as it is "anti-romantic." It may be culturally suppressed — a structural "hole" in the psycho-sexual-social conditioning of behavior. I wanted the "piece" to be, simply, this psycho-sexual-social "hole" — truncated on the page alone as printed matter. To create it, I advertised in several places. In late 1966 I advertised for a qualified medical writer in the "National Tatler" (a sex tabuloid). In early 1969 "The New York Review of Sex" gave me an ad. As both of these ads were somewhat edited, I bought an ad in "SCREW" in mid-1969. I HAVE RECEIVED NO RESPONSES.

Fig. 11. Dan Graham (American, born 1942), *Detumescence*, 1969. Reproduced in Dan Graham, *For Publication* (New York: Marian Goodman Gallery, 1991)

of medical writing and seller of the description of his own detumescence—the artist's name appeared as the contact in a want ad in a 1969 issue of *The New York Review of Sex:* "WANTED: Professional medical writer willing to write clinical description covering equally the physiological and psychological (lassitude/pleasure) response of the human male to sexual detumescence. The description selected will be reproduced as a piece in a national magazine. Writer of piece retains copyright and is free to use description for his own purposes. Contact: Dan Graham, 84 Eldridge St., NYC 10002."[23] Here the name Dan Graham performs a triple function: it subverts the high art values of authorial signature, flouts the conventions of gallery art by treating advertising as a site-specific artistic medium, and puns on the idea of the artist who sells himself, or sells out.[24] In *Proposal for Aspen Magazine* (1967–68) signature became a means of hawking the self as a transmitter of information. And in *Proposal for Art Magazine* (fig. 12) of May 1969, Graham proposed the commission of himself as arbiter of artists' comments on each other's work. In specifying that "The magazine feature, appearing with my name as its author, will consist only of a *verbatim* [*sic*] transcript"[25] he tested the protocols of copyright and aesthetic property.

Graham's 1969 *Income (Outflow) Piece* is arguably the strongest of his experiments with subjective property. Conceptually, as he explained in a December 1973 lecture to students at the University of the State of New York at Oswego, the work was indebted to Robert Morris:

> This was spring, 1969. At that time artists in New York were starting to question the economics of and their role in the art world. Artists wanted to control the uses (economic and otherwise) their products were put to by collectors and museums. The United States economy was booming. Morris had been offered a one-man retrospective show ... at the Whitney Museum. He proposed instead that the Museum, who it had been revealed had substantial monetary assets, simply loan Morris the total of these reserves for him to invest in the stock market for the duration of the show. Whatever money was made in that period he would take as his fee.... Morris's closed-system strategy was a calculated success; in the context of the present art world it represented an example of an artist not being used by the system, but using it and as an artist (in the art history strategy of that moment) updating concerns of "Concept" art to "Process art."[26]

PROPOSAL FOR ART MAGAZINE

A Museum or a gallery makes an 'important' exhibition
of 3 artists presently working in the same genre all
of whom are familiar with each other and each other's
body of work. Dan Graham, a known art critic,
is commissioned by this magazine to produce an article
dealing with this exhibition.

I interview each artist, completely tape-recording
their comments. I ask each of them to speak (also) about
the work of the other two artists.

The magazine feature, appearing with my name as its
author, will consist only of a *verbatum* transcript of:

1. The first artist's comments about the second and
the third artist('s work).

2. The second artist's comments about the first and
the third artist('s work).

3. The third artist's comments about the first and the
second artist('s work).

The resultant structure is only the socio-psychological
framework (a self enclosing triad), the reality that
is 'behind' the appearance of any article in the art
magazine, or *art criticism.*

May, 1969

Fig. 12. Dan Graham, *Proposal for Art Magazine*, 1969. Reproduced in Dan Graham, *For Publication*

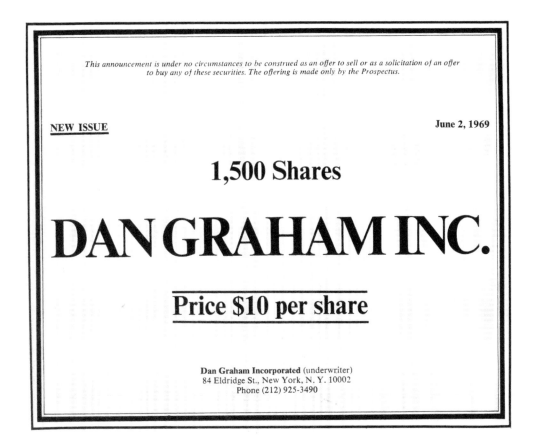

This announcement is under no circumstances to be construed as an offer to sell or as a solicitation of an offer to buy any of these securities. The offering is made only by the Prospectus.

NEW ISSUE **June 2, 1969**

1,500 Shares

DAN GRAHAM INC.

Price $10 per share

Dan Graham Incorporated (underwriter)
84 Eldridge St., New York, N. Y. 10002
Phone (212) 925-3490

Fig. 13. Dan Graham, *DANGRAHAMINC.* (part of *Income (Outflow) Piece*), 1969. Reproduced in Dan Graham, *For Publication*

Graham's gloss on Morris involved "incorporating" himself as a stock entity worth 1,500 shares to be sold at ten dollars per share (fig. 13). He wrote an announcement for the offering of himself to be placed in a host of periodicals including *The Wall Street Journal, Time, Life, Artforum,* and *Vogue.* In large boldface letters that slurred visually into the abbreviation "Inc.," the proper name Dan Graham, dominating the framed space of the advertisement, morphed into a logo or trademark. As an early experiment in subjective copyright, Dan Graham Inc. anticipates by some thirty years the current vogue for logo art and the legal battles over name domain property on the Web.

Mindful, perhaps, that offering shares in himself was dangerously venal, Graham justified the action as a way of earning a living wage, with any surplus above the salary promised to investors as a return. In a "Statement of the Artist

INCOME (Outflow) PIECE

STATEMENT OF THE ARTIST EXHIBITED AT DWAN GALLERY, NEW YORK, "LANGUAGE III"

From April 2, 1969 I have been performing activities required to allow my placing legally an advertisement (termed a 'tombstone') in various magazines offering the prospectus describing a public offering of stock in *Dan Graham, Inc.* The 'object' (my motive) of this company will be to pay Dan Graham, myself, the salary of the average American citizen out of the pool of collected income from the stock's sale. All other income realized from the activities of Dan Graham beyond the amount *will be returned to the investors* in the form of dividends. I, Dan Graham, am to be the underwriter of the forthcoming issue. Advertisements, it is planned, will be placed sequentially in a number of contexts-magazines. These are divided into 'categories' as, first: "The Wall Street Journal" (then in this order), "Life", "Time", "Artforum", "Evergreen Review", "Vogue", "Psychology Today", "The Nation". My intention is to solicit responses to my and my company's motives from a spectrum of 'fields.' Such responses *might* range from: "Mr. Graham is attempting to create socialism out of capitalism" (*political* motive) or, "Mr. Graham is a sick exhibitionist" (*psychological* motive) or, "Mr. Graham is making art" (*aesthetic* motive) . . . all categories of meaningful information feedback. Categories of responses will define feedback in terms of motive. A sampling of responses in print would be printed as additional in-formation as the advertisements progressed in their appearances. Author and place the comments appeared would also be printed. In placing the comments of additional in-formation, I would be motivated solely to induce (through 'come-ons') the greatest response in terms of new stock buyers. The prospectus outlining the terms of the offering will also include a valuation of myself and past activities by a friend, an artist, an astrologer, and anthropologist, a doctor, and others. These individuals will each take a small percentage of shares of the stock in exchange for these services.

1. Money is no object, but a *motive, a modus vivendi,* a means to my support; the artist changes the homeostatic balance of his life (environment) support by re-relating the categories of *private* sector and *public* sector; a modus operandi, a social sign, a sign of the times, a personal locus of attention, a *shift* of the matter/energy balance *to mediating my needs* — the artist places himself as a situational vector to sustain his existence and projected future (further) activities in the world. Money is a service commodity: in come and out go while in-formation.

2. The artist will have as his object (*motive*):

a. to make *public* information on social motives and categorization whose structure upholds, reveals in its functioning, the socio-economic support system of media.

b. to support himself (as a service to himself).

c. for other persons to emulate his example and do the same.

Fig. 14. Dan Graham, *Income (Outflow) Piece,* 1969. Reproduced in Dan Graham, *For Publication*

Exhibited at Dwan Gallery, New York, 'Language III'" Graham elaborated the program of *Income (Outflow) Piece* (fig. 14):

> From April 2, 1969 I have been performing activities required to allow my placing legally an advertisement (termed a "tombstone") in various magazines offering the prospectus describing a public offering of stock in *Dan Graham, Inc.* The "object" (my motive) of this company will be to pay Dan Graham, myself, the salary of the average American citizen out of the pool of collected income from the stock's sale. All other income realized from the activities of Dan Graham beyond the amount *will be returned to the investors* in the form of dividends. I, Dan Graham, am to be the underwriter of the forthcoming issue.[27]

Operative here is a play on the libertarian assumption (often attributed to Locke), that people can be the object of private property rules, and may alienate the property in their person if they so choose. At first blush Graham's stock offering of himself seems tantamount to an act of supreme subjective destitution. But on further reflection, it represents a wager on a higher rate of return, since Dan Graham the artist retains copyright over the signed work comprising his own self-sale. In principle, this work rests on the voluntarist assumption that you control yourself in submitting yourself freely to the will of the other; a perverse notion of contract that risks trading the whole person away for the sum of the parts. Graham acknowledged such a risk in his talk to the Oswego students: "The system (I have created), is designed as an exposure device; it 'uses' media to maximize availability to my ideas or art. The more people 'invest' in my work, the more it is in that many more people's interest that others are interested. It uses the trend of artists using the art magazines and their personalities to sell the magazines and their art. . . . However, the model *is* open-ended. For instance, the Board of Directors may wind up controlling whatever my sense of 'self' is in a particular future."[28] In unlinking "what owns" from "what one owns," Dan Graham Inc. apportions the subject into alienable properties that may ultimately become entirely the property of the corporate entity holding the controlling shares.[29]

Portraying the risks attendant on expropriation of property in the person, *Income (Outflow) Piece* foretells anxieties around the right to self-ownership surfacing in the age of the genome. For certainly the concept of "self *as* property" has become a more pressing concern as genome research has attained what scientists

Fig. 15. Larry Miller (American, born 1944), *Who Owns Your DNA?*, 2000. From *www. creativetime.org*

have called the "Holy Grail" of inheritance.[30] The concern has been astutely captured by a number of artists working in "genesthetics," prominent among them Larry Miller, whose coffee-cup piece *Who Owns Your DNA?* (fig. 15) shows a fingerprint functioning as a mass-produced barcode or commercial logo.[31] In spearheading a Genetic Code Copyright Certification Project that would "allow humans to claim their genomes as protected private property," Miller works off the assumption that as "the human" is increasingly objectified as corporately patented code, the risk is high that, one day, it will no longer be the private property of the subject. Even though you could become the consummate vanity license plate, a kind of super-I.D. owned and operated by you, there would always lurk the fear of a hostile takeover: your code sold to a higher bidder; copyrighted, warehoused, or cloned. Though cloning, on one level, demands to be interpreted as the consummate self-fetish (a fulfillment of the dream of self-preservation as infinite autoreproduction), it also undermines self-fetishization insofar as the original you could no longer be guaranteed mastery over its clones. The copying gene, say, cDNA (a non-natural, man-made version of the coding sequences of a gene), may be the private property of a corporation, thus constituting a potential legal blockade to the subject's possession of his or her "sequence tagged site" or DNA identification.

Perhaps it is in response to such anxieties, that "the human" has been fetishized as an x-factor or quantum that defies genetic engineering. The fetish, in this case, refers to the cult value of that which is extra to DNA, a kind of last bastion of subjective private property.[32] But this self-fetishization, heroic as it may be, is nonetheless constrained by a logic of compromise, a rationale of making do with personhood when you can no longer possess your genetic blueprint. It was Karl Krauss who best captured this logic when he wrote, "There is no more unfortunate being under the sun than a fetishist, who longs for a woman's shoe and has to make do with a whole woman." Krauss's aphorism not only captures the irony of having something big compensate for the loss of something small, it also points to the inferior status of the human as a fetish. For the genome is the ultimate part object, a micro-partitive entity, and, as such, a better fetish. In the war of the fetishes, in which nothing short of the property of the subject is at stake, the genome takes

all. The "human" is left with the prospect of trying to reappropriate itself, a self which, in the form of the genome, is now radically outside itself. It must remarry itself to its own thing. The genome, I would suggest, poses just this kind of setback to the individual's ownership of self-as-private-property. Individuals will have to make do with fetishizing an idea of subjective property constituent of the "I" in lieu of claiming exclusive rights to a whole genic identity.

1. Etienne Balibar, "'Possessive Individualism' Reversed: From Locke to Derrida," *Constellations* 9 (2002): 306.

2. C. B. Macpherson's highly influential notion of possessive individualism has its roots in the theory of Locke and Hobbes. Among its important tenets are: (1) emancipation signifies freedom of the individual in relation to others; (2) the individual is sole proprietor of his person and his faculties, for he owes nothing to society for them; (3) the individual can not alienate the property of his person in total, but he can choose to alienate his labor; and (4) society may be imagined as an ensemble of market relations among propertied persons. Etienne Balibar casts possessive individualism as a setback to the "collective and communitarian dimensions of life" (300).

3. For a critique of the literature on self-ownership, including such seminal contributions as C. B. Macpherson, *The Political Theory of Possessive Individualism* (Oxford: Clarendon Press, 1962), Attracta Ingram, *A Political Theory of Rights* (Oxford: Clarendon Press, 1994), and G. A. Cohen, *Self-Ownership, Freedom and Equality* (Cambridge: Cambridge University Press, 1995), see Carole Pateman's "Self-Ownership and Property in the Person: Democratization and a Tale of Two Concepts," in *Journal of Political Philosophy* 10 (2002): 20–53. See also Joshua Cohen, "Structure, Choice, and Legitimacy: Locke's Theory of the State," *Philosophy and Public Affairs* 15, no. 4 (autumn 1986): 301–24. Cohen questioned the alienability of property of the person, and argues that theories of equality and rational choice must account for the property system within the social contract.

4. John Locke, *The Second Treatise of Government* (1690; reprint, New York: Bobbs-Merrill, 1952), 17.

5. Ingram, *Political Theory,* 38.

6. Sigmund Freud, "Fetishism," in *The Standard Edition of the Complete Psychological Works of Sigmund Freud,* trans. James Strachey (1927–31; reprint, London: Hogarth Press, 1995), 21:156–57.

7. Karl Marx, *The Economic and Philosophical Manuscripts of 1844,* ed. James S. Allen et al. (New York: International Publishers, 1975), 307.

8. Ibid., 306.

9. Balibar disallows a model of ownership based solely on "disfruting" the ability of the other to enjoy property on the grounds that, in Lacanian terms, the self is barred access to the object (*das Ding*).

When the political institution says to man "Thou shalt never enjoy," it prescribes, Balibar main-tains, "legitimate 'private' property as the renunciation of real or intimate enjoyment. In a deep sense—as Lacanians might say—legitimate property not only *excludes others* from what is my own, it basically *excludes myself from something (some 'Thing') that I can never 'own.'* (Balibar, "'Possessive Individualism' Reversed," 306–7).

10. I use the expression "embarrassment of riches" with reference to Simon Schama, *The Embarrassment of Riches: An Interpretation of Dutch Culture in the Golden Age* (Berkeley: University of California Press, 1988). Hal Foster's essay "The Art of Fetishism" (in *Fetishism as Cultural Discourse,* ed. Emily Apter and William Pietz [Ithaca: Cornell University Press, 1993], 251–65) remains the most intel-lectually compelling interpretation of Dutch *pronk* still lifes in terms of property and capitalist subjectivity.

11. John W. Smith, ed., *Possession Obsession: Andy Warhol and Collecting* (Pittsburgh: The Andy Warhol Museum, 2002). Of particular interest is Michael Lobel's essay, "Warhol's Closet," which traces a link between Warhol's personal collection (or secret domestic museum) and the 1969 show *Raid the Icebox* that Warhol curated at the Institute for the Arts in Houston, and whose selection of incongruous objects (including close to 200 pairs of women's shoes) was culled from the store-rooms of the Rhode Island School of Design Museum.

12. Thierry de Duve, *Kant after Duchamp* (Cambridge, Mass.: MIT Press, 1996), 350.

13. Karl Marx, *Capital: A Critique of Political Economy,* ed. Frederick Engels, trans. Edward Aveling and Samuel Moore (New York: Random House, 1906).

14. Thomas Sokolowski used this Baudrillard quote from *Le Système des objets* (1968) as an epigraph to his essay "Artists Who Collect," in Smith, *Possession Obsession,* 142.

15. When Marx wrote that what "chiefly distinguishes a commodity from its owner is the fact, that it looks upon every other commodity as but the form of appearance of its own value. A born lev-eller and a cynic, it is always ready to exchange not only soul, but body, with any and every other commodity," he not only assigned uncanny animus and agency to things, he emphasized the sim-ilarity between the commodity and its owner, a similarity inherent in the confusion between Warhol the collector and Warhol the "eye" that is self-collected (Marx, *Capital,* 97).

16. Andy Warhol, *The Philosophy of Andy Warhol: From A to B and Back Again* (New York: Harcourt Brace Jovanovich, 1975).

17. Kate Linker, *Vito Acconci* (New York: Rizzoli, 1994), 22. "Possibly, in earlier pieces, I used the body as a proof that 'I' was there—the way a person might talk to himself in the dark. So, with that assumption—that the body was analogous to a word-system as a placement device—there was an attempt made to 'parse' the body: it could be the subject of an action, or it could be the receiver, the object (it should be noted that most of the earlier pieces were kinds of reflexive sentences: 'I' acted on 'me.')." This statement by Acconci prompted Linker to remark: "The formula presumes

a closed system of self-reflexive gestures that zero in on and define the person of their maker. In aesthetic terms, the actions are all syntactic derivatives of a single utterance, 'I make art.'"

18. Vito Acconci, *Trademarks* (1970), as cited in Linker, *Vito Acconci,* 22 (a note in her text to this quote signals that she is citing unpublished answers to questions posed by Lea Vergine concerning the work *Plot* in 1974).

19. Etienne Balibar, "Le renversement de l'individualisme possessif," unpublished paper.

20. On systems theory and cybernetics in 1960s art, see Pamela M. Lee, *Chronophobia: On Time in the Art of the 1960s* (Cambridge, Mass.: MIT Press, 2004), 62–75.

21. Dan Graham, *Articles* (Eindhoven: Van Abbemuseum, 1978), 66.

22. Ibid., 65.

23. Dan Graham, *For Publication* (New York: Marian Goodman Gallery, 1991), n.p.

24. Artistic sellout has been taken by critics as the major theme of this early work. Birgit Pelzer asserts that *Income (Outflow) Piece* "obeys the same marketing ploys adopted by artists who use themselves to promote their work in art magazines. The circuit of celebrity and publicity sets up this overlap, i.e., the artist, the work, and the representation become one. The artist's fame within this system is an artificial creation of the media and the gallery. Graham challenged the myth of the celebrity artist produced by this circuit, a myth designed to obscure the facts." Birgit Pelzer, "Double Intersections: The Optics of Dan Graham," in *Dan Graham,* ed. Birget Pelzer, Mark Francis, and Beatriz Colomina (New York: Phaidon Press, 2001), 43.

25. Graham, *For Publication.*

26. Ibid.

27. Ibid.

28. Ibid.

29. This formulation plays on and takes apart G. A. Cohen's thesis that the self is coincident with "the whole person." He wrote: "What owns and what is owned are one and the same, namely, the whole person." see Cohen, *Self-Ownership,* 69.

30. See Daniel J. Kevles, "Out of Eugenics: The Historical Politics of the Human Genome," in *The Code of Codes: Scientific and Social Issues in the Human Genome Project,* ed. David J. Kevles and Leroy Hood (Cambridge: Harvard University Press, 1992), 3. The essay begins: "The scientific search for the 'Holy Grail' of biology dates back to the rediscovery, in 1900, of Gregor Mendel's laws of inheritance." See also the chapter "In Search of the Holy Grail," in Tom Wilkie, *Perilous Knowledge: The Human Genome Project and Its Implications* (Berkeley: University of California Press, 1993), 1. Wilkie begins by drawing an analogy between the genome project and the Apollo lunar mission. Just as the Apollo moon shot in 1968 delivered the "Holy Grail" of global vision—the first time anyone had gotten far enough away to see the entire earth from another place—so the Human Genome Project delivered, in 2000, the "Holy Grail" of humanity, the map of "every single gene

within the double helix of humanity's DNA." Apollo and the genome are thus twinned in relation to the Holy Grail trope, the former cosmologically infinitesimal, the latter, biologically infinitesimal.

31. For Larry Miller, see *www.creativetime.org.*

32. Tom Wilkie relied on this line of argument when he wrote: "This then may be the final challenge posed by the Human Genome Project: to redefine our sense of our own moral worth and to find a way of asserting, in the face of all the technical details of genetics, that human life is greater than the DNA from which it sprang." Wilkie, *Perilous Knowledge,* 190–91.

Quiccheberg and the Copious Object:
Wenzel Jamnitzer's Silver Writing Box

Mark A. Meadow

In 1628 the Augsburg merchant and art broker Philipp Hainhofer traveled to Innsbruck at the behest of Archduke Leopold of Tyrol, who had ordered from him a lavish writing desk filled with artifacts.[1] While there, he paid a professional visit to the *Kunstkammer* assembled by Leopold's father, Archduke Ferdinand II, at Ambras Castle. Hainhofer noted in detail much of what he saw:

> [W]e went along the hallway to the *Kunstkammer,* which is a long chamber with windows on both sides, and throughout the middle are twenty cabinets from floor to ceiling, which one can walk around and which are open towards the windows. . . . [In the chamber were] a chamois pelt, upon the back of which a small horn had grown; an oak trunk, through which a deer's antlers had grown, by which one understood that an avalanche had struck the deer and so forcefully thrown it into the earth that the roots and wood had grown together with it.
>
> Summarily, in the cabinets were to be seen:
>
> 1. Every kind of thing made of alabaster: turned, carved, cut, such as statues, caskets, bowls, cups . . .
>
> 2. The next cabinet is full of glasses, small and large, cut and uncut.
>
> 3. The third cabinet is full of corals, [carved into] crucifixes, a mountain with statues and animals, . . . white, red, yellow, white and black coral, star coral. . . .
>
> 4. In the fourth cabinet are various antique statues and vases in bronze, also modern copies cast in gold and silver.
>
> 5. In the fifth cabinet worldly vessels made from porcelain, terra sigillata, Armenian bole and other foreign earths, artful and well-crafted work, also Geisslinger fragrant stoneware.
>
> 6. In the sixth cabinet are writing chests, including one completely in silver with drawers, full of carved cameos and precious stones, dishes and statuettes made of black amber, . . .
>
> 7. In the seventh chest are ancient weapons. Three swords and two helms, with which the Pope honored Emperor Ferdinand. . . .

8. In the eighth chest there is a bunch of grapes, with a beard 3 1/2 feet long; some Indian clothes, linen, shoes, weavings of grass and roots, dishes made of horn, and other vessels. Straw helmets. A straw chain. Some little animals. A stag with a horn that grew from its nose. A Japanese silk hat. Pieces sewn out of silk. Rubber. . . .

9. In the ninth cabinet are things made of wood. A skeleton. 1 stag's hoof with five claws. 1 large vessel made of boxwood. 1 wooden girdle. 1 cinnamon stick. Stone wood, or wooden stone [i.e., petrified wood].

10. In this cabinet are: Pomegranates from St. Dominic's tree. . . . Indian idols. A copper knife, with which the Jews circumcise their children, together with the stone that belongs to it, 1 deer antler, which sweated blood in a synagogue during Lent. . . .

11. In the eleventh cabinet are things made out of feathers. The king of Cuba's dress. A perspective out of glass.

12. Various old books are in this twelfth cabinet. Paper made of papyrus with hieroglyphs written on it. Some wooden paper. Writings, which Thomas Schweigger from Schwabian Halle, and others, who had mangled arms and hands, had written with the feet.

13. In the thirteenth chest is ironwork. Some masterpieces, bolts, locks, keys. An iron chair in which someone can be caught and bound.

14. In the fourteenth cabinet are works of stone, vessels made of jasper, marble, alabaster. Some vessels carved in the form of animals. Stone which grew on a nail. Stone mushroom. Star opal, blood stone. Toads and snakes of stone.

15. The fifteenth cabinet holds all kinds of clocks . . . and striking mechanisms, guns, a castle with clockwork. Mathematical instruments. Sundials. . . .

16. In the sixteenth cabinet stand and hang musical things. An instrument made of glass. An organ with lark songs. A Spanish theorbo and further rare instruments.

17. In the seventeenth cabinet lie: beautiful handstones, ore, mountain pieces. Diamond growths. Very many carved statues out of mountain ore. Large clumps of mined gold and silver. Red gold ore. . . . Malachite. Wood grown into ore, which one calls an indulgence, because when the miners are working in an unexplored mountain and come across something like this, they thus have the belief that good ore is to be found behind it, but if they find the same thing inside the mineshaft, it is ob-

served that there will be no more ore to be found afterwards, but rather the mining works there must be shut down.

18. In the eighteenth cabinet are miscellany, such as: gryphon claws, co-conuts or Indian great nuts, a craftsman's kiln, globes, board games....

19. The nineteenth cabinet has in it: impressively beautiful crystal vessels of various kinds, among which is a bird with outstretched wings. All mounted in gold, sometimes decorated with precious stones and pearls. Marcus Curtius carved from a unicorn horn, mounted in gold. A delicately carved ivory crucifix, mounted in gold, to be worn on the finger. Archduke Ferdinand of Austria's seal carved in emerald.... A bear in black amber.

20. In the twentieth cabinet everything is made of ivory, to wit: various beautiful turned vessels, caskets made of bone, a fan and umbrella of bone. Fish bones.[2]

It is hard to imagine spaces that are more object-filled, and object-oriented than rooms such as this, one of the encyclopedic collections of the sixteenth and seventeenth centuries known as *Kunst-* and *Wunderkammern,* or cabinets of art and curiosities.[3] We are by now very familiar with the extraordinary heterogeneity of these early-modern encyclopedic collections, as revealed in numerous period images and such written sources as Hainhofer's account.

We can start with a very simple question: What are all these objects doing together in the same space? Or, to put the question another way, what effect does the presence of such heterogeneity have upon the individual object within the *Wunderkammer?* I wish to argue that our understanding of *Wunderkammer* objects must take into account the nature of the institution in which they reside and the complex set of functions that that institution serves. This is true of objects collected by any socially complex institution. Royal courts, public museums, and modern universities, to name a few examples, are highly complex and stratified environments that correspondingly generate a class of complex, or as I call them in my title, copious objects.[4] I shall argue that we should see the *Wunderkammer* as an informative case study of such institutions, one which effectively illustrates how objects function within such sites of multiple, simultaneous, and dynamic systems of value.

It is in this sense that I invoke the term *copia,* a critical term for early-modern epistemology. Copiousness etymologically suggests not just abundance, though that is an important aspect of the copious object, but also utility.[5] As Terence Cave so compellingly demonstrates, the semantic field of early-modern *copia* is ex-

traordinarily rich; I would argue that it is especially germane to our understanding of the *Wunderkammer*. Derived from *ops, copia* always invokes explicit associations of wealth and abundance, opulence and limitless variety. Given the courtly settings of the objects and collections under discussion here, this sense of plenitude seems especially apt, as does the implicit assumption that these riches are on display. Hoarding, storage, and treasure all lie within the connotative range of *copia,* which links that concept to the term *thesaurus,* treasure house, an alternate name for *Wunderkammern.* The plural form, *copiae,* has since Roman times denoted military forces, princely power. It is worth noting here the strong connection between the *Wunderkammer* and both the armories and stables of princely houses. These and a host of other practical workshops—foundries, apothecaries, printing presses, libraries, cabinetry workshops—were understood to be places where the knowledge contained and produced within the curiosity cabinets could be put to pragmatic use. Through such works as Erasmus's school textbook *De duplici copia verborum ac rerum,* early-modern copiousness is strongly linked to eloquent verbal performance *(copia dicendi)* and thus to another form of enacted knowledge. As we will see below, *Wunderkammern* were sites of active research and analysis and included both texts and images as enactments of the knowledge produced. The complex, copious objects to which I refer gain that richness through their capacity to function within a broad range of such coexisting value systems.

Before turning to the main subject of my paper, it may be helpful to see an example of these issues in a more familiar setting, that of the contemporary university. In 1995 my colleague Bruce Robertson and I co-curated *Microcosms: Objects of Knowledge: A University Collects,* an exhibition at the University Art Museum of the University of California Santa Barbara.[6] Proceeding from the thesis that the courtly *Wunderkammer* was a place of active research and technical development, our idea was to create a working version of a Renaissance *Wunderkammer* out of the objects being used in the university today. For circumstantial and philosophical reasons we did not approach this installation in an antiquarian fashion. Our goal was not to track down sixteenth-century artifacts or their facsimiles, but to create a room that facilitated our viewers' associational engagement with the objects in the room in a manner comparable to how early-modern visitors may have experienced collections in their day. After a lengthy treasure hunt across campus, we eventually installed around 350 objects in a quite small gallery (fig. 1). In order to equip our visitors with the kind of associational skills they would be asked to use in the densely packed main gallery, we created an introductory space with three sets of surprising object pairings.

Fig. I. Gallery installation for *Microcosms: Objects of Knowledge: A University Collects,* 1995. University Art Museum, University of California Santa Barbara. Mark A. Meadow and Bruce Robertson, curators

The first of these introduced the concepts of *naturalia* and *artificialia,* the main continuum along which all *Wunderkammer* objects could be ordered. The first object in our pairing was a mounted caribou head that had long hung in the classroom used for art history discussion sections (art historians being the keen iconographers that they are, this room is to this day known in our department as the Moose Room, some fifteen years after the head was removed). Below the caribou head we mounted a Plexiglas waveform, designed and produced in the College of Engineering for an experiment in wave dynamics (fig. 2). Thus we presented our viewers with a living creature that had been taken from nature and turned into an artifact, and a purely artificial substance that was used to model and study natural phenomena. By this comparison we introduced our visitors to the important slippage between the things of nature and those of human production.

Another of our object pairings was a pangolin skin matched with a pinecone (fig. 3). This was a visually based comparison that served to show that similarity of form in otherwise disparate objects can reveal a similarity of function, here thinking of how the similarly shaped scales of both relate to their protective function.

Fig. 2. Caribou head and Plexiglas waveform, from *Microcosms: Objects of Knowledge: A University Collects*

Fig. 3. Pangolin, pinecone, and pineapple, from *Microcosms: Objects of Knowledge: A University Collects*

A plastic pineapple, borrowed from the French department, introduced etymology as a further term of association.

Our third object pairing raised rather different issues, however, which are more germane to the topic of this article. In this case, we took a seventeenth-century Flemish still life of fruit by Cornelius Mahu, owned by the UCSB University Art Museum, and matched it with a still life that we composed out of a collection of plastic fruit used by the French department in its introductory language courses ("la pomme," "une grappe de raisin," etc.) (fig. 4). One of the points of this pairing is that different representational forms provide different kinds of knowledge about their subjects, that you learn something different from a painting than you do from three-dimensional models. But more importantly, this pairing raises the question of multiple relative-value systems. From a market perspective, the Flemish painting is worth incommensurably more than the used and grubby dime-store plastic fruit; we can say much the same about the two still lifes in regard to aesthetic value.

However, when we turn to the relative knowledge value of the painting and the plastic fruit within the context of a modern university, the situation is very different. From this perspective, the French fruit is, if anything, the more valuable of the two, at least in pedagogical terms, since it is used much more frequently and actively for instructional purposes than is the paint-

Fig. 4. *Still Life* by Cornelius Mahu and plastic fruit, from *Microcosms: Objects of Knowledge: A University Collects*

ing. Furthermore, if we think of sentimental value and institutional memory, the very grubbiness of the fruit and the fact that it has sat in the department's office closet for so many years are among the reasons why it is prized. To give another example of such institutional/sentimental value, the misidentified caribou head, which is actually owned by the studio art department and was probably originally used for drawing classes, means considerably more to the art history department than does any painting in our museum. My point is that universities simultaneously are sites of research and of instruction; they are social institutions and commercial ones; they house both sciences and humanities; they are repositories of prior knowledge and places to generate new knowledge. University collections and the objects within them inevitably respond to all these aspects.

To return to the sixteenth-century *Wunderkammer,* let us consider how a single artifact, a small silver box made by the Nuremburg goldsmith Wenzel Jamnitzer, can also be seen as an institutionally bound, complex object (fig. 5).[7] Produced between 1560 and 1570, the box is exactly contemporaneous with the emergence of the encyclopedic *Kunst-* and *Wunderkammern* in princely courts across Europe. The top of the box is divided into ten cells, each neatly framing a different natural creature or specimen. Included are a frog, a mouse, a pair of lizards with intertwining tails, a crayfish, two different beetles, two different seashells, a grasshopper, and a cicada. Difficult to make out in reproduction, each specimen retains the finest details of texture and structure, such as the delicate hair of the mouse, the bumpy skin of the frog, the more grainy texture of the lizards' skins, the minute ridging along the beetles' carapaces, and even the cell-like structure of the cicada's wings.

We take this remarkable fidelity to nature to be a demonstration of Jamnitzer's supreme skills as a craftsman, which indeed it is, although in a different way than we might at first think. For each of these creatures, as well as the dozens of other insects, reptiles, and plants that make up the garland wrapped around the

Fig. 5. Wenzel Jamnitzer (German, 1508–1585), *Writing Box,* c. 1560–70. Silver, 8 ⅞ × 4 in. (22.7 × 10.2 cm) Kunsthistorisches Museum, Vienna

sides of the box, are cast from actual natural specimens. Jamnitzer's virtuosity lies in his control of the molding and casting processes, in his ability to take the most fragile subjects and reproduce them in the minutest of detail in precious metal, and then to order them into a pleasing composition. This virtuosity, this supreme artifice, rivals that of nature itself, whose variety and sculptural skills are displayed in the collection of creatures atop the box. Jamnitzer's interest in and skills at molding from nature are things he shared with another master artisan of the sixteenth century, the French ceramicist Bernard Palissy, who produced earthenware platters decorated with fish, reptiles, crustaceans, and plants, all of which he also cast from natural specimens.

Owning something by Jamnitzer or Palissy became a virtual necessity for any self-respecting collector in the period, at least for those with the financial means to acquire one of their pieces. As objects of superb craftsmanship and as examples of both preciousness and preciosity, this is hardly surprising. However, neither the fact that it is beautifully crafted nor that it is made of a precious metal begins to account for the complexity of Jamnitzer's silver box, for the multiple systems of value in which it participated, for its blurring of the distinction between nature and artifice. Nor, given that it is a box, do these aspects take into account what it might contain. If we take the task of representing the world, of functioning as a microcosm, to be one of the primary tasks of the *Wunderkammer,* what might the role or roles of an object like this be within it? To answer this question, we must first consider how the *Wunderkammer* was understood in its own day.

Among Jamnitzer's most important patrons was Duke Albrecht V, ruler of Bavaria and compiler of one of the earliest princely *Wunderkammern.* The Bavarian *Wunderkammer* is also among the better documented of such collections, especially in regard to its role in the Bavarian court in which it was situated.[8] On 3 July 1557 Albrecht's Council of State sent him a lengthy report that tried to rein in the new

ruler in terms of his expenditures. In addition to firm lectures about such matters as the costs of extravagant clothing and lavish feasts, the council also addressed his interest in collecting: "Furthermore, the Council should also caution that His Princely Grace should not imitate the city burghers and merchants in (the acquisition of) various strange luxuries, as these merchants have unfortunately managed to lead great rulers, electors and princes (to the point) that, because of their prodigality and extravagance, they have to finance and support their splendor and luxury."[9] This is a remarkable admonition in many ways. To begin with, it signals that the collecting of rarities and exotica in Munich was already a well-entrenched practice in the late 1550s, although the Munich *Kunstkammer* did not come into formal existence until 1565. Further, it adverts to the fact that such collecting involved a sufficiently high level of expenditure to rise to the level of a matter of state. And, perhaps most significantly, the Council of State attributes primacy in developing these kinds of collections to the merchant class and places the princes in the position of imitators. This is a stark reversal of the more usual narrative concerning the origins of early-modern encyclopedic collections, which sees them beginning with princes and then taken up by members of the middle class keen on advancing themselves socially.

The issue that lay at the heart of this stern warning concerned not just the amount of money being spent on the collections, but also the propriety of using state funds for this purpose. The council clearly preferred that Albrecht build his collections using the accounts of his personal household. Albrecht was less than pleased at the explicit personal critique contained in the admonition as a whole and strongly expressed his personal displeasure in a letter dated 8 July. Albrecht's response, interestingly enough, is written in the hand of Hans Jacob Fugger, a merchant banker from Augsburg.[10] As I have argued elsewhere, Hans Jacob Fugger and his family were major collectors in their own right, with a fully developed *Wunderkammer* some thirty years before that of princes like Albrecht.[11] Hans Jacob himself acted as a direct catalyst in transforming the Bavarian collections and those of the Habsburgs into what we now recognize as full-fledged Renaissance *Kunst*- and *Wunderkammern*. Albrecht thus turned for assistance in drafting his rebuttal to the council to the one person who perhaps most exemplified the sort of "burghers and merchants" that he had been told he should not imitate in the "acquisition of various strange luxuries."

Albrecht and his council continued to bicker about financing for some time to come.[12] What we might see as his final response, at least in regard to the collections, came in 1565, this time written by Samuel Quiccheberg, a Flemish

physician who was then working for Albrecht in the capacity of a collections manager. In that year, Quiccheberg published his *Inscriptiones vel tituli theatri amplissimi,* or *The Inscriptions or Titles of the Most Complete Theater,* the earliest known treatise on museums.[13] This work, which probably should be seen as a form of job application for the author's continued employment at Munich, is a kind of "how to" manual for creating the ideal princely *Wunderkammer.* In its first section, Quiccheberg provides a comprehensive list of all the things one should collect and instructions on how to organize them, the *inscriptiones vel tituli* of the title, which I discuss at greater length below. In the second section of his book, Quiccheberg speaks to the reasons why a prince might wish to devote himself to developing a collection on this scale. One passage from this section is particularly interesting, and should, I think, be understood as a definitive rebuttal to the arguments of Albrecht's state council, one that explains why the finances for the collections should come from the state budget: "For I sense that it cannot be expressed by any person's eloquence how much prudence and how much use for administering the state—in the civil and military spheres and the ecclesiastical and cultural—can be gained from examination and study of the images and objects that I have prescribed. For there is no discipline under the sun, no field of study, or pursuit, which cannot most justifiably seek its own instruments from these prescribed furnishings (of the collection)."[14]

This, too, is a remarkable statement. Quiccheberg here argues that the *Wunderkammer* serves not only as a place of amusement for the aristocracy, or even as a political showcase for princely magnificence, but as a practical, working research center directly at the service of the state's economy, defense, religion and culture. Given that Quiccheberg worked in the personal household of Albrecht V, and that the treatise was to all intents and purposes addressed to the duke, it is reasonable to assume that he here voiced an opinion consonant with Albrecht's own thoughts.

In exactly the same period that Quiccheberg produced his treatise, Albrecht V formalized the Munich *Kunstkammer* as an institution within the court in two ways. First, he issued a decree declaring a select group of objects to be inalienable objects, inheritable only under the condition that they never leave the collection.[15] This proclamation coincided with the establishment of Bavaria as a political entity along the lines of a modern nation-state, with an integral territory and a fully hereditary government. These objects, then, were to serve as indices of Bavarian and Wittelsbach identity rather than as compact forms of potentially disposable wealth, a role also to be played by the collections as a whole. Second, Albrecht ordered the construction

of a new *Kunstkammer* building, the first truly classicizing architecture in Munich, and the first purpose-built collections facility in early-modern Europe.

That Quiccheberg's *Wunderkammer* was intended to serve research purposes is made still more explicit in other parts of his treatise. Speaking of the comprehensive nature of his list of desirable artifacts, he makes clear that the role of his proposed collection as a site of knowledge production is a function of its universality: "[T]his has all been proposed in this way, just as Cicero did for the ideal orator, [in order] to impress this universal, absolute enumeration upon the minds of men. By [these means] they can measure the magnitude of their knowledge of all things, so that they may be stimulated mentally to conceive of new matters and to continually investigate [them]."[16]

The ability of the *Wunderkammer* to map the cosmos, to function as a microcosm, is thus what allows the visitor to gauge his or her relative knowledge and ignorance and to pursue research into new areas. What Quiccheberg envisions being produced, however, is less the esoteric knowledge of hermeticists and cabbalists, and more the pragmatic knowledge of engineers and artisans. For example, in Class I Inscription 10, he recommends collecting: "Tiny models of machines, such as those for drawing water, or cutting wood into boards, or grinding grain, driving piles, propelling boats, stopping floods, and the like; by means of these examples of machines and structures, larger ones can be built correctly and, subsequently, better ones can be invented."[17]

Indeed, the *Wunderkammer* itself is just one element, albeit the central one, in a whole complex of what Quiccheberg terms *officina*, or workshops (fig. 6). These include a library; a printing office complete with specialized type for printing music and mathematics; a turning shop with wood, metal, and ivory lathes (turning was a favorite hobby of sixteenth-century princes, including Albrecht and Ferdinand II); a working pharmacy (a particular interest of the wives of sixteenth-century princes); a foundry and mint; a ceremonial armory and a working one; a map room; a music room; the stables; and so forth.[18]

The passage just cited comes from the opening section of Quiccheberg's treatise, which provides a list of all the things one might collect, organized into a cycle of five classes of objects, each in turn divided into ten or eleven subclasses, or what he terms "inscriptions." More than just a shopping list for the acquisitive margrave or duke, Quiccheberg's inscriptions map the cosmos itself and serve collectively as what we may term a "finding aid" for the vast and heterogeneous collection he proposes. Quiccheberg's cycle of classes and inscriptions begins with

Fig. 6. Quiccheberg's ordering system I, with related workshops, based on S. Quiccheberg, *Inscriptiones vel tituli theatri amplissimi* (Munich: Adam Berg, 1565)

God and the founder of the collection as analogous creators, and then proceeds by stages through the world of crafted objects, the world of nature, the tools and instruments by which nature is studied and turned into artifacts, and finally the world of representations (paintings, maps, diagrams) as a form of enacted knowledge produced from the rest of the collection.

Within this group of five classes, all possible things, representing all possible knowledge, may be ordered. The classes represent a linked cycle, which can be graphed in the form of two pairs of matched terms with the fifth term defining the system. There are three equally effective ways of charting the relationships among the classes. The first of these shows *naturalia* at the base, followed by a pairing of works of artifice and the tools by which those artifacts were made on the next

Fig. 7. Quiccheberg's ordering system II, based on *Inscriptiones vel tituli theatri amplissimi*

level, surmounted by God and the founder of the collection as the efficient causes of the macro- and microcosm, respectively, paired with the class of enacted knowledge in the form of representations.

In practice this system is open-ended. The five classes represent a cycle that can be as effectively graphed with either the first, the third, or the fifth class in the definitional position. By placing at the head of the system Class I, that of God and founder of the collection, the respective efficient causes of macrocosm and microcosm, we find crafted artifacts, specifically in the form of three-dimensional objects, paired with enacted knowledge in the form of two-dimensional representations, and the world of nature matched with the tools and instruments that are used to act upon nature (fig. 7).

By moving the fifth class, comprised of representations and metacollections, into the primary position, Quiccheberg matches the founder and God, as analogous creators, with the tools and instruments used in the creative acts by which nature is transformed into artifice, with *artificialia* and *naturalia* themselves as the base of the system (fig. 8). At the level of the individual inscriptions, the open-endedness continues. This is not a categorical system, which permits any given object to reside in

Fig. 8. Quiccheberg's ordering system III, based on *Inscriptiones vel tituli theatri amplissimi*

only a single place, but a topical one. Each topic, or inscription, describes some aspect of the objects grouped within it, but does not prevent those objects from simultaneously belonging elsewhere in the system.

The Jamnitzer box demonstrates how this works. As a superb example of the goldsmith's art, it clearly has a place in the *artificialia* of Class II, under both Inscription 2, which houses the "handiwork of artisans, manufactured from some or other kind of metal, for example those of goldsmiths"[19] and under Inscription 10, as one of the "tiny products of goldsmiths, which display certain shapes in the round. Among these are . . . leafy, flowery, grotesque, shell-shaped, and so forth."[20]

Quiccheberg's third class is that of the natural world, with the inscriptions describing that world in sequence from animals down through plants to metals and earths. Quiccheberg allows facsimiles of specimens into this class, which makes a great deal of sense when we remember that taxidermy was still quite primitive and climate control did not yet exist. So it is not surprising to find that under Class III Inscription 2, are grouped "animals cast from metal . . . all of which appear alive thanks to artistry. For example: lizards, snakes, fish, frogs, crabs, insects, and shells . . . [represented] so that they are thought to be real."[21] Jamnitzer has included flora as well as fauna, though, so the box equally well corresponds to Inscription 6, that of "plants, flowers [and so forth] . . . cast from metals."[22] Nor should we forget that metals themselves are a part of the natural world, so that by virtue of its material, the silver box also fits into Inscription 7, which is that of metals in raw, refined, and worked forms.[23]

The original owner of the box, Archduke Ferdinand II of Tyrol, placed it in a cabinet that corresponds to Quiccheberg's Class III Inscription 7. He primarily grouped his collection according to material, including crystal, silver, gold, and coral. Each type of material was housed in a cabinet painted in a suitably contrasting color. The Jamnitzer box is listed in the 1598 inventory of Ferdinand's collection as belonging in the second cabinet of the *Kunstkammer*, painted green, which was devoted to things made of silver.[24] The inventory entry points us to the

next topic in Quiccheberg under which the box belongs, by finally informing us as to its contents: "A beautiful silver [box of] old writing implements, with several compartments, on top of which are assorted crafted insects [*keferwerch*], with cast garlands along the side, weighing 10 marks and 12 lots."[25]

Class IV in Quiccheberg's system consists of instruments, tools, and implements that are used to work upon nature and to create the artifacts in Classes II and V. The third inscription in this class concerns "equipment and furnishings for writing and painting . . . collected in their own containers," and is thus an exactly apt rubric under which to place Jamnitzer's silver writing box (fig. 9).

As a container, our object belongs under one last heading, this time located in Class V. Most of this class is concerned with two-dimensional representations, including oil paintings, watercolors, and prints. But it also includes a series of meta-collections, among which are organizational charts, genealogies, and textual commonplaces, located under Inscriptions 4, 5, and 9.[26] Our box belongs under the last meta-collection and the tenth and final inscription of the system, which is that of "containers that can be viewed from all sides, so that objects can be stored or hidden in them."[27] Here Quiccheberg does something quite odd, raising the container to the same epistemological level as the objects it contains.

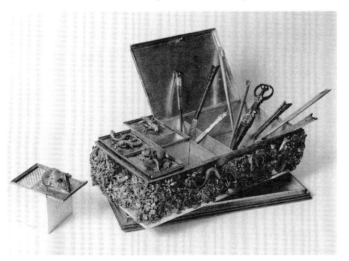

Fig. 9. Wenzel Jamnitzer, *Writing Box* (fig. 5), opened, showing writing instruments

The placement of this inscription at the end of the entire system adverts to the fact that the classes and inscriptions are themselves containers, as too is the physical infrastructure of boxes, rooms, and buildings that make up the *Wunderkammer* as a whole.

I suggested toward the start of this paper that the *Wunderkammer* served as a place of practical and technical research, and that as such it was situated at the center of a complex of workshops and laboratories in which the practical work of court and state was undertaken. As a piece of metal casting, we might expect the silver box to be of relevance to one workshop in particular, that of the foundry, as indeed

Quiccheberg indicates: "There should also be a foundry and mint, together with the metalsmith's and alchemist's forges, to suit the smelting of all kinds of metals and for the melting, refining, preparing, molding and so forth, of whatever kind of material you like. Here it will perhaps be all the more pleasing to be engaged with the more elegant objects, such as plants, insects, and reptiles, made from little plaster shapes modeled from the real, live beings, and cast in silver, gold or bronze."[28]

It is tempting to think that Quiccheberg had Jamnitzer's work in mind when he wrote passages like this in his treatise. The Ambras box dates from exactly the same period in which Quiccheberg was writing and Albrecht V did indeed own works by Jamnitzer. One such piece, from the Munich collections, is a ewer made from a trochus shell. The shell is mounted in gold and enamel, with a foot comprising a slug attacked by an eagle, surrounded by snakes. The snakes are also cast from life, as is supposedly the slug. The correspondence between text and object attests to the fact that Quiccheberg wrote his treatise based on the knowledge he gained working with the ducal collections and that it stands in a definite relationship to them and to the objects they contain.

Under each of these various inscriptions and within the foundry, the Jamnitzer box represents different forms of knowledge, either about fine craftsmanship; or about the animals, plants, and metals of the natural world; or about the tools of writing and scholarship; or about physical and conceptual containment and ordering; or about technological research and development. In each of these guises, different specialists would make use of the box in different ways. One of the major implications of this is that the Munich *Kunstkammer*—and the princely *Wunderkammern* in general—must have been considerably more socially accessible than scholars have generally understood. Certainly visiting princes and potentates could examine these collections as an aspect of diplomatic statecraft, and traveling scholars with sufficient credentials could also gain entry, probably through collection managers like Quiccheberg. But we must also recognize that maintaining these extensive collections and workshops required considerable staff, and that engineers, craftsmen, and artists from outside the court likely were allowed use of the collections to develop local industry and agriculture. These were what we can call "invisible visitors," since little or no effort was made to record their presence. They would have been the primary means, however, by which the practical knowledge disseminated by the collections was put at the service of "administering the state—in the civil and military spheres and the ecclesiastical and cultural."

I began this essay with the testimony offered by Philipp Hainhofer, a quite

visible visitor to Ferdinand's collections at Ambras. Hainhofer, too, came to Ambras as a specialist. His professional interests, though, were concerned with the furnishing of and the construction of the collections themselves, being best known for his role as broker in the manufacturing of *Wunderkammern* in the form of furniture—cabinets, tables, and writing desks such as that ordered from him by Leopold—and filling them with a similar range of artifacts, in miniature, as those found in Quiccheberg's inscriptions.[29] These pieces of furniture, in other words, were themselves both containers and copious objects in their own right; they were the direct analogue to Jamnitzer's box and to the larger collection that might have contained them both. Like a set of nesting dolls, we find a set of writing implements inside a box, inside a writing desk, inside a cabinet, a room, a museum, a territory . . . and all, of course, located within the world at large. The copiousness of the object, though, means that it serves as a microcosm, containing the totality of the macrocosm within itself, invoking that infinite sphere discussed by sixteenth-century hermeticists and by Borges, whose "center is everywhere and whose circumference is nowhere."[30]

1. Hainhofer's diaries of his trip to Innsbruck and subsequent visit to Dresden are published in O. Doering, ed., *Des augsburger Patriciers Philipp Hainhofer Reisen nach Innsbruck und Dresden, in Quellenschriften für Kunstgeschichte und Kunsttechnik des Mittelalters und die Neuzeit. Neue Folge,* vol. 10 (Vienna: Carl Graeser & Co., 1901).

2. Ibid., 83–88, my translation.

3. The paired term *Kunst-* and *Wunderkammern* dates back to Julius von Schlosser's foundational book, *Die Kunst- und Wunderkammern der Spätrenaissance: Ein Beitrag zur Geschichte des Sammelwesens* (Leipzig, 1908). For the remainder of this essay I will primarily use *Wunderkammer* in reference to the collections under discussion. I do so largely because the primary text that I am discussing, Samuel Quiccheberg's *Inscriptiones vel tituli* (see note 13, below), specifically invokes that term.

4. For an overview of the complex structures of early-modern courts, see the essays in *Princes, Patronage, and the Nobility: The Court at the Beginning of the Modern Age,* ed. R. Asch and A. Birke (Oxford: Oxford University Press, 1991). The literature on museums is vast and expanding at a furious rate. On the topic of institutional complexity, two excellent places to begin are S. Pearce, *Museums, Objects, and Collections: A Cultural Study* (Washington D.C.: Smithsonian Institution Press, 1993), and *Exhibiting Cultures: The Poetics and Politics of Museum Display,* ed. I. Karp and S. Levine (Washington D.C.: Smithsonian Institution Press, 1991). On the social structure of the modern university and its

relation to knowledge production, see esp. T. Becher, *Academic Tribes and Territories: Intellectual Enquiry and the Cultures of Disciplines* (Buckingham and Bristol: Society for Research into Higher Education & Open University Press, 1989). M. Douglas, *How Institutions Think* (Syracuse, N.Y.: Syracuse University Press, 1986), brings a provocative anthropological approach to the general question of institutional effects on knowledge and ethics.

5. For an introduction to sixteenth-century thought on copiousness, see Desiderius Erasmus, *De duplici copia verborum ac rerum commentarii duo* (Basel: Froben, 1534). Published in translation as *Copia: Foundations of the Abundant Style,* ed. and trans. B. Knott, in *Collected Works of Erasmus: Literary and Educational Writings,* vol. 2 (Toronto, Buffalo, and New York: University of Toronto Press, 1978). See also Terence Cave's seminal work, *The Cornucopian Text: Problems of Writing in the French Renaissance* (Oxford: Clarendon Press, 1985), esp. 3–34.

6. This exhibition may be viewed in more detail at *http://www.microcosms.ihc.ucsb.edu.*

7. Wenzel Jamnitzer remains a seriously understudied artist. For a biographical overview, see M. Frankenburger, *Beiträge zur Geschichte Wenzel Jamnitzers und seiner Familie* (Strasbourg: Heitz, 1901). The exhibition catalogue *Wenzel Jamnitzer und die Nürnberger Goldschmiedkunst 1500–1700,* ed. G. Bott (Munich: Klinkhardt & Biermann, 1985), is the best general introduction to the artist and work, esp. K. Pechstein, "Der Goldschmied Wenzel Jamnitzer," 57–70, in that volume.

8. See "The Munich Kunstkammer: Art, Nature and the Representation of Knowledge in Courtly Contexts," the forthcoming doctoral dissertation by Katharina Pilaski, Department of History of Art and Architecture, University of California, Santa Barbara.

9. My translation, with the assistance of Katharina Pilaski. "Ja S.F.G. sollten es auch der reth erachtens den burgeren und kaufleutten in stetten mit vilerlai frembder köstlichait nit geren nachtun wellen, dieweil sy, die kaufleut, die grossen potentaten, chur- und fursten dahin laider gepracht, das sy inen iren pracht und uberfluß von wegen ires ubelhausens und uberfluß wol bezalen und aushalten muessen." From the "Denkschrift (B) der über den Staat verordneten Räte vom Sommer 1557," transcribed in S. Riezler, "Zur Würdigung Herzog Albrechts V. von Bayern und seiner inneren Regierung," *Abhandlungen der historischen Classe der königlich Bayerischen Akademie der Wissenschaften, Philosophisch-Historische Klasse, 1884,* 65–132; this quote, 126.

10. M. Lanzinner, *Fürst, Räte und Landstände: Die Entstehung der Zentralbehörden in Bayern 1511–1598* (Göttingen: Vandenhoeck & Ruprecht, 1980), 55 n.136. Albrecht's reply is transcribed in H. Busley, "Zur Finanz- und Kulturpolitik Albrechts V. von Bayern: Studie zum herzoglichen Ratsgutachten von 1557," in *Reformata Reformanda: Festgabe für Hubert Jedin zum 17. Juni 1965,* ed. E. Iserloh and K. Repgen (Münster: Verlag Aschendorff, 1965), 209–35. The transcription is reproduced on 233–35.

11. M. Meadow, "Merchants and Marvels: Hans Jacob Fugger and the Origins of the Wunderkammer," in *Merchants & Marvels: Commerce, Science, and Art in Early Modern Europe,* ed. P. Smith and P. Findlen (New York and London: Routledge, 2002), 182–200.

12. Riezler, "Zur Würdigung Albrechts."

13. S. Quiccheberg, *Inscriptiones vel tituli theatri amplissimi complectentis rerum universitatis singulas materias et imagines eximias, ut idem recte quoque dici posit: Promptuarium artificiosarum miraculosarumque rerum, ac omnis rari thesauri et pretiosae supellectilis, structurae atque picturae quae hic simul in theatro conuqiri consuluntur, ut eorum frequenti inspectione tractationeque, singularis aliqua rerum cognitio et prudential admiranda, cito, facile ac tuto comparari possit* (Munich: Adam Berg, 1565). All translations are by Grant Parker, Bruce Robertson, and Mark Meadow.

14. Ibid., fols. 13v–14r. "Censeo enim etiam nullius hominis facundia edice posse, quanta prudential, & usus administrandae reipublicae, tam civilis & militaris, quam ecclesiasticae & literat, ex inspectione et studio imaginum et rerum, quas praescribimus, comparari possit."

15. Gründungsurkunde Herzog Albrechts V. von Bayern, 19 Mar. 1565, Geheimes Hausarchiv im Hauptstaatsarchiv München, 5/2, no. 1253. Transcribed in *Schatzkammer der Residenz München: Katalog*, ed. H. Thoma and H. Brunner (Munich: Bayerische Verwaltung der staatlichen Schlösser, Gärten und Seen, 1970), 7–18.

16. Ibid., fol. 13v. "[S]ed quod volverim, tanquam Cicero perfectum oratorem it haec universa absolutissima enumeratione hominum cogitationibus infundi: quibus magnitudinem cognitionis rerum omnium omnium metirentur adque res iterum alias animo concipiendis et pervestigandas excitarentur." Quiccheberg, *Inscriptiones vel tituli*.

17. Ibid., fol. 3v. "Machinarum exempla minuta: ut ad aquas havriendas, ligna in asseres dissecanda, grana comminuenda, palos impellendos, naves ciendas, fluctibus resistendum: ect. pro quarum machinularum aut structurarum exemplis, alia maiora rite extrui & subinde meliora inveniri possint."

18. Ibid., fols. 12r–13r.

19. Ibid., fol. 4r. "Inscriptio secunda: Fabrilia artificiosa opera: ex quocunque metallo confecta. Ut aurifabrorum."

20. Ibid., fol. 5v. "Inscriptio Decima: Aurifabrorum formulae minutae . . . unidique formam particulatim suggerentes. Inter quae & ornamentorum formulae frondosae, floridae, bellvatae, conchiliatae, volutatae, etc."

21. Ibid., fol. 6r. "Inscriptio secunda: Animalia fusa: ex metallo . . . qua arte apparent omnia viva: ut lacertae, angues, pisces, ranae, cancri, insecta . . . ut vera esse putentur."

22. Ibid., fol. 6v. "Inscriptio sexta: Herbae, flores . . . aut eiusmodo metallo fusa. . . ."

23. Ibid., fol. 7r. "Inscriptio septima: Metalla & metallicae fodinarum materie tucque verae radices metallorum. & minerae cadmiaeque etc. Item eodem modo solidae venae purissimorum metallorum. Denicque artificio ista omnia imitata: & metalla ignem gradatim experta, aliaque plus, alia minus excocta segregatacque."

24. "In den negsten casten daran, so grien angestrichen, darinnen silbergeschirr: . . ." The 1596 Ambras inventory is transcribed in full by H. Zimmermann, ed., "Inventarii. Nachlaßinventar des Erzherzogs

von 1596," in *Jahrbuch der kunsthistorischen Sammlungen des allerhöchsten Kaiserhauses* 7 (1888): ccxxvi–cccxii, and 10 (1889): i–x, this citation cclxxxi. The sequence of cabinets, and to some extent their contents, had changed by the time of Hainhofer's visit, due in part to Rudolf II "acquiring" many of the more valuable and unusual items.

25. Ibid., cclxxxi. "Ain schöner silberner alter schreibzeug mit vil luckhen, darauf allerlai keferwerch, auf den seiten mit gegossnem laub(w)werch, wigt 10 marckh 12 lot."

26. Quiccheberg, *Inscriptiones vel tituli,* fols. 10v–11r.

27. Ibid., fol. 11v. "Inscriptio decima: Repositoria undique in promptu: ad singulas res in se recipiendum aut recludendum."

28. Ibid., fol. 12r. "Fusoria officina, cusoriaque: cum foco ipso fabrili, alchimisticoque conveniens omni metallo sundendo, cuilibet materiae collquandae, sublimandae, preperandae, exprimendae, & c. Et quidem hic quibusdam magis forte versari placebit in mondioribus: ut gypsatatiis forumulis producendis, herbulis, vermibus, reptilibusque argenteis, aureis, stanneisque ex vivis rebus fundendo."

29. In addition to the text mentioned in note 1, above, see also *Des Augsburger Patriciers Philipp Hainhofer Beziehungen zum Herzog Philipp II. von Pommern-Stettin: Correspondenzen aus den Jahren 1610–1619,* ed. O. Doering, *Quellenschriften für Kunstgeschichte und Kunsttechnik des Mittelalters und der Neuzeit. Neue Folge, v. 6* (Vienna: C. Graeser, 1894) and *Der Briefwechsel zwischen Philipp Hainhofer und Herzog August d. J. von Braunschweig-Lüneburg,* ed. R. Gobiet (Munich: Deutscher Kunstverlag, 1984).

30. Jorge Luis Borges, "Pascal's Sphere," in *Jorge Luis Borges: Selected Fictions,* ed. E. Weinberger (London and New York: Penguin Books, 2000), 351–53.

Naturalezas Mexicanas: Objects as Cultural Signifiers in Mexican Art, c. 1760–1875

Edward J. Sullivan

This brief paper is a précis of a few elements of my forthcoming book, in which I examine the propensity of numerous New World artists, working in various media, to concentrate on the object as their principal frame of reference. I contend that representations of objects, which includes the category of conventional still-life painting, carry especially strong weight within American visual contexts. The works examined here are all from Mexico, one of the many countries and regions categorized under the highly problematical denomination of "Latin America," a term that came into common use only in the nineteenth century. In examples drawn from the art from the viceregal period to the post-independence era, the object (often a geographically and/or culturally specific entity, from local fruits and vegetables to fauna and local commodities such as tobacco or sugar) usually becomes a loaded symbol, a signifier of covert (or sometimes obvious) sociopolitical messages. In few visual discourses do we find the representation of objects deployed with more potency than in those of Mexico. Here I wish to propose a reading of the multiple meanings inherent in the visual description of objects. My arguments consider a critical period of modern Mexican history, from about 1760 to about 1875. The final decades of the eighteenth century are marked first by a renegotiation, under the reigns of Charles III and IV of Spain, of viceregal political and cultural agency. The so-called Bourbon reforms consolidated political power and centralized the production of commodities, favoring Spain and reasserting its hegemony in virtually every way in its most important colony.

This is the era of the Enlightenment's arrival in the most advanced New World centers, such as Mexico City, Lima, and Havana, and the founding in 1783 of the first artistic academy in the Americas, the Academia de San Carlos in the Mexican capital. After independence from Spain was achieved there followed the declaration of a short-lived empire under Agustín Iturbide, the Mexican-American War and loss to the United States of roughly half of Mexico's territory, the establishment of foreign imperial supremacy in the figures of French monarchs Maximilian and Carlota, and the restoration in 1867 of a Mexican republic under the presidency of Benito Juárez. As this period developed, from the last years of colonial status through these traumatic events as well as other political and aesthetic vicis-

situdes of the early nineteenth century, a conscious but by no means standardized emphasis was placed on the depiction of products of local industry, commerce, agriculture, and the accoutrements of local pastimes (which included hunting, bull-fighting, dancing, and others). This helped to establish certain visual paradigms for a nation emerging from the strictures of colonial government. This vocabulary of images became highly significant in the creation of a repertory of cultural archetypes for the concept of *mexicanidad* or "Mexicanness." This visual lexicon continued to prove viable as a device to suggest a culturally specific and, at times nationalist, exclusionary sense of identity well into the twentieth century, when it ultimately fell into the trap of cliché through hollow repetition, devolving into the chaotic morass of tourist art by the mid-twentieth century.

The first of two contrasting periods considered here is represented by the visual phenomena known as *casta* painting that arose in New Spain by the 1720s. After years of relative neglect from the scholarly community, *casta* painting, images that define racial blending *(mestizaje)*, has become a topic of intense research in the last decade and a half. Debates regarding the multiple meanings of these images have engendered a lively critical discourse among scholars from Mexico, the United States, and Europe. Among the most outstanding researchers in the field have been María Concepción García Sáiz of the Museo de América in Madrid and Ilona Katzew of the Los Angeles County Museum of Art. Both have organized pathbreaking exhibitions of *casta* painting and have written standard monographs on the subject. The most recent scholarly effort in this area, Katzew's exhibition *Inventing Race: Casta Painting and Eighteenth-Century Mexico* and her book *Casta Painting: Images of Race in Eighteenth-Century Mexico* have gone far in the direction of solving many of the ambiguities associated with these images, which, although allegedly based on observed reality, actually paint a much more complex view of the territory than we had imagined.[1]

Castas illustrate *mestizaje* in the colonial milieu through a depiction of families. In these scenes a mother and father, each representing a different racial category (Spaniard or white, mulatto, indio/Indian, mestizo, and many other characterizations, each with its own descriptive name) combine to create a "new" racial type. While the majority of *casta* paintings are anonymous, some were done by well-known artists such as Miguel Cabrera, a native of the city of Oaxaca who was active in the Mexican capital in the third quarter of the eighteenth century.[2] Cabrera, who has been called by Katzew "possibly the most influential artist of Mexico in the eighteenth century,"[3] executed a well-known series of *casta* paintings in 1763, among the

relatively few signed and dated pieces. Many of these are now in the Museo de América, with a few in private collections in Mexico, Europe, and the United States.

Each of the paintings by Cabrera, as well as virtually all other *castas*, are labeled with the (often highly idiosyncratic) name of the racial stratum with which the three participants in the scenes (mother, father, and child) are associated. These identifications and other texts, such as the explanatory charts that name the other visual elements of the scenes, both offer information and flatten the image, distancing it from the viewer and enhancing the quality of these taxonomic charts as *exempla*. *Castas* were often painted in series of sixteen paintings, although larger and smaller series are known. The problematic nature of the racial profiling of these works (which are believed to have been executed by Mexican artists for Spanish collectors) has been underscored by virtually all scholars of them. Much less emphasized in the literature on *castas* is the concentration on the depiction of things that accompany the objectified human subjects of these works; these include locally produced cloth stuffs with indigenous patterns, as seen in an example from Cabrera's series, or native fruits and flowers, cigars, cigarettes, shoes, and other commodities, invariably numbered and named on the surfaces of the pictures. This aspect takes on an importance almost equal to that of the family groups. Within the objectification, these classifications of objects and people are significant strategies of colonial control and possession. These symbols of abundance in the Spanish-controlled land may also be understood as signifying the growing commercial strength of the native-born *castas* who, with their homegrown and home-produced products, were entering into a more fully developed transatlantic capitalist discourse that came into maturity in the early postcolonial period.

In a work from the series by Cabrera there appears the inscription "De español y de índia mestiza" (from Spaniard and Indian, Mestiza).[4] The Spaniard, his Indian wife, and their mestiza daughter are all dressed in elegant clothing, denoting an elevated social status associated with the whiteness of the father. The mother wears pearl earrings; her daughter, pearl and coral. They sell bolts of fabric with their Nahuatl name written directly on the surface of the canvas. At the lower right there is a *piña* (pineapple), labeled as such, a quintessentially exotic fruit for the intended audience for the picture.

Another set of *casta* paintings is attributed to the well-known artist José de Alcíbar. In an example now in the Jan and Frederick Mayer Collection in the Denver Art Museum, we observe the blending of an *español* and a *negra* to produce a *mulato* (fig. 1). In this picture, painted sometime between 1760 and 1770,

the father holds a small brazier for his son to blow on, thus creating a fire that will light the man's cigarette; the mother is about to stir chocolate in a copper pot. The picture reaffirms the significance of two prominent New World exports, tobacco and chocolate, but in addition to this reference to trade, Alcíbar's painting distinguishes between the dress of the two very different social classes, the privileged Spaniard and the Afro-Mexican woman.[5] Katzew has commented on these subjects of products and people: "Featuring typical American products in paintings whose subject was miscegenation—believed to be especially widespread in the New World—offered a highly mediated view of life in New Spain, one that casts the colony as the producer of goods and people."[6]

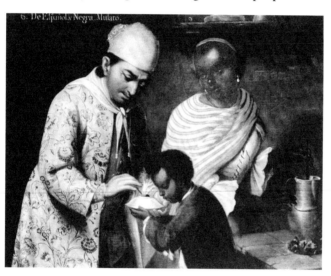

Fig. 1. Attributed to José de Alcíbar (Mexican, active 1761–1803), *De español y negra, mulato* (From Spaniard and black, *mulato*), c. 1760–70. Oil on canvas, 31 × 38 ¼ in. (78.8 × 97.2 cm). Denver Art Museum. Collection of Jan and Frederick Mayer

Even more elaborate characterizations of the "fruits of New Spain," as they are often labeled on *casta* paintings, are in another example of a work from the same series as that discussed above, attributed to Alcíbar (fig. 2). This picture, now in the Philadelphia Museum of Art, depicts another form of *métissage*. The caste of the child is that of a *coyote*, a combination of two darker-skinned racial types, the *índio* and the *mestiza*. They are portrayed in a modest market context. The father is clothed in a very simple cloak which appears to fall from his shoulder, possibly indicating that he is from the semi-naked "barbarous Indians" (as they are often labeled on *casta* paintings) from the northern frontier of the country. The mother wears a striped *rebozo* (shawl) and the prominent beauty mark made of cloth on her face that is often an indicator of marital status. This produce vendor suckles her child before a profusion of fruits—chirimoyas, grapes, watermelons, zapotes, mameyes, chayotes, guacamotes, jicamas—all there for the delectation of the viewer. With this tableau the painter succeeds in displaying the abundance of his native land while catering to the European taste for *casta* series and their implicit symbols of territory and abundance.

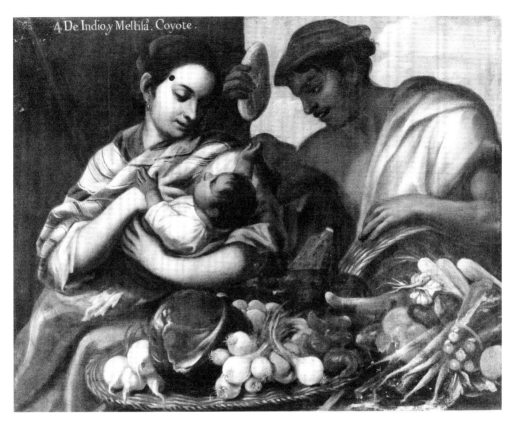

Fig. 2. Attributed to José de Alcíbar, *De índio y mestiza, coyote* (From Indian and mestiza, *coyote*), c. 1760–70. Oil on canvas, 31 × 39 ¾ in. (78.7 × 101 cm). Philadelphia Museum of Art. Gift of the nieces and nephews of Wright S. Ludington in his honor

One series from about 1785 is by Francisco Clapera, the only known Spanish-born artist to have executed *casta* paintings.[7] One of the components represents a market scene with a bounty of pineapples, pomegranates, bananas, and other tropical produce; another illustrates the union of a Spaniard and Indian with their mestiza child (fig. 3). In a third component of the same series, *De chino e índia, genízara* (fig. 4), there is another image of Mexican exports: hanging on the back wall of the simple room is a profusion of pottery, recognizable by its distinctive red color as ware from Tonalá, near Guadalajara, long famous for its export of earth-colored crockery to Spain and other European countries.[8]

Although *casta* painting is largely a Mexican phenomenon, there are some exceptions, including a series from eighteenth-century Peru (now in the Museo de Antropología, Madrid). In the Museo de América, Madrid, another group of works from Ecuador, signed "Vicente Albán, pintor de Quito, 1783" comprises six pictures

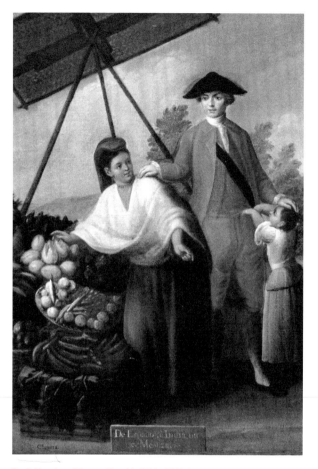

of racial and social types. While not specifically illustrating the racial blendings characteristic of *casta* paintings, they are intimately related to this form of art through their classifications of people and objects. The figures in these works are set within an idealizing landscape, more lush then in the Mexican examples. In the first of the series an elegant woman holds a papaya slice in her right hand and a black velvet hat with silver and gold embroidery in her left.[9] The "Lady with her Black Slave," as she is labeled on a cartouche "affixed" to a plinth holding an assortment of fruits, wears a fancifully embroidered dress. Her elaborate jewelry consists of a long string of black pearls, a gold chain with a large cross, a shorter necklace of black pearls, as well as elaborate pearl earrings and gold hair ornaments. Her slave, who stands slightly behind her, wears

Fig. 3. Francisco Clapera (Spanish, 1746–1810), *De español e índia, mestiza* (From Spaniard and Indian, *mestiza*), c. 1785. Oil on canvas, 21 1/4 × 16 in. (54 × 40.5 cm). Denver Art Museum. Collection of Jan and Frederick Mayer

equally elaborate garb, with a large gold necklace and pearl earrings. She carries a large platter of papaya slices and is unshod, indicating her servile status, but her profusion of jewelry and elegant clothing indicate that she serves the woman's city residence, not one in the countryside, where this and other scenes in the series are set.[10] The two, however, are referred to collectively, with a large "A" above the head of the white woman; the inscription on the cartouche below identifies them both. The classifications continue with exhibits "B" through "F," identifying the fruits and trees in the scene. Other examples, from the same series, also label and identify birds, animals, and other objects. In these paintings the objects occupy more space and play roles as noteworthy as those performed by the people in this taxonomic chart.

While *casta* painting ceased as a phenomenon by the time of Mexico's independence from Spain and the reconceptualization of the social order, analogous images classifying people and objects survived in late colonial and early independence-period Mexico. *The Artist's Cupboard* (1769, Museo Nacional de Arte, Mexico City), by Antonio Pérez de Aguilar is one of the few examples of eighteenth-century still life in the Spanish colonies, although we know from inventory records that kitchen scenes or dining-room paintings were popular decorations for secular homes of the emerging middle and upper classes.[11] This painting, in its rigid categorization of things through their placement on shelves, appears to be diametrically opposed to the narrative taxonomy of *casta* paintings. It may

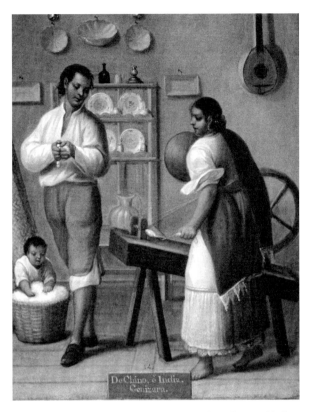

Fig. 4. Francisco Clapera, *De chino e índia, genízara* (From Chino and Indian, *genízara*), c. 1785. Oil on canvas, 21 ¼ × 16 in. (54 × 40.5 cm). Denver Art Museum. Collection of Jan and Frederick Mayer

be defined as a simple still life based on the tradition of placing objects on a variety of levels, an artistic trope since ancient times, but its perceived banality is deceiving. *The Artist's Cupboard* is ultimately derived from Spanish Golden Age *bodegón* paintings of objects on shelves or series of platforms, which had been imported to Mexico. This type of object placement became known as the *alacena* (shelf) type and was very popular in the nineteenth and into the twentieth centuries.[12] Art historian Magali Carrera has referred to this work by Pérez de Aguilar as a case study in cultural *mestizaje*, pointing out that the top shelf, with its implements of the arts—painter's palette, sculptor's model, and musical instruments—represents a higher level of the social scale from the other two planes.[13] Mexican critic Jaime Cuadriello points out that the picture could also be read as a metaphorical self-portrait in which the artist muses on the need to elevate art from the mechanical level to that of intellectual endeavor.[14] *The Cupboard* includes several unmistakably indigenous objects, such as

the rough-woven basket, possibly for storing tortillas, and the *jícara,* or incised gourd atop the chocolate pitcher on the lowest of the three levels. This painting predates the official opening of the Real Academia de Pintura, Escultura y Arquitectura (also called the Academia de San Carlos) in 1785, but it entered the academy's picture collection soon after. It evidences the rational spirit of the institution's classification and analysis, of artistic creation as well as objects such as humble kitchen vessels.

The first several decades of the history of the Academia de San Carlos have been charted in detail by scholars.[15] Intensely active for several decades after its first opening, the school served as the principal agent for neoclassical styles in painting, sculpture, architecture, and the graphic arts. The Academia foundered by the 1830s, however, amidst the political turmoil of post-independence Mexico,[16] and President General Antonio López de Santa Anna ordered its restructuring in 1843. A still life of the following year by Jesús Corral (Museo de las Intervenciones in Mexico City) displays a virtual encyclopedia of Mexico's artistic and political endeavors in this era of bourgeoning self-projection.[17] The main focus is an escutcheon with the national symbol, the eagle, a snake in its mouth, flying above a cactus growing on an island in the midst of a lake. This is derived from the legend of the founding of Tenochtitlán, later Mexico City. A Phrygian cap above signals affinities with other wars of independence, notably the French Revolution. The flags projecting from behind the coat of arms bear the national colors: green, white, and red.[18] All the elements of this picture, including its allusions to the arts of painting, sculpture, and architecture (brushes, a palette, a compass, a plaster bust, a Corinthian column, and manuals by Leonardo da Vinci) speak eloquently of the artistic and nationalist aspirations of the Academia.

In 1869, the year of the expulsion of French troops and the execution of Emperor Maximilian (commemorated so poignantly in several compositions by Edouard Manet), the Academy's director, Ramón Alcaraz, announced a national history painting competition for the purpose of creating a repertory of national images celebrating the achievements of the country in pre-Hispanic and modern times. The submissions were numerous; within several decades there was a whole catalogue of heroic themes, with characters garbed in ancient Aztec clothing displaying Davidian and Ingresque rhetorical gestures. Among the many well-known examples are Rodrigo Gutiérrez's *The Senate of Tlaxcala* (1875) and Leandro Izaguirre's *Founding of Tenochtitlán* (1889).[19]

Yet outside the capital and its officially sanctioned painting, in provincial

centers in the states of Puebla, Querétaro, Guanajuato and Jalisco, an alternative symbolic discourse was developing that presented a very different syntax of inert objects, provincial items, and everyday implements that were integral to the lives of mid- and late-nineteenth-century Mexicans. Artists such as José Agustín Arrieta, Hermenegildo Bustos, and many anonymous painters were certainly aware of the European traditions of still life, because even though still life was not taught in the national academy or other Mexican centers, many original European still-life paintings and reproductive prints circulated widely. In their *bodegones* (genre scenes) and *cuadros de comedor* (dining-room pictures), these artists created a compelling hybrid of transatlantic and locally conceived visual modalities. Displaying the varieties of comestibles produced in the kitchens of Puebla or the abundance of fruits in the local markets of Querétaro or Guanajuato, Arrieta, Bustos, and their colleagues fashioned subtle paradigms of the newly independent nation.[20]

Arrieta's paintings of kitchens and dining rooms are especially filled with the specificities of their creation. *The Puebla Kitchen* of 1865,[21] now in the National Museum of History (Chapultepec Castle), Mexico City, defines a typical kitchen work space and its raw and cooked foods, but it is also a moralizing scene of a young woman confronted by a procuress, who gestures to a man waiting outside the door. The picture hints at the lax morals of working-class women, not unlike those found in Dutch seventeenth- and eighteenth-century genre paintings (with which Arrieta was familiar), but the objects themselves are the real protagonists of the picture: pots and pans hang on the walls—metal at the left, clay at the right. On the right half of the space is the food awaiting preparation: vegetables on the floor, fruit on the table, and a large turkey, the meat for the most traditional Puebla meal, *mole poblano*. At the left of the distracted cook, two attentive workers prepare the meal. One of them kneels on the floor, working at a *metate,* or three-legged stone implement (also of Aztec origins) for grinding the *masa* for tortillas. Each element in the scene presents the viewer with a detailed picture of all necessary objects in a Puebla kitchen.

Hermenegildo Bustos, from Purísima del Rincón, a small town in the Bajío region of central Mexico, is best known for his extraordinary series of starkly realistic likenesses of country people, which Walter Pach and Octavio Paz likened to Fayum portraiture.[22] However, his two remarkable still lifes are signed and dated 1874 and 1877 and describe the variety of fruits native to the Bajío and the more tropical coastal lowlands. Most of the fruits are open to reveal the inside and are displayed as if on a whitewashed floor. The 1874 work also depicts a scorpion and

a frog amidst the display of comestibles. The German-Mexican art historian Paul Westheim first pointed to the similarity of these paintings to botanical illustrations; indeed Bustos may have known a French 1786 treatise on natural history.[23] However, his decision to give his *bodegones* this format goes further: his exacting and meticulous renderings of natural objects should be considered in the context of other non-metropolitan Mexican artists who created similar records of the details of time and place.

The objects recorded in still lifes by Arrieta and Bustos, as well as in dozens of related works created by less well-known and anonymous provincial artists in the second half of the nineteenth century, extend beyond the usual repertory of fruits, flowers, and vegetables to include local—especially pre-Hispanic—dishes; such as the plates of *mole, chilaquiles,* or *tamales* so often present in Arrieta's pictures; traditional drinks such as *pulque;* and local crafts such as textiles, ceramics, baskets, and kitchen implements. This pictorial vocabulary signified cultural uniqueness and the developing identity of post-independence and post-restoration Mexico.

I have already mentioned the sexual stereotyping in Arrieta's kitchen scene. Other works by this artist and his contemporaries, which primarily depict inert objects, also carry with them intimations of contemporary sexual politics. Gender issues play a critical but little-discussed role in analyses of object representation in nineteenth-century Mexico. In closing, let us look briefly at one direction in which we might explore this topic further.

It is critically important to consider the participation of women in the emerging nineteenth-century nationalist object-based visual discourse, especially in light of the dominance of male protagonists and male-dominated *machista* values in the art of the time. Women had been associated with the Academia de San Carlos since its beginnings, although often tangentially. The catalogues of the annual exhibitions (based on the model of the Paris Salons), held there since 1848, and the extensive criticism of these shows make it clear that the contributions of virtually all of the female participants were in the category of "non-member artist" and consisted of genre and still life. A note of benign condescension in a critique of the 1877 San Carlos exhibition evidences the popularly held opinion that "we have always felt that women could be successful [with these pictures], for their instincts and fine powers of observation, and because these subjects are more frequently available to them than to men, who spend so little time at home."[24] Eulalia Lucio, the daughter of an outstanding intellectual and artistic family from Mexico City, was one of the most prominent women to exhibit at the academy in the 1870s and

1880s, and her specialty was still life.[25] Lucio's *cuadros de comedor* (as they are described in the catalogues) bear meanings that go considerably beyond their surface appearances. An example is *Objects of the Hunt* (private collection, Mexico City), a painting sent, along with another of her still lifes, to the Paris Exposition Universelle of 1889.[26] The setting is the corner of an intimate middle-class parlor. A table with an embroidered red cloth stands near a window. A heavy curtain is parted to allow light to enter. The floral wallpaper and the mahogany chair with blue upholstery describe the atmosphere of a comfortable home cared for by a woman, perhaps the owner of the fringed shawl that covers a corner of the table. Yet what might appear to be a formulaic scene of female domesticity is disrupted by the objects themselves, all of which relate to a distinctly male activity: the hunt. The outsized *sombrero,* horn, musket, canteen, knife, gun belt, and bottle of alcohol define a pursuit that was, by tradition, strictly limited to men. The chase alluded to here is not the generic kind illustrated in European hunt still lifes, such as the pictures by such Dutch painters as Jan Weenix. It is an unambiguously Mexican scene in which Lucio refers to elements found in another genre of Mexican nineteenth-century painting: pictures depicting *charros,* or elegantly clad horsemen.

This and similar paintings by Lucio represent the metropolitan tradition in nineteenth-century Mexican painting. The picture adheres, at least on the surface, to certain prescribed formulas in content and style, yet it evidences a subtle rupture of the status quo in its choice of objects. Within the limitations of still life Lucio transcended gender conventions and created a work that corresponds to the contemporary taste for emblematic images. As had the earlier *casta* paintings and the still lifes of Arrieta and Bustos, Lucio's still lifes asserted national self-definition through their displays of commodities, the essentials of material culture in Mexico.

1. On the history of *casta* painting, and for further bibliography see María Concepción García Sáiz, *Las castas Mexicanas. Un género pictórico americano* (Milan: Olivetti, 1989); Ilona Katzew, ed., *New World Orders: Casta Painting and Colonial Latin America* (New York: Americas Society, 1996); Ilona Katzew, *Casta Painting: Images of Race in Eighteenth-Century Mexico* (New Haven and London: Yale University Press, 2004). See also Magali M. Carrera, *Imagining Identity in New Spain: Race, Lineage, and the Colonial Body in Portraiture and Casta Paintings* (Austin: University of Texas Press, 2003).
2. For Miguel Cabrera and further bibliography see Guillermo Tovar de Teresa, *Miguel Cabrera: Pintor de Cámara de la Reina Celestial* (Mexico City: Grupo Financiero InverMéxico, 1995).

3. Katzew, *Casta Painting,* 95.

4. Illustrated in ibid., fig. 116.

5. See ibid., 109: "In 1679 the Bishop of Michoacán complained about 'the notable disorder . . . in dress, both for its scant honesty and for its indiscriminate use of silks and precious materials, as well as for gold, silver, and pearls, by nobles and plebeians.' In effect, the increasing blurring of boundaries between the different classes was also the cause of much concern in Spain . . . The fact that Cabrera, as well as many other artists who painted *casta* cycles after him, used clothing as indicators of socioeconomic class echoes the pervasive concern in Mexico and Spain regarding the loss of social boundaries. Social stratification is thus rendered clear in these paintings through the differentiation of clothes."

6. Katzew, catalogue entry for *From Spaniard and Black, Mulato,* in *Painting a New World: Mexican Art and Life 1521–1821,* ed. Donna Pierce, Rogelio Ruiz Gomar, and Clara Bargellini (Denver: Denver Art Museum, 2004), 245.

7. On Clapera and this series of *casta* paintings see Clara Bargellini, "Dos series de pinturas de Francisco Clapera," *Anales del Instituto de Investigaciones Estéticas* 65 (1994): 159–78.

8. Numerous seventeenth- and eighteenth-century Spanish still lifes, e.g., by Francisco de Zurbarán, Antonio de Pereda, and Luis de Meléndez, display Tonalá ware. See William B. Jordan and Peter Cherry, *Spanish Still Life from Velázquez to Goya* (London: The National Gallery, 1995).

9. These paintings are illustrated and discussed in García Sáiz, *Las castas,* 232–34. The Peruvian *castas* are discussed in the exhibition catalogue *Frutas y castas ilustralas* (Madrid: Museo Nacional de Antropología, 2004).

10. Scarlett O'Phelan Godoy, "El vestido como identidad étnica e indicador social de una cultura material," in *El barroco peruano* (Lima: Banco de Crédito, n.d.), 108.

11. See the catalogue entry by Juana Gutiérrez Haces for this painting in *Mexico: Splendors of Thirty Centuries* (New York: Metropolitan Museum of Art, 1990), 435, as well as the references to this work in Pierce, *Painting a New World,* 222–25.

12. Among the most distinguished twentieth-century painters of *alacena* still lifes are María Izquierdo and Elena Climent.

13. Carrera, *Imagining Identity,* xiii–xvi.

14. Jaime Cuadriello, "Los umbrales de la nación y la modernidad de sus artes: Criollosmo, Ilustración y Academia," in *Hacia otra historia del arte en México* I, ed. Esther Acevedo (Mexico City: Conaculta, 2001), 22.

15. On the early history of the Academia de San Carlos see David Marley, ed., *Proyecto, estatutos y demás documentos relacionados al establecimiento de la Real academia de pintura . . .* (Mexico City: Rolston-Bain, 1984); José Enrique García Melero, "Nexos y mimésis academicistas: América en la Academia de Bellas Artes de San Fernando," in García Melero et al., eds., *Influencias Artísticas entre España y América*

(Madrid: Editorial Mapfre, 1992), 261–359; and Stacie G. Widdifield, *The Embodiment of the National in Late Nineteenth-Century Mexican Painting* (Tucson: The University of Arizona Press, 1996), 14–31. The history of the academy by Jean Charlot, *Mexican Art and the Academy of San Carlos 1785–1915* (Austin: University of Texas Press, 1962), is an anecdotal but interesting study on the institution.

16. Frances Calderón de la Barca (née Francis [Fanny] Erskine Inglis), Scottish-born wife of the first Spanish minister of post-independence Mexico, gives the most evocative description of the dilapidated state of the Academy in the late 1830s in her letters written during her stay in the Mexican capital from 1839 to 1842. These letters were published in 1943. See Frances Calderón de la Barca, *Life in Mexico* (London: Century, 1987), 127–28.

17. Illustrated in Fausto Ramírez, *La plástica del siglo de la independencia* (Mexico City: Fondo Editorial de la Plástica Mexicana, 1985), 40.

18. Ramírez, ibid., 40, underscores the lack of specifically military symbols such as trophies or laurel wreaths to symbolize victory and power in order to stress a sense of pacific development in the arts under the protection of the government.

19. See Ramírez, *La plástica,* for illustrations and discussions of these paintings and other academic history "machines" in which ancient Aztec history was illustrated in a Davidian or Ingresque manner.

20. On Arrieta's work (and for an extensive bibliography) see *Homenaje Nacional. José Agustín Arrieta (1803–1874)* (Mexico City: Museo Nacional de Arte, 1994). On Bustos (and for further bibliography) see *Hermenegildo Bustos 1832–1907* (Mexico City: Museo Nacional de Arte, 1993).

21. Illustrated in *Homenaje Nacional,* 226–27.

22. Octavio Paz, "Yo pintor índio de este pueblo . . . ," in *Los privilegios de la vista. I. Arte antiguo y moderno* (Mexico City: Fondo de Cultura Económica, 1987), 163. Paz discusses Pach's opinions expressed in his article "Descubrimiento de un pintor Americano," *Cuadernos Americanos,* Nov.–Dec. 1942.

23. Gutierre Aceves Piña, "Hermenegildo Bustos: A Passion for Naturalism in Painting," in *Hermenegildo Bustos,* 13–14, discusses Paul Westheim's theory of Bustos's knowledge of books of botanical illustration. He notes the similarity of Bustos's still lifes to engravings by Jacques Le Moyre (1533–1588) and cites affinities with those in Abbot M. Pluch, *The Spectacle of Nature or Conversations on Natural History* (1786), which circulated in Bustos's region of Purísima del Rincón (see note 6, p. 133).

24. L. Agontía, "La Academia Nacional de San Carlos en 1877. El arte," quoted in Ida Rodríguez Prampolini, *La crítica de arte en México en el siglo XIX, II* (Mexico City: UNAM, Instituto de Investigaciones Estéticas, 1997), 422. For a theoretical analysis of the role of women in nineteenth-century Mexican painting, see Angélica Velázquez Guadarrama, "La representación de la domesticidad burguesa: el caso de las hermanas Sanromán," in Acevedo, *Hacia otra historia,* 122–45.

25. On Lucio and other nineteenth-century women artists see Leonor Cortina, *Pintoras Mexicanas del siglo XIX* (Mexico City: Instituto Nacional de Bellas Artes, 1985).

26. Illustrated in Ramírez, *La plástica,* 96.

PART TWO

AFTER THE OBJECT

Material as Language in Contemporary Art

Christian Scheidemann

Fig. 1. Matthew Barney (American, born 1967), *The Cabinet of Harry Houdini*, 1999. Cast nylon, salt, epoxy resin, woven polypropylene, prosthetic plastic, and beeswax, 83 ⅝ × 64 × 73 in. (212.3 × 162.5 × 185.4 cm). Private collection

During the first venue of Matthew Barney's *Cremaster Cycle* in Cologne in 2002, I was the conservator in charge of several pieces coming from museums and individual collections. The works were meticulously installed by the highly skilled team of Barney's studio. All of the objects looked pristine, virginal, almost antiseptic, and highly aesthetic. Prior to the opening I noticed some fingerprints and smears on the inside and ceiling of the polyethylene walls of one of the objects, *The Cabinet of Harry Houdini* (figs. 1, 2). I asked Barney if this was something that had to be cleaned: "Oh no, these fingerprints represent the struggle of Harry Houdini, how much he fought to escape from this coffin." I was a little shocked. How dangerous is it to physically deal with contemporary art these days? We, as conservators, are preoccupied with cleanliness.

I had been working on Barney's pieces since 1991 and often visited his studio, where we talked about all his projects and the choice of materials. Until this time I had never seen anything dirty in his work, nor had I expected fingerprints and smears to be charged with significance. So I began to investigate the significance of dirt, dust, and bird droppings in contemporary art and found quite a number of samples of this sublime new "art material" in the art of today.[1] In this paper I discuss our notion of material and add other substances, however unexpected or controversial, to our accepted ideas of materials.

Dust famously appeared in 1920 in *Dust Breeding,* a collaborative photo work by Marcel Duchamp and Man Ray, and continues today in works of Matthew Barney and other

Fig. 2. Detail of fig. 1, showing smears and fingerprints

artists. The appearance of dust, dirt, and droppings has established these materials as immensely powerful mediums, enriching the meaning of material in terms of time and history. In the hierarchy of artist's materials, these heavily loaded substances are placed at the very bottom end—if they are mentioned at all.

Contemporary works of art decipher their meaning through the use of materials. Much valuable information can be gained about the intention and the mind of an artist by investigating the contextual significance of the materials at hand and the fabrication or technique of the piece. Today conservators may find themselves in the position of a co-conspirator in the work, as a consultant for choosing the right material and doing the research about durability and the complementary natures of the materials with regard to the artist's intention. Talking to artists about the physical aspect of a specific object often helps to reveal the secret language of material in their work.

In our mainly scientific approach to works of art (with some art historical background) we would like to share our observations with art historians to help in saving a substantial part of the culture of our time. To conservators, artworks are like animals—or human beings. They are created, lead their own lives, and develop a life of their own. Often in the beginning, pieces may be underestimated in their cultural value and thus neglected for a while, only later to be discovered as precious and worth caring for properly.

Language

When one studies a foreign language, one does not begin with slang or nuances. Since my research on characteristics in contemporary art is based on the foundation of European cultural history, I would like to discuss briefly the grammar that has shaped the art of the western world.

Historically, materials and substances of art have been chosen for longevity rather than meaning. The fact that Michelangelo was commissioned to sculpt a snowman may be seen as an exception to this rule.[2] The matter had to be subordinate to the form and the creative expression (the mind). The matter—not the individual material, according to Thomas Raff[3]—was seen as a necessary evil, as the lowest part of the artwork. Matter—bronze, ceramic, stone—has traditionally been viewed as a category, a way of cataloguing a collection rather than as a means of interpretating the work. The essence, the artistry of an artwork, is the idea behind or above it, the *concetto* or *disegno,* rather than the material.[4] In his treatise *De Pittura,* Leon Battista Alberti gave a warning not to fall prey to the fascination

of precious materials since they were in danger of taking attention from the virtual art, which presents itself solely in the creative form and idea of the artist.[5] Since the beginnings of the Dada movement in Europe, material has become important for its own contextual significance. In 1934 Walter Benjamin pointed out in his lecture "Author as Producer" the meaning of introducing real things into Dada artworks: "The revolutionary strength of the Dada movement consists in the attitude to evaluate the authenticity of the art. Still-lifes were made out of tickets, thread rolls and cigarette butts, all were related through painterly elements . . . the tiniest authentic fragment of daily life tells more than painting. Similar to the bloody fingerprint of the murderer that tells more than the written words."[6] Finally, the "adequacy of material," proclaimed by the founders of the Bauhaus and later expressed by Marshall McLuhan in *The Medium is the Message,* has become enormously influential to a generation of artists.[7]

A New Discipline

In recent years a number of publications have referred to material as a key introduction to a new approach in understanding and defining contemporary art. An extended research into the iconography of material was conducted by Monika Wagner in 2001 and was the subject of her book on the material in art, in which she surveys the function, mission, and message of various materials in their historical context.[8] Another investigative research on materials and their authenticity, by Martha Buskirk, has recently been published.[9]

Truth and Interpretation

In her paper for this conference, Ewa Lajer-Burcharth raised a provocative question: Can an artwork lie? I found this question very intriguing and posed myself the opposite: Is there truth in an artwork? Or, to be more precise: Is there only one truth in an artwork? We conservators, being the physicists of the artworks, are not destined to provide an interpretation of the artwork. We might, however, help to understand some of the artist's ideas and struggles through exploring the physical creation and the sense of material. In his essay "Avant Garde and Kitsch in Art and Culture," Clement Greenberg said that all great artists of the modern era—Picasso, Miro, Pollock and Kandinsky—gained their prime inspiration through the mediums in which they were working.[10] This is definitely true for the modern and postmodern times. For contemporary art, however, I would consider—and this is my thesis—that either artists introduce historically charged material into their

work or they infuse objects of everyday life with their own stories, comprising bio-graphical, sociological, or contextual material.

Potatoes in Art: Three Examples

Of all materials introduced in contemporary art, the representation of actual food carries the significance of the existential. Food is the organic basis of our existence and the basis of our culture. Its consumption provides energy; its loss or refusal may lead to a fatal end. Food is intertwined with our life; it expresses our lowest material needs as well as, in a Eucharistic way, high spirituality.

The potato is a good example of how one object can be used as a vehicle for entirely different ideas and stories. The potato, which has a historical cultural value as well as a symbolism imbued with known forms and ideas, has both a high nutritional and physiological value. It contains valuable proteins, starch, vitamins C, B1, B2, and minerals. This knowledge, however, does not help one to unravel the meaning of the works of such artists as Sigmar Polke, Jason Rhoades, or Matthew Barney.

In search for the origin of creativity, Polke has developed a truly "Potato-sophy" under the motto "each potato equals one artist." In an interview the artist explains:

> I was just about to give up my investigation since I could not find a suit-able object of study, when one day I went into the basement and finally found what I had been looking for: it is the incarnation of everything that art criticism and theory can expect from an innovative, sponta-neously creative subject: the potato! Just watch the way how—just lying there in the dark basement—it spontaneously starts to sprout and in-novates in virtually inexhaustible creativity, seed by seed, and how—stepping back behind its work—it is covered by its sprouts, thereby generating the most astonishing creatures.[11]

As a parody of Duchamp's *Bicycle Wheel,* in 1970 Polke invented the *Apparatus that Allows One Potato to Revolve around Another Potato* (fig. 3).[12] A "Christian, Catholic" way of viewing the potato is undertaken by the Los Angeles–based artist Jason Rhoades in his work *A.B.S. Gun With Pom Fritz Choke and Aqua Net* (fig. 4). The gun can be loaded with potatoes, which are fired through a mesh that cuts them into pieces like French fries, a Belgian speciality.

Fig. 3. Sigmar Polke (German, born 1941), *Apparatus that Allows One Potato to Revolve around Another Potato,* 1970. Wood, metal, Bakelite, electric motor with battery, and potatoes, 31 ½ × 15 ¾ × 15 ¾ in. (80 × 40 × 40 cm). Kunstmuseum Bern

Fig. 4. Jason Rhoades (American, born 1965), *A.B.S. Gun with Pom Fritz Choke and Aqua Net,* 1994. Private collection

A.B.S. Gun is part of the installation *P.I.G. (Piece in Ghent),* which he did in the Museum van Hedendaagse Kunst in Ghent on the occasion of a group exhibition in 1994. The installation is based on the fictitious idea of an American youth approaching the famous Ghent Altarpiece *(The Adoration of the Mystic Lamb)* without knowing anything about its symbolism or religious significance. In accordance with this perspective, the symbols of the Ghent Altarpiece are replaced by familiar objects from the American environment and thereby acquire new meanings: the fountain in the painting becomes a whirlpool, and the riders mounted on horses become rockers on motorcycles. The paradise is a landscape that turns into an American suburb. In this way, both Christian iconography and the cultural history of a geographical area are addressed and reinterpreted. Oil paint, the invention of which is generally attributed to the Van Eyck brothers, here becomes associated with the energy source oil.[13]

In Matthew Barney's film *Cremaster 3,* the famous model and Paralympics athlete Aimee Mullins, acting as a goddess of harvest and fertility (or a goddess of war), is sitting in a snug, a hidden room dating back to the days of Prohibition, next to the Cloud Bar in the Chrysler Building, surrounded by a pile of potatoes (fig. 5). The potatoes are Idaho potatoes, a reference to the state where Barney grew up. Barney uses them to represent the famous deadly potato famine in Ireland in the 1840s that forced millions of people—among them, Barney's ancestors and the Chrysler family—to

Fig. 5. Matthew Barney, *Cremaster 3, Partition,* 2002. Chromogenic print, 44 × 34 in. (111.7 × 86.4 cm). Barbara Gladstone Gallery, New York

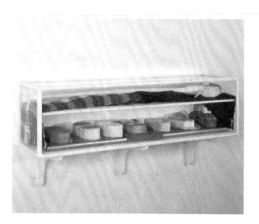

Fig. 6. Matthew Barney, *The Metabolism of the Hubris Pill,* 1992/2001. Cast glucose, hard candy, sucrose, petroleum jelly, tapioca, meringue, pound cake, stainless steel, self-lubricating plastic, prosthetic plastic, acrylic, Black Watch tartan, and Dress Stewart tartan. Stedelijk Museum voor Actuele Kunst (SMAK), Ghent

emigrate to the United States. In this sequence, Aimee Mullins is cutting the potatoes into a wedge shape with a cutter form attached to her prosthesis shoes; later the wedges were cut into a pentagonal shape representing the Chrysler emblem. Here, finally the span of the geographic location of the entire *Cremaster Cycle* is summed up by the potato, from Ireland to the West Coast of the United States.

It may be of particular interest that while the Polke and Rhoades works are meant to be replaced with fresh potatoes, Matthew Barney wanted the Idaho potatoes to be preserved for the purpose of stability. By finding a company that could shock freeze the potatoes, we later replaced the extracted moisture with synthetic resin.

Metabolism and Alchemy

As part of the trilogy *OTTOshaft,* in 1992, Matthew Barney created a series of pills that appeared in the video *Ottodrone.* The pills, cast in fructose, sucrose, sugar, petroleum jelly, tapioca and meringue, signify the biochemical energy sources of Jim Otto, the famous Oakland Raiders football player of the seventies. The representation of external conflicts in the competitiveness of the football game is analogous to the unseen bodily processes that reflect the stressful demands made on the active body (fig. 6). In digesting these pills, according to Barney, Jim Otto endeavored to become the famous escape artist Harry Houdini who, for Barney, represents the incarnation of someone who is in full control

of his body. The pound-cake pill as the amalgam of all previously mentioned essences is broken: Jim Otto has failed in his attempt. This is a recurrent theme in many of Barney's works, symbolizing the notion of attempt and failure.

For ten years these pills have been sitting on a stainless steel shelf in his studio, exposed to dirt, dust, mice excrement, and sunlight. As Barney explains, for a long time he was not sure what he was going to do with them. Only now, as they have attracted a lot of dust and dirt, he feels that they have finally found their rightful place in his oeuvre. By putting it into a vitrine, the process of metabolism has come to an end. When he came to our studio, we asked him about the dirt. While he put on latex gloves, so as not to remove any of the dust, he explained: "Digestion has to do with dirt, with excrements; this is all about alchemy, like making gold out of shit. Metabolism is about alchemy, alchemy is about failure. Jim Otto failed to become like Harry Houdini. That's why the pound cake is broken."

To my surprise, there *is* a lot of dirt and excrement in Barney's work. The sculpture *Erich Weiss Suite* from *Cremaster 5* represents the coffin of Houdini, whose

Fig. 7. Matthew Barney, *The Erich Weiss Suite,* 1997. Acrylic, polyethylene, Aquaplast, and Jacobin pigeons (installation). Private collection

given name was Erich Weiss. In the *Cremaster Cycle* this is the final sculpture, installed in a separate room at the very end of the Guggenheim show. Through a glass door you could watch five Jacobins sitting on the coffin, gradually creating a layer of bird droppings on the highly polished acrylic surface. Barney says: "I see this guano on the coffin of Harry Houdini as sediment, as something that is coming to an end and at the same time it is the beginning of something else" (fig. 7).[14]

Iconography

As we've already seen, iconography in contemporary art is partly based on the material involved. It can also be read and deciphered through associations related to or implemented in the mystery created by the artist. A few months ago we had the opportunity to examine and treat a wax object by Robert Gober, *Untitled (Leg)* from 1989–90 (fig. 8). The leg was broken just above the ankle. The crack was covered by the sock. Of particular interest were some observations and comments by the artist, who came to the studio after finalizing the treatment in order to re-authorize the piece. The object is made from the cast of the right leg of the artist,

not exactly picking up the surface of the skin, but rather the form. The weight of the bleached wax is held and reinforced by an internal one-by-two-inch wooden ledge, which is fixed to a plywood plate that goes onto the wall. He purchased the hair—Asian male hair, which is the strongest and darkest of all human hair—at a wig store in the hair district in Manhattan. Each strand of hair then was applied into the wax with tweezers, the hole then smoothed out in all one direction with the back of the tweezers. To allow a peek into the part of flesh shadowed by the pant leg, the hem is reinforced by a wire.

When I visited the artist for the first time in 1990, he had told me how he became intrigued by this little part of human flesh between the upper rim of the sock and the hem of pants. During a flight to Bern in 1989, he noticed a man sit-

ting with crossed legs on the other side of the aisle. Gober was fascinated by this little intimate part in the entire sterile world of traveling businessmen and decided to render precisely this privately hidden, sexy section as a sculpture. We also talked about his favorite museum, the American Museum of Natural History in New York, where one can find all kinds of body parts of extinct species, but not one part of a human being. He bought about twenty pairs of shoes (Alden) at Brooks Brothers in New York for the project; when I asked him if he had actually worn the shoe, he replied: "There was this female cross-dresser in the East Village, someone who liked to dress as a man. So I asked her to wear these shoes for a few months and gave her a small fee. When she came back to the studio after three months, I looked at the shoes and told her to come back in two more weeks."

Fig. 8. Robert Gober (American, born 1954), *Untitled (Leg)*, 1989–90. Wax, cotton, wood, leather, and human hair, 12 ⅝ × 5 ⅛ × 20 in. (31.7 × 12.9 × 50.8 cm). Museum of Modern Art, New York

The Process of Aging

As I said earlier, artworks are like animals: they lead their own lives and receive traces of material imminent degradation over the period of time. Artists react in

different ways to these (usually) unexpected changes. As we know from our daily experience, some artists ignorantly do not accept any decomposition or traces. As if their life were eternal, they refuse to "let go" of their artwork. One artist, however, the Swiss-German Dieter Roth, developed a particular joy in nature's process. He was actually planning the decomposition of mostly food material—chocolate, Camembert cheese, yogurt, and cast colored-sugar sculptures. In a letter to his dealer he made a proposal to build a pyramid of cheese cubes and let them gradually decay within the next ten weeks. In the drawings accompanying the proposal he outlined the various stages of decay and did not leave any doubt about the fact that he was actually frolicking toward the process of degradation.

In closing, I would like to share the experience I had with the conservation of a collaborative installation work by Paul McCarthy and Mike Kelley—*Heidi House.* In 1992 a television stage set was built after blueprints and a model provided by the artists and executed by "a very bad carpenter"[15] in Vienna. The house, a "schizophrenic collusion of Alpine decoration and reductive Modernism"[16]—an Alpine chalet on one side and the American Bar by Adolf Loos on the other—acted as the set for a video that was shot by the artists in Vienna. The construction itself consisted of more than 120 parts and pieces. Since the set was never intended to be disassembled and reinstalled, the joints were all nailed and glued, as they do in the Hollywood studios (where McCarthy worked when he was a student at UCLA). Eventually, after the shooting in Vienna, the set was deinstalled, reassembled at the Art Fair in Basel, and purchased by a collector in Greece. In the following years the piece was exhibited eight times in museums around the world, requiring four persons to install for two weeks and at least one artist to position the props.

The plywood has suffered with each deinstallation from pulling out nails and shipping to the next venue. The spackling paste fell off, and all walls had to be repainted with each reinstallation. The collector asked if we could talk to the artists to find a way to stabilize the piece and have twenty stable units instead of hundreds of walls and ledges. So I talked to the artists and we all agreed on the task—as little as necessary should be done to the walls; the structure and appearance should not change at all; and only worn-out parts should be replaced. This concept reflects a true consideration of the authenticity of the piece. About thirty crates were shipped from Greece to Los Angeles and we met in Kelley's studio, where the restoration was to take place. Being responsible for the authenticity of the work, I made it very clear that only invisible changes in the internal structure should be made. No more overpaint and spackling should be involved. Both artists

agreed and I left for New York. When I returned to L.A., half of the house was rebuilt. I got quite upset and told them to follow our initial concept in doing as little as necessary to keep the integrity of the work. Kelley argued "now is the chance to finally make the construction 'right'—it has never been done the right way." Some of the walls were reskinned, all joints were equipped with bolts and screws, many smaller sections were combined into fewer bigger compartments. Now the house was more solid, although the appearance had not changed.

McCarthy was not very happy with what was going on in Kelley's studio. When the work was finished and a manual was made, he told me: "This is not my house anymore, my work has always been about 'covering up the imperfections'—like they do in Hollywood." Kelley, on the other end, was not happy either, since I had not allowed him to rebuild the set entirely. And I was unhappy since so much original material had been replaced. Neither artist was happy, but for different reasons. Why do I mention this attempt and failure? Because I think this shows an almost hidden but very important side of the artist's attitude toward sculpture and performance. McCarthy's attitude is always to be involved in the process and the performance of the piece. He is aware of the disintegration and sees each reinstallation as a ritual, a shamanistic way to revive the performance, whereas Kelley's interest is more in producing a solid work of art, an autonomous object in the spirit of Marcel Duchamp. While both artists agreed to create this sculpture/video set, they do strongly disagree on its afterlife. Preserving contemporary art involves far more than just preserving the materials it is made of.

1. Christian Scheidemann, "The Significance of Dirt, Dust and Bird Droppings in Contemporary Art," paper presented at Portland, Oregon AIC Conference, 2004 (publication forthcoming in 2005).

2. Martin Warnke, "Schneedenkmaeler," in Michael Diers, ed., *Mo(nu)mente: Formen und Funktionen ephemerer Denkmaeler* (Berlin: Akademie Verlag, 1993), 51–60.

3. Thomas Raff, *Die Sprache der Materialien* (Munich: Deutscher Kunstverlag, 1994), 18.

4. See also Erwin Panofsky, *Idea, Ein Beitrag zur Begriffsgeschichte der aelteren Kunsttheorie* (1924, reprint Berlin: Wissenschaftsverlag Spiess, 1993).

5. Leon Battista Alberti, *De Pictura,* lib. II, ed. Cecil Grayson (London: Laterza, 1972).

6. Walter Benjamin, "Author as Producer," in *Arcades Project* (Cambridge: Harvard University Press, 1999), 32ff.

7. Marshall McLuhan, *The Medium is the Message* (New York: McGraw Hill, 1967).

8. Monika Wagner, *Das Material der Kunst: Eine andere Geschichter der Modern* (Munich: C. H. Beck, 2001).

9. Martha Buskirk, *The Contingent Object of Contemporary Art* (Cambridge: MIT Press, 2003).

10. Clement Greenberg, "Avant Garde and Kitsch in Art and Culture" (1939), reprinted in Greenberg, *Art and Culture* (Boston: Beacon Press, 1961).

11. Sigmar Polke, "Frühe Einflüße, späte Folgen oder: Wie kamen die Affen in mein Schaffen? Und andere ikono-biografische Fragen," in Sigmar Polke, *Die Drei Luegen der Malerei* (Bonn: Kunst- und Ausstellungshalle Bonn, and Stuttgart: Hatje Cantz Verlag, 1997), 293.

12. In Ralf Beil, *Die Künstlerkueche des Künstlers, Lebensmittel als Kunstmaterial: Von Schiele bis Jason Rhoades* (Cologne: DuMont, 2002), 226.

13. Eva Meyer Hermann, *Volume: A Rhoades Referenz* (Nuremberg: Oktagon Verlag, 1998).

14. Conversation with the author, Jan. 2004.

15. Paul McCarthy, in conversation with the author, May 1996.

16. Ralph Rugoff, *Paul McCarthy* (London: Phaidon Press, 1996), 126.

Art in the Age of Visual Culture: France in the 1930s

Martha Ward

It is now a commonplace to observe that a primary medium for twentieth-century art history was the photographic reproduction, and its favored mode of deployment was the binary comparison. As established by Wölfflin and others at the beginning of the century, the comparison of works of art through reproductions made possible the construction of an argument based on the careful observation of formal similarities and differences between well-chosen examples. To some, this made art history a science.[1] By the 1930s we find didactic comparisons figuring in the design of not only slide lectures and book illustrations, but also exhibition layouts, as the one-row hang became increasingly the norm for the display of original works. By this time, a generation was coming to maturity whose own training in art history had largely been through the comparison of reproductions, and their exhibition walls tended to correspond with—and look like—book pages. The comparisons Alfred Barr created through the one-row hang at the *Cubism and Abstract Art* show at the Museum of Modern Art in 1936 are often duplicated in the catalogue and didactically explicated in its text. Whatever the lure in such shows of individual objects, it was structured through stylistic and historical comparisons, remembered through photographs, and mediated by words.[2]

Elsewhere at this time, however, there were other ideas developing about how reproductive photographs might be arranged and for what purpose. Owing to recent developments in the technology of photographic reproduction, the quality of images had substantially improved in the late 1920s, and art-related publications had come to feature larger illustrations and more extensive spreads. Journals claimed that the new prominence given the image meant that it was now poised to triumph over text. Advertising began to affect the making and presentation of reproductions, with bold departures from the standard document that had been on offer from art photograph agencies. In France a series of museum catalogues featured images of ancient works taken by a successful publicity photographer and claimed to offer his special point of view: sequences of shots presenting Egyptian figures culminated in breathtakingly intimate, starlike close-ups of the faces, while captions were held to a minimum and historical information was relegated to small type at the front and back.[3] Such projects reveal the hope, paradoxical as it may

now seem, that innovations in the making and deployment of reproductions might produce a truly visual art history. What it might mean for art history to be truly visual, however, varied significantly from one initiative to another.

René Huyghe, the main subject of this essay, was a young curator at the Louvre in the early 1930s when he came to feel that the slow-paced linearity of the text-bound book was not modern enough, or perhaps not intuitive enough, for an age of "visual culture," a term he used to characterize a society dominated by cinema, photography, and advertising.[4] His hope was that rather than serving simply as representations of the principles and periods of art history, the new high-quality reproductions might be arranged in such a striking manner as to spark unverbalized, perhaps unverbalizable, insights. In his editorial work for the journal *L'Amour de l'art*, reproductions of art historical objects were made to intersect with the techniques and images of visual culture, often in the interests of multi-faceted comparative play. It was particularly the possibility of simultaneously circulating or activating a number of works across the page that Huyghe found challenging and rewarding.

Before delving further into the nature and content of Huyghe's experiments, it is worth observing that putting art historical reproductions into circulation—that is, into arrangements that were deliberately intended to be more open-ended than the binary comparison—is a practice that we find at this time in a surprisingly diverse range of projects. Marcel Duchamp's *Boîte en valise,* begun in Paris in 1935, for instance, is a miniaturized catalogue raisonné of his own works that is half an exhibition of objects, half a loose-leaf book of photographic reproductions. With each item captioned as if in a book or labeled as if in a show, the reproductions have the makings of a comparative or sequential order but none of the fixity that an exhibition wall or a bookbinding would provide. Just as no text structures this collection, the multiplicity of its movable objects encourages reshuffling and chance discoveries. Although obviously related to earlier archives compiled by Duchamp, this one specifically references the book, the exhibition, and the photographic reproduction of works of art, deliberately upending expectations of the interrelated functions of these forms in art-world practice.

The novel relationship among exhibition, book, and photograph that has become most famous from this period is André Malraux's *musée imaginaire*. Published after the war but steeped in the previous decade's experimentation and writing in Paris, the project for the *musée imaginaire* held that the photograph had freed the object from the material constraints of its embodiment and that this freedom rep-

resented another step in what the museum had first accomplished in removing the work from the geographical confinement of its site of origin. The photo made style visible as never before, across a range of objects, times, and places. In arranging the photos for his sculptural museum without walls, Malraux had specifically in mind a theory of cinematic montage: the pages of the book would juxtapose images in a progression that would itself be constructive of surprising points, and each reproduction was to be experienced as would a new shot. Malraux's lyrical text is surely important to the *musée imaginaire* but not as instruction in how to see specific works or as commentary on their sequencing.[5]

As a final example of a project that aspired to break the hold of the binary comparison in art history and set works into some new unverbalized relationship, Aby Warburg's experiments in the late 1920s with his *Mnemosyne Atlas* come to mind. Using photographic reproductions of works of art alongside a heterogeneous mix of other images, ranging from postage stamps to newspaper illustrations, Warburg arranged up to ten, twenty, or thirty images on a dark panel to form a freewheeling tableau. The assemblages were to bring into view the themes of historical recurrence that interested Warburg, motifs of motion based on gestural and physiognomic formulas, but his images were not sequentially placed within a panel, nor was there a consistent basis for comparison from one panel to the next. Although his intention of abolishing art history's stylistic comparison seems clear enough, no verbal or textual commentary intervened in this experiment in "thinking though images."[6]

So we can say, as background for Huyghe's practice, that the manipulation of multiple photographic reproductions, either in open-ended arrangements or in montage-like sequences, was a vital undertaking at this time for several ambitious art history–related projects. Although for different reasons and with different effects, all these men felt the need to challenge the practice of concept-driven comparison as it was becoming a standard convention structuring exhibition walls, book design, and textual commentary. Pushed on in some cases by the visual culture of cinema, magazines, and advertising that demanded a rethinking of what it meant to arrive at a point visually, and in other cases by the avant-garde practitioners of collage and montage that provided powerful critiques of verbally contained, stylistically driven comparisons, these interwar figures all attempted to expand the field of art history in the direction of photography's latest cultural uses.[7] The reproduction took on an art historical life of its own, apart from texts and originals.

My hope in this short essay is to contribute to the study of this broader and relatively unexplored development by sketching out the nature of Huyghe's ex-

periments in *L'Amour de l'art,* along with a brief account of his motivations, inspirations, and audience. Huyghe, the son of a newspaper editor, had worked in journalism when he was sixteen. He held degrees from the Sorbonne and the Ecole du Louvre and was, at twenty-one, the youngest curator ever appointed at the Louvre. When he was charged in 1931 to take over the editorship of *L'Amour de l'art,* he was uniquely poised in the world of French art history to try something new.

———

More than fifteen years before Malraux's initial experiment with trying to make reproductions of objects from around the world function cinematically, Huyghe engaged in a series of experiments in *L'Amour de l'art* designed to publish photographs of art that crossed cultural hierarchies. Upon becoming editor, he immediately introduced several changes. On the one hand, he expanded its historical and geographical scope to embrace what he called "universal art."[8] Although still decidedly Eurocentric, *L'Amour de l'art* under Huyghe included cross-cultural comparisons with Asian and occasionally African art, coverage meant to expand the compass of art history. On the other hand, Huyghe introduced popular culture into the journal by addressing photography, cinema, and posters. Sometimes scenes from popular culture were treated as art and sometimes used as points of comparison. Although not nearly so bold as the cross-cultural mix of the preceding decade in the German publication *Der Querschnitt,* where a publicity photo of a contemporary movie star ice skating in New York was flanked on either side by stiff ancient Egyptian wooden figures—still, for an elite French publication, *L'Amour de l'art* offered up a strikingly heterogeneous lot.[9]

Working with this expanded cultural field, Huyghe embarked on a sustained examination of the possibilities of using photography and layout to affect the perception and understanding of the fine arts. He aimed not just to reproduce works in such way as to give primacy to the visual over the textual, but also to impress upon the past the look of the modern: to provide for objects, through innovative page design and unorthodox comparisons, a point of view that was resolutely contemporary. In an issue from 1931, for example, Degas's paintings were paired with compositionally similar movie stills and the small type commentary provided remarks on the psychology of off-center composition. As a result, Degas appeared to have precociously grasped truths about narrative and design that would only come into view with the development of the movie shot. The historian needs to present the art of all

civilizations "from a surprising point of view," Huyghe wrote. "All older art can be contemporary if it satisfies or enriches our curiosity, our sensations."[10] The value of this presentation of Degas, then, was in making him answer to the cinema.

Huyghe's primary innovation was what he called a "*synoptique*," a spread of photos across two pages, the arrangement of which was to be in accord, he said, with the visual habits and curiosities of this age of visual culture.[11] Part of the expressed goal of the *synoptiques* was to make past or unfamiliar art stimulating for the present, to bring objects into the present tense by providing striking points of view. In an issue of 1931, for instance, Huyghe and his assistant, Germain Bazin, distributed views of different statuettes by Degas arcing across and down adjoining pages so as to suggest the trajectory of a single figure's dance, an adaptation of a Marey-like progression of actions (fig. 1). Made to answer to the appreciation for sequential frames of human movement, the photographs of Degas's sculptures gave a more modern appearance. But the example also shows how contemporaneity in *L'Amour de l'art* had its limits, out of respect for the past and for the fine arts. Sequentiality aside, the layout retains a quite decorative aspect and the figure is far from mechanized.

Fig. 1. *L'Amour de l'art* 12 (1931): 296–97. Courtesy of Ryerson Library, The Art Institute of Chicago

Huyghe later claimed that the reduction of text to a few lines in many of the *synoptiques* was designed to direct the reader's perceptible attention to the illustrations and oblige him to look in order that an affective response could occur.[12] Perceptual manipulation was to ensure that words and concepts would be absorbed in the wake of the visual effect of works of art, rather than vice versa. As the name *synoptique* suggests, the visual arrangements were to be both synthetic and comparative; like a tableau, they were to be apprehended at a *coup d'oeil,* which meant that they would make a strong and instantaneous impact, but the dispersal of images across the page was also to invite a meandering gaze, indulging in multifaceted comparisons and a freedom of association. Most *synoptiques,* or article layouts inspired by them, involved three to eight images or fragments thereof and encouraged the viewer to scan through an orchestrated ensemble. In an issue from 1937 (fig. 2), for instance, an open-mouthed, outwardly facing figure looms at center, isolated from a drawing by Veronese, while a similarly dynamic figure, cut from a work by Daumier, clutches the page bottom. Together these serve as the anthropomorphic base and pillar for four lively drawings by Delacroix at

Fig. 2. *L'Amour de l'art* 18 (1937): 12. Courtesy of Ryerson Library, The Art Institute of Chicago

top. This was the last page in an article comparing earlier and nineteenth-century works in terms of baroque sensibility and linear expression. Huyghe's hope must have been that the viewer would, at first glance, be struck by the successful architectural integration of the various figures into a novel design. Such recontextualization and animation of fragments by their placement on the page and in relation to one another were crucial to many of the *synoptiques.* Another approach used by Huyghe in creating tableaux was to charge the page with the vectors provided by the per-

Fig. 3. *L'Amour de l'art* 13 (1932): 174–75. Courtesy of Ryerson Library, The Art Institute of Chicago

spectives and depicted actions within different scenes. In the spread devoted to Manet's work (fig. 3), for instance, formal designs created a field of force that was meant to keep the viewer's eye moving among images. Though there were common strategies for layout design in the synoptics, the art historical issues varied widely and a lack of rigor seems to have been part of the plan. Variety, surprise, and discovery were of the essence in creating "*exposés* for the eyes."

In creating designs that made a strong initial impact but also accommodated scanning and meandering, Huyghe clearly had thought about what the temporality of the gaze might mean in relation to contemporary culture. Nowhere is this more evident than in the layout that accompanied his article comparing Vermeer and Proust (fig. 4). In filmlike strips that ran along each side of a text column, Huyghe invited the eye to follow what seemed to be the same object, or part of an object, drawn from different paintings by Vermeer. This was a means for visualizing his own dialectical basis for comparing Proust and Vermeer. He builds the essay on Proust's claim that Vermeer depicted in each of his paintings the same world known through consistency of detail—the same carpet, the same woman, the same beauty. Whereas Vermeer's is an art of visual presence that is constant

from one painting to the next, Proust's can only be seized through the desires and obsessions that drive repetition, memory, and loss. Probably relying on recent film theory, though it's hard to be specific here, Huyghe sequenced shots of details of everyday life from paintings so as to suggest a dialectic between unchanging presence and haunted repetition. As the eye sweeps down the column of similar details from different scenes, the comparisons accumulate, each informing the other, yet with the difference from cinema that the frame is also always there, to be held alone, a detail that might in itself open onto the viewer's memory of the larger world from which it has come. Vermeer is made into Proust, and vice versa, through the filmlike strip.

Huyghe's interest in casting painting into cinematic roles also led him, in the mid-1930s, to make a film about Rubens. Later he noted that this was the first French film made about art that provided a dynamic, as opposed to a static view of painting. Though it won a prize at the Venice Biennale, it seems now to have disappeared altogether, so we do not know exactly how the camera directed the gaze to look at Rubens's paintings, nor how those shots related to verbal com-

Fig. 4. *L'Amour de l'art* 17 (1936): 8–9. Courtesy of Ryerson Library, The Art Institute of Chicago

mentary. Huyghe noted that he had used tracking shots to suggest the directions and speeds of the gaze in looking at paintings, and remarked that this enabled a better interpretation of the work.[13] After the war, however, he would critique those art films that isolated details and led the viewer's gaze through paintings for being overly directive and allowing insufficient room for choice and reflection.[14] Ultimately, as with the presentations in *L'Amour de l'art,* there seems to have been a fine line for Huyghe between the perceptual manipulation of the viewer's attention and his own liberal values and humanism.[15]

The need Huyghe felt to activate a single photographic reproduction through editing and multisided juxtapositions was no doubt a response to his sense that a

different sort of temporality—both quicker and more active—would accord with the visual culture of his time and bring the work of art into dialogue with the modern age. In this regard, his project bears comparison with the New Typography, represented here by a Zdenek Rosmann cover from 1927 (fig. 5). Like the layouts of the New Typography, the image in *L'Amour de l'art* often was not allowed to be static in its presentation on the page, and there was little temptation to immerse or hold oneself within it; insight was to come quickly, intuitively, and primarily through the impact of a striking design. Huyghe's occasional use of filmstrips to present images on the page finds precedent in the New Typography, as does his explanation of his innovations at the time with what Frederic Schwartz has called a "psychotechnical language" of visual

Fig. 5. Zdenek Rosmann, cover of *Fronta* by Frantisek Halas et al., 1927. Courtesy of University of Illinois Library, Champaign

attention, direction, duration. Schwartz categorized the New Typography as an overhauling of book space: "traditional culture's flat printed page and its steady orderly unfolding of information was clearly no longer valid as a model of visual attention

and organization for the modern subject surrounded by a world of machines, traffic and text."[16] In a similar vein, Huyghe would later write at length about contemporary visual culture's usurpation of the book civilization that had prevailed since the Renaissance; the world of the intellect and reflection, still present in the nineteenth century, had given way in the twentieth to the automatic response.[17] His account of modern life highlights advertising's requirements for optical efficiency, and considers the rest of everyday life from this perspective. If not by the time he took the editorship of *L'Amour de l'art,* then certainly by later in the decade, Huyghe was quite conversant with the "psychotechnical" thinking that had informed the overhauling of book space in Germany.

But closer to home, Huyghe's experiments might also be understood, I think, as a reaction to certain uses of the photographic reproduction as a "document." In Molly Nesbit's formulation, a document was destined for technical work—for historical, cultural, or scientific research or for use in copying or design.[18] It was not subordinated to a text, as an illustration would be, but could lay claim to having value in itself. In the journal *Documents,* published from 1929 to 1930 under the leadership of the dissident surrealist Georges Bataille, photographs had been employed to disruptive ends. Like *L'Amour de l'art,* the intention of *Documents* was to deploy the visual independently of the verbal. But Bataille's intention was to critique the scope and practice of art history.

James Clifford has given a vivid description of *Documents'* use of photographs:

> *Documents* itself is a kind of ethnographic display of images, texts, objects, labels, a playful museum that simultaneously collects and reclassifies its specimens. The journal's basic method is juxtaposition—fortuitous or ironic collage. The proper arrangement of cultural symbols and artifacts is constantly placed in doubt. High art is combined with hideously enlarged photographs of big toes; folk crafts; *Fantômas* (a popular mystery series) covers; Hollywood sets; African, Melanesian, pre-Columbian and French carnival masks; accounts of music hall performances; descriptions of the Paris slaughterhouses.... Once everything in a culture is deemed worthy in principle of collection and display, fundamental issues of classification and value are raised.[19]

Georges Didi-Huberman has seen Bataille's method in *Documents* to be not playful collage, but critical montage in the manner of Eisenstein, a systematic

Fig. 6. J.-A. Boiffard, *Big Toe, Male Subject, Age 30*, in *Documents* 6 (Nov. 1929): 298–99. Courtesy of Regenstein Library, University of Chicago

transgression of traditional disciplinary fields, a refusal of an iconographic or stylistic basis for comparison, and of abstract summations of purpose.[20] This montage required that each document remain, on some level, utterly incomparable to the others. The relatively heavy format of the journal, its preference for frontally positioned and centered objects, and its blocky type and large margins also encourage a sense of weightiness. The reproductions usually each have their own page, resting there as objects to be confronted individually in all their singularity and materiality, as with the infamous big toes, photographed by J.-A. Boiffard (fig. 6).

L'Amour de l'art, with its title to shed all doubt, was not the least subversive of the category of art, but shared with Bataille an interest in using photographic reproductions as a means of overcoming the limitations of text-based accounts. Its easy circulation of images, achieved through a manipulation of the devices and structures of visual culture, was meant to open up the field to a diversity of associations and effects, some typically art historical, others more identified with the "psychotechnical" language that informed advertising. In the playful detail from Leonardo's *Virgin of the Rocks* (fig. 7), the finger gesturing across the page toward a demure portrait by C. G. Pilo is made to function like the detached hand, ubiquitous in advertising of the time, that pointed toward important goods or useful

captions. If Huyghe's innovations are seen as a counterpoint to the challenge to art posed by *Documents'* practice, it appears that what most had to be overcome was the documentary status of the photograph itself, with its static appearance and concreteness, its seemingly deadpan neutrality and material singularity. Rather than rest with stylistic or iconographic comparison, Huyghe animated the page and directed the gaze to circulate so that a variety of associations might accumulate. Through editing and layout, he sought to make documentation yield to shifting points of view (cinema, advertising, Marey), ones that would be simultaneously modern and aesthetically resonate. The gaze was to be kept in motion, encountering surprises and challenges to its habits and assumptions.

How, then, might Huyghe's innovations have been appealing for the readership of *L'Amour de l'art*? Surely not as a form of popularization; this was not a project of making past art accessible to an audience not otherwise engaged. *L'Amour de l'art* had been founded in 1920 by the president of the Société des amis du Louvre, Albert S. Henraux, along with help from a group of amateurs, and when Huyghe took over the editorship, the journal resumed its close association with

Fig. 7. *L'Amour de l'art* 13 (1932): 240–41. Courtesy of Ryerson Library, The Art Institute of Chicago

the museum and with the circle of amateurs around it.[21] The amateurs and like-minded readers of *L'Amour de l'art* would not be coming to Vermeer for the first time through photography, but would know to sense the jolt and surprise, the dislocation, in seeing details from his paintings made into filmstrips. This sense of the startling effect of remediating one art through the imposition of conventions and temporalities from another suggests a basis for the appeal of the *synoptiques:* the relativist and comparativist mode that guided *L'Amour de l'art* seems to have had its equivalent in the amateur's delight in seeing a taste that had been cultivated in relation to one period being extended and developed in relation to another. Consider the pleasure the French amateur Georges Salles, himself a curator at the Louvre during these years, thought would result from viewing an Asian collection formed by the taste of a collector of fifteenth-century Italian bronzes.[22] The pleasure was in seeing different aesthetic sensibilities, not only juxtaposed, but also, as it were, superimposed. I think Huyghe made a bid for the pacing and techniques of visual culture to be incorporated in this sophisticated play. The game was one of extending taste and sensibility through surprising metamorphoses and affective experiences, not through the exemplification of categories and periods. At a time, then, when the lure of the object was being cast for the public as the embodiment of an art historical concept in a book-like exhibition, Huyghe attempted with the *synoptiques,* for the sophisticated audience of *L'Amour de l'art,* to make art once again a matter of open-ended play.

1. Roland Recht, "Du Style aux catégories optiques," in *Relire Wölfflin* (Paris: Ecole nationale supérieure des beaux-arts, 1995), 33–53. Robert S. Nelson, "The Slide Lecture, or the Work of Art History in the Age of Mechanical Reproduction," *Critical Inquiry* (spring 2000): 414–34. For Wölfflin's own reservations, see Frederick N. Bohrer, "Photographic Perspectives: Photography and the Institutional Formation of Art History," in *Art History and its Institutions,* ed. Elizabeth Mansfield (London: Routledge, 2002), 246–59.

2. I discuss the "bookification" of the exhibition, and contemporary objections to it, in my forthcoming work on René Huyghe's exhibitions in the 1930s.

3. *Encyclopédie photographique de l'art,* 5 vols. (Paris: Editions Tel, 1935–49). The photographer for these volumes was Andé Vigneau. For comments about this edition and a useful history of photography in French art publications, see Henri-Jean Martin, Roger Chartier, Jean-Pierre Vivet, eds., *Le Livre concurrencé 1900–1950* (Paris: Promodis, 1986), 440–41.

4. René Huyghe, "Directives," *L'Amour de l'art* 12 (1931): 1–2. For his comments on the temporality of the book, see Huyghe, "Le Rôle des musées dans la vie moderne," *Revue des deux mondes,* 15 Oct. 1937, 779ff.

5. See Henri Zerner's analysis of the cinematic aspects of Malraux's presentation, in *Ecrire l'histoire de l'art* (Paris: Gallimard, 1997), 153.

6. Georges Didi-Huberman, *L'Image survivante: Historie de l'art et temps des fantômes selon Aby Warburg* (Paris: Les Editions de Minuit, 2002), 452ff. Kurt W. Forster, "Aby Warburg: His Study of Ritual and Art on Two Continents," *October* 77 (summer 1996): 5–24.

7. For the relationship of Warburg to avant-garde practices, see Benjamin H. D. Buchloh's thoughtful sorting out in "Gerhard Richter's Atlas: The Anomic Archive," *October* 88 (spring 1999): 116–47.

8. For his account of *L'Amour de l'art,* along with the implication that Malraux borrowed from his example, see René Huyghe, *De l'Art à la philosophie: réponses à Simon Monneret* (Paris: Flammarion, 1980), 33. See also *Discours de réception de René Huyghe à l'Académie française* (Paris: Flammarion, 1962), 59. Eric Vatré, "Enquête sur la photographie: René Huyghe," *Photo-ciné revue,* Sept. 1980, 458–59.

9. My thanks to Charles Haxthausen for pointing to this periodical as a point of comparison for the juxtaposition of popular culture, "primitive" objects, and fine-art reproductions. For the scene described above, see *Der Querschnitt* (1925): unnumbered plate between pp. 232–33.

10. Huyghe, "Directives," 1–2.

11. Ibid.

12. Huyghe, *Une Vie pour l'art* (Paris: Editions de Fallois, 1994), 76. The synoptic formula, as laid out in the initial issue, survived the first year as a separate entity and then gradually merged with the layouts for articles. In 1934, with the arrival of a new publisher, the journal changed format altogether, but experimentation resumed in 1935.

13. Vatré, "Enquête," 458.

14. René Huyghe, *Dialogue avec le visible* (Paris: Flammarion, 1955), 54–56. My thanks to Katie Kirtland for her efforts to locate Huyghe's film in French archives.

15. These conflicts are developed further in my forthcoming article on Huyghe. His position on film after the war comes close to André Bazin's, and may in fact be derived from it: see *What is Cinema? Essays Selected and Translated by Hugh Grey* (Berkeley: University of California Press, 1967–71), 1:41–52. I want to thank Tom Gunning for his generous help with French film theory.

16. Frederic J. Schwarz, "The Eye of the Expert: Walter Benjamin and the Avant Garde," *Art History* 24 (June 2001): 401–44. For filmstrips in book design, see "The Cinematic Page" in Jaroslav Andel, *Avant-Garde Page Design 1900–1950* (New York: Delano Greenidge Editions, 2002), 281–305.

17. René Huyghe, "L'Art et la civilization moderne," *Bulletin de l'Institut national genevois* 52 (1947): 86ff. René Huyghe, *Dialogue avec le visible* (Paris: Flammarion, 1955), 14ff.

18. Molly Nesbit, *Atget's Seven Albums* (New Haven: Yale University Press, 1992), 14ff.

19. James Clifford, "Ethnographic Surrealism," in *The Predicament of Culture* (Cambridge: Harvard University Press, 1988), 132.

20. Georges Didi-Huberman, *La Ressemblance informe, ou, Le Gai Savoir visual selon Georges Bataille* (Paris: Macula, 1995), 13ff.

21. For a history of the journal, see Yves Chevrefils Desbiolles, *Les Revues d'art à Paris 1905–1940* (Paris: Entr'revues, 1993), 137.

22. Georges Salles, "La Présentation de l'objet d'art," *Encyclopédie française Arts et litératures dans la société contemporaine* (Paris: Comité de l'Encyclopédie française, 1935), vol. 16, part 84, pp. 10–12.

Photography's Expanded Field

George Baker

I begin not with a negative, nor with a print, but with a screen. On the screen can be seen a landscape, a campus it seems, identified by cheerful signage and imposing brutalist buildings. This is a screen in motion, as the view begins to rotate, parading before us the series of changing buildings but also the denizens of this place: various youth, students both bohemian and conformist, potential professors, security, and police. Along with the bodies, the camera scans automobiles not so much in motion as sentenced to their destruction: car wreck after car wreck, an obvious homage to both one of the great moments in the history of photography, Andy Warhol's use of catastrophe photographs in his series "Death in America," and one of the great moments in the history of cinema, Jean-Luc Godard's infamous eight-minute tracking shot of wrecked automobiles in the film *Weekend.* Yet if the cars here do not move, neither do the people; both wrecked object and frozen subject simply pass by in an endless scroll, punctuated repetitively by one accident after another, a revolution that reaches its end only to loop and repeat itself again. Indeed, the strangely static moving-image work in question, Nancy Davenport's *Weekend Campus* (fig. 1), was made by a photographer; it consists entirely of a scanned series of photographic still images and was positioned as the introductory piece in a recent exhibition otherwise given over to digital photographic prints.[1]

Fig. 1. Nancy Davenport (Canadian, born 1965), stills from *Weekend Campus*, 2004. Nicole Klagsbrun Gallery, New York

Everywhere one looks today in the world of contemporary art, the photographic object seems to be an object in crisis, or at least in severe transformation. Surely it has been a long time since reformulating the history and theory of photography has seemed a vital intellectual necessity, an art historical project born rather of the new importance of the photograph in the art practice of the 1970s

and 1980s. As theorized then, postmodernism could almost be described as a photographic event, as a series of artistic practices were reorganized around the parameters of photography taken as what Rosalind Krauss has recently called a "theoretical object": the submission of artistic objects to photography's logic of the copy, its recalcitrance to normative conceptions of authorship and style, its embeddedness within mass cultural formations, its stubborn referentiality and consequent puncturing of aesthetic autonomy.[2] With hindsight, however, we might now say that the extraordinary efflorescence of both photographic theory and practice at the moment of the initiation of postmodernism was something like the last gasp of the medium, the crepuscular glow before nightfall. For the photographic object theorized then has fully succumbed in the last ten years to its digital recoding, and the world of contemporary art seems rather to have moved on, quite literally, to a turn that we would now have to call cinematic rather than photographic.

We exist in a quite different moment than that described by Krauss twenty-five years ago in her essay "Sculpture in the Expanded Field": the elastic and "infinitely malleable" medium categories then decried by the critic seem not to be our plight.[3] Critical consensus would have it that the problem today is not that just about anything image-based can now be considered photographic, but rather that photography itself has been foreclosed, cashiered, abandoned—outmoded technologically and displaced aesthetically. The artist stars of the present photographic firmament are precisely those figures, such as Jeff Wall, who reconcile photography with an older medium such as history painting, in a strange reversal of photography's former revenge on traditional artistic media; or those, such as Andreas Gursky, who have most fully embraced the new scale and technology of photography's digital recoding (this is hardly an opposition of possibilities: Wall has also embraced the digital, and Gursky is also a pictorialist). And even the most traditional of a younger generation of contemporary photographers cannot now resist the impulse to deal the concerns of other mediums into their practice, not so much utilizing photography to recode other practices as allowing the photograph to be recoded in turn, as when Philip-Lorca di Corcia lights his street photography with the stage lights of theater or cinema, or Thomas Demand now accompanies his constructed photographic simulacra with equally simulated projections placing his constructions into motion, or Rineke Dijkstra feels compelled to place video recordings of her portrait subjects alongside their photographic inscriptions. Even among those artists, then, who continue in some form the practice of photography, today the medium seems a lamentable expedient, an insufficient bridge to other, more compelling forms.

And yet I am pulled back from the finality of this judgment, from this closure of the photographic, by the strange vacillation in the Davenport work with which I began. How to describe its hesitation between motion and stasis, its stubborn petrifaction in the face of progression, its concatenation into movement of that which stands still—its dual dedication seemingly to both cinema and photography? It is this hiccup of indecision, whether fusion or disruption, that I want to explore here. For it seems that while the medium of photography has been thoroughly transformed today, and while the object forms of traditional photography are no longer in evidence in much advanced artistic practice, something like a photographic effect still remains—*survives,* perhaps, in a new, altered form. And if we could resist the object-bound forms of critical judgment and description, the announcement of a medium's sheer technological demise, we might be able to imagine critically how the photographic object has been "reconstructed" in contemporary practice—an act of critical imagination made necessary by the forms of contemporary art, and one that will answer to neither technological exegesis nor traditional formalist criteria.

To "reconstruct" one's object: this is a structuralist vocation, as long ago described by Roland Barthes, and it was precisely the critical gesture made twenty-five years ago in Krauss's demonstration "Sculpture in the Expanded Field."[4] At a moment today when the photographic turn in theories of postmodernism no longer seems so dominant, this other explanatory device from that era—the notion of postmodernism as opening onto a culturally and aesthetically "expanded field" of practice—only gains in usefulness.[5] And yet it is striking to me that the explanatory schema of postmodernism's expanded field was never, to my knowledge, put into place to explore the transformation of photographic practice undergone twenty-five years ago, during the early years of aesthetic postmodernism, this event that was otherwise sensed by critic after critic as a photographic one. Surely writers such as Abigail Solomon-Godeau absorbed Krauss's critical lesson and described postmodern photography as opening onto an "expanded" rather than reduced field of practice; and yet the precise mapping of this expansion was never essayed, nor concretely imagined.[6] If today the object of photography seems to be ever so definitively slipping away, we need to enter into and explore what it might mean to declare photography to have an expanded field of operation; we need to trace what this field has meant for the last two decades of photographic practice, in order to situate ourselves with any accuracy in relationship to the putative dispersal—whether melancholic or joyful—that the medium today is supposedly undergoing.

Perhaps photography's notorious epistemological slipperiness—think of the famous difficulty faced by Roland Barthes throughout the entirety of his book *Camera Lucida* to define in any general way the object of his analysis—inherently resists the structural order and analysis of Krauss's expanded field. Perhaps, indeed, photography's expanded field, unlike sculpture's, might even have to be imagined as a group of expanded *fields,* a multiple set of oppositions and conjugations, rather than any singular operation. And yet it is striking how consistently photography has been approached by its critics through the rhetoric of oppositional thinking, whether we look to the photograph as torn between ontology and social usage, or between art and technology, or between what Barthes called "denotation" or "connotation," or what he also later called "punctum" and "studium," between "discourse and document" (to use an invention of Benjamin Buchloh's), between "labor and capital" (to use one of Allan Sekula's), between index and icon, sequence and series, archive and art photograph. One could go on.

This tearing of photography between oppositional extremes is precisely what we need to begin to map an expanded field for its practice, and indeed any one of the above oppositions might serve as this field's basis. However, in the very first art historical essay I ever published, I introduced my own opposition into the mix, an exceedingly general as well as counterintuitive one, but an opposition intended nevertheless to encompass many of the terms just mentioned, between which photographic history and practice have been suspended since their invention. In an essay otherwise devoted to an analysis of the photography of August Sander, I asked when would it become necessary to conceive of the photograph as torn between narrative, or what I also called "narrativity," and stasis?[7] The question was counterintuitive, for the frozen fullness of the photographic image—its devotion to petrifaction or stasis—has seemed for so many to characterize the medium as a whole. And yet, by the early twentieth century it had become impossible not to think of all the ways in which the social usage of photography—its submission to linguistic captioning, its archival compilations, its referential grip on real conditions of history and everyday life, its aesthetic organization into sequence and series—thrust the photographic signifier into motion, engaging it with the communicative functions of narrative diegesis, the unfolding of an unavoidable discursivity.

"Photography between narrativity and stasis," I called this condition, isolating its emplacement within the aesthetics of Neue Sachlichkeit at the moment of high modernism, an aesthetic, in Sander's case, that was torn between the narrative dimensions of his archival compilation of portraits, and its typological

repetitiveness, its inability to avoid freezing its own diegesis through the systematic and serial deployment of identical poses, formats, and types. While Sander's engagement with a kind of narratological, even literary "noise" in his photography might be dismissed as one sign of Neue Sachlichkeit's anti-modernism, his project complicates such a judgment by rupturing every claim it makes to narrative cohesion, and by simultaneously rupturing its supposedly photographic dedication to immobility or stasis. In the twentieth century this had been an unnoticed but increasingly unavoidable condition for photography. While Roland Barthes had always wanted to separate a narrative art such as cinema from the different temporality of the photograph, he was also always unsure that a specific "genius" of photography in fact existed, and in his own most thrilling criticism, would be unable to keep the cinematic and photographic apart at all. For when he would look to find the "genius" of cinema in a series of films by Eisenstein, he would of course focus all of his attention on the photographic film still, in which he would locate the paradoxical essence of the "filmic" (in the essay "The Third Meaning"); and in his book *Camera Lucida,* the "genius" of photography would ultimately turn out to be its creation, in what Barthes began to call the photographic "punctum," of a movement onward and away from the image that Barthes also called the image's "blind field," a property he had otherwise earlier reserved in his book for the medium of film.

It is this rending of photographic language between the movements of narrative and the stoppage of stasis that might become visible today as a structuring condition for modernist photography as a whole. Applicable to both artists of the avant-garde and the *retour à l'ordre* (return to order), this is a condition that we sense structuring the Soviet model of the photo file (Rodchenko) as much as the FSA legacy of the photo novel (Walker Evans). It haunts every attempt by the modernist artist to create a medium of visual communication and the various sequencing and captioning schemes that were devised for so doing. It simultaneously haunts every counterattempt by other modernist schools of photography to invent modes of silencing the photograph's referentiality, of inducing the photographic image to a more pure and purely visual stasis, a condition and a limit that no modernist photograph in the history of the medium was ever truly able to achieve. In this way the modernist usage of photography—what we could call its *rhetoric*—seems to result in a general condition of double negation, like what we find more specifically with Sander. The modernist photograph seems suspended in the category of the neither/nor: it is either that object that attempts to produce narrative

communication only to be disrupted by the medium's forces of stasis, or it entails the creation of a static image concatenated by the photograph's inherent war between its own denotative and connotative forces.

Another, less confusing way of generalizing this condition is to depict modernist photography as suspended between the conditions of being neither narrative nor fully static; the modernist photograph is an image that is, paradoxically, both a function of *not-narrative* and *not-stasis* at the same time. My terms here begin to echo the logical conjugation explored by Krauss in her "Sculpture in the Expanded Field" (see diagram below). As was the case with her structuring opposition for (modernist) sculpture of "not-landscape" and "not-architecture," the depiction of modernist pho-

tography as being suspended between not-narrative and not-stasis has a compelling interest. For, like the terms landscape and architecture, these two terms open onto what we could also call the "built" (or constructed) and the "non-built," with narrative signaling something like the cultural dimension of the photograph, and stasis its unthinking "nature" (Barthes's terms of connotation and denotation are not far away). This opposition of nature and culture has long been one around which theories of the advent of postmodernism themselves turned, and in the history of photography it would seem that it was the gradual relaxing of the rending suspension of photography between the conditions of not-narrative and not-stasis that would signal the emergence of postmodernism in photographic terms: the re-evaluation in the 1970s of narrative functions, of documentary in all its forms, and of many types of discursive framings and supplements for photographic works.

In "Sculpture in the Expanded Field" Krauss utilized the mathematician's Klein group or the structuralist's Piaget group to open up the logical opposition she had constructed. I will paraphrase her terms and her usage of this structure here. For if modernist photography was somehow caught between two negations, between the conditions of being neither truly narrative nor static in its meaning effects—if the modernist photograph had become a sum of exclusions—then this

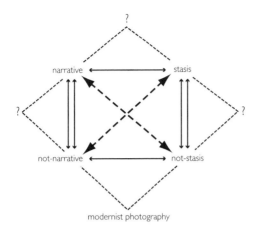

opposition of negative terms easily generates a similar opposition, but expressed positively. "That is"—to substitute my own terms while really quoting Krauss—"the [*not-narrative*] is, according to the logic of a certain kind of expansion, just another way of expressing the term [*stasis*], and the [*not-stasis*] is, simply, [*narrative*]."[8] The expansion to which Krauss referred, the Klein group, would then transform a set of binaries "into a quaternary field which both mirrors the original opposition and at the same time opens it up."[9] For modernist photography, that expanded field would look like the diagram above.

Now I have been drawing Klein groups and semiotic squares ever since I first met Rosalind Krauss, sitting in her office conjugating the semiotic neutralization of things such as the terms of gender and sexuality, some twelve years ago. When I first drew this particular graph, however, about three years ago, I was at first unclear as to what new forms might correspond to the expanded field of which

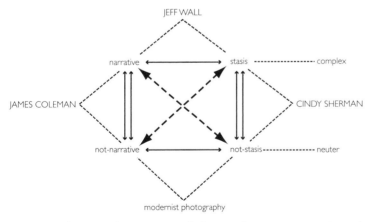

modernist photography, with its medium-specific truths, was now not the master term, but only one displaced part. The graph became immediately compelling, however, when I began to think of the major uses to which the photograph had been put in the most important artistic practices to emerge since the mid- to late 1970s, after the closure of modernism and the legitimization of avant-garde uses of photography by movements such as conceptual art (see lower diagram).

I was struck, first, by how the so-called "Pictures" generation of artists (Douglas Crimp's term) most often foregrounded the photograph as a self-conscious

Fig. 2. Cindy Sherman (American, born 1954), *Untitled Film Still #21*, 1978. Black-and-white photograph, 8 × 10 in. (20.3 × 25.4 cm). Courtesy of the artist and Metro Pictures

Fig. 3. Cindy Sherman, *Untitled Film Still #6*, 1977. Black-and-white photograph, 8 × 10 in. (20.3 × 25.4 cm). Courtesy of the artist and Metro Pictures

fragment of a larger field, the most compelling example of this being of course the untitled "film stills" of Cindy Sherman (figs. 2 and 3). Such works were photographic images that, crucially, would not call themselves photographs, and that would hold open the static image to a cultural field of codes and other forces of what I am calling *not-stasis*. At the same moment, however, postconceptual uses of projected images would see an artist such as James Coleman producing, in the 1970s, works based directly on narrative cinema, works that would, as in *La Tache Aveugle* (1978–90), freeze the cinematic forms of movement into still images to be projected over long delays; or that would eventually freeze films more generally into the durational projection of continuous still images (*Untitled: Philippe VACHER,* 1990); or, in Coleman's most characteristic working mode, would seize upon slide projections with poetic voiceovers continually disrupted in their narrative diegesis by the frozen photographic forces of what I have been calling *not-narrative* (fig. 4).[10] Two expansions of my quaternary field had thus been spoken for, the schemas of *narrative* and *not-narrative* as well as *stasis* and *not-stasis,* and the uncanny connection—but also the opposition—that had always puzzled me between the projects of Sherman and Coleman logically explained. More puzzling, perhaps, was what the structuralists would call the "complex" axis of my graph, the inverted expression of the suspension of modernist photography as a sum of exclusions, neither narrative nor stasis in its neuter state. What would it mean to invert this exclusion, to locate a project not as the photographic suspension between the *not-narrative*

and the *not-stasis,* but as some new combination of both terms, involving both narrative *and* stasis at the same time? But of course Sherman and Coleman in the late 1970s have a rather compelling and logical counterpart in the claiming of new uses for "photography," even if the medium-specific term now evidently needs to be reconsidered; if Sherman claims the "film still" and Coleman the "projected image," Jeff Wall's appropriation then of the advertising format of the light box for his image tableaux arrives as yet another major form invented at precisely that same moment which now seems to complete our expanded field (fig. 5).

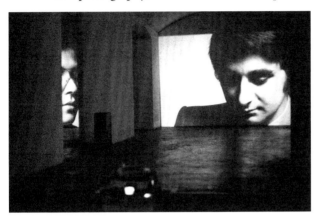

Fig. 4. James Coleman (Irish, born 1941), *Clara and Dario,* 1975. Projected images with synchronized audio narration. © James Coleman

Fig. 5. Jeff Wall (Canadian, born 1946), *The Storyteller,* 1986. Transparency in light box, 90 ⅛ × 172 in. (229 × 437 cm). Museum für Moderne Kunst, Frankfurt am Main, Germany

Critics have often wondered about the operation of the condition of pastiche in Wall's images; they have wondered, too, about his reclamation of history painting, disparaging his aesthetic as the false resuscitation of the "talking picture."[11] These questions too we can now answer, as Wall's aesthetic gambit was to occupy the complex axis of photography's expanded field, positioning his own practice as the logical and diametric inversion of modernist practice, as opposed to the oblique continuation of at least partial forms of modernist disruption or negation in the opposed projects of Coleman and Sherman (the *not-narrative* in the one, the *not-stasis* in the other). Two artists here, then, move obliquely away from and yet manage to continue the critical hopes of modernism; the third simply inverts its terms, allowing the ideological exclusions of modernism to shine forth without disruption.

It is clear to me now that in the art of the last ten years, rather than speaking tendentiously, as critics are wont to do, about the "influence" of Cindy Sherman

on a younger generation of photographers, or Coleman's or Wall's "impact" on contemporary art, we should be instead tracing the life and potential transformation

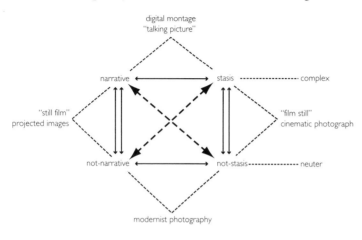

of a former medium's expanded field. We are dealing less with "authors" than with a structural field of new formal and cultural possibilities (see diagram at left), all of them ratified logically by the expansion of the medium of photography.

For the positions occupied by the great triumvirate of postmodernist "photographers" in the late 1970s have themselves spawned the more general birth of new forms we have witnessed in recent years. By the moment of the early to mid-

Fig. 6. Sharon Lockhart (American, born 1964), *Shaun*, 1993. Framed chromogenic print (from a series of five), 14 × 10 in. (35.6 × 25.4 cm). Edition 8 + 2 Aps. Courtesy Barbara Gladstone Gallery, New York

1990s, a whole generation of artists using photography began to mine the possibilities of *stasis* and *not-stasis,* embracing the impulse to what could be called "counterpresence" that such an action upon the photograph provides, pushing the still image always into a field of both multiple social layers and incomplete image fragments. And so it will be apparent now that the intense investment in what might be called the "film still" or what I will call the "cinematic photograph" in contemporary art lies not in the closure of photography *tout court,* but in an expansion of its terms into a more fully cultural arena.[12] Thus we witness the mad multiplication of connotational codes within a single still image (the project in the 1990s, most conspicuously, of Sharon Lockhart's photographs, fig. 6); or the opening of the still image onto manipulations from other cultural domains (such as Danish artist Joachim Koester's use of the blue filters popularized by François Truffaut in the

Fig. 7. Joachim Koester (Danish, born 1962), *Day for Night, Christiania,* 1996. Chromogenic print mounted on aluminum, 25 ³/₄ × 38 ½ in. (65.5 × 98 cm). Galleri Nicolai Wallner, Copenhagen

Fig. 8. Sharon Lockhart, *Teatro Amazonas,* 1999. Production still. Courtesy Barbara Gladstone Gallery, New York. © Sharon Lockhart

former's series *Day for Night, Christiania* [fig. 7], or the sci-fi menace of Norwegian artist Knut Åsdam's nighttime documents of urban housing projects). The latter work by Åsdam has been presented as an open-ended series of photographic prints and then, significantly, it has been reconfigured into slide projections where the sequencing and narrative possibilities discovered would lead to the artist's subsequent dedication to producing semi-narrative films.

Thus, singular artists will now occupy opposing and quite different positions within this expanded field; Lockhart, for one, is known for her production not only of cinematic photographs but also for a series of nearly static films, like *Teatro Amazonas* (fig. 8), that we can call instead of the film still the "still film."[13] Both the still film and many forms of the projected image began to give expression, at the same moment in the mid-1990s, to the possibilities opened up by the specific combination of *narrative* and *not-narrative.* For during the last decade, the projected slide sequence has attracted a whole new group of adherents, an example again being an artist that I have just associated with another aspect of my field—namely Joachim Koester, who uses found slides abandoned at the developers to create fleeting narratives. New forms will be invented in each position within the field. Tacita Dean's frozen films might occupy this position of *narrative* and *not-narrative* along with Lockhart's, just as Dean will devote as much of her practice to still photography as the photographer Lockhart does to film. And Douglas Gordon's "slowed" films

(fig. 9)—which in their most extreme versions reduce the narrative cinematic prod-
uct to the foundation of the still frame through extending films to playtimes of
twenty-four hours or even years—will occupy the position of the "still film" just
as much as Lockhart's *Teatro Amazonas.* For even though one project may depend
upon *video* and the other on *film,* both are linked conceptually to a field mapped
out by the expansion of *photography,* to which however neither of them will, of
course, correspond.

The "talking picture" or complex axis of our field—the fusion of *narrative*
and *stasis*—has encompassed the wildest variety of solutions in recent years, from the
painterly manipulations of digital montage (from Wall to Davenport and others), to
the large-scale Hollywood tableaux of the school of Gregory Crewdson (e.g., Anna
Gaskell, Justine Kurland, and the like), to the invention of what I would call the
"narrative caption" in the photographic projects of artists as diverse as Andrea Robbins

Fig. 9. Douglas Gordon (Scottish, born 1966), *24 Hour Psycho,* 1993. Video installation. Yvon Lambert Gallery, Paris and New York

Fig. 10. Sam Taylor-Wood (British, born 1967), *Five Revolutionary Seconds IV*, 1996. Color photograph on vinyl with sound, 8 ⅛ × 78 ¾ in. (20.5 × 200 cm). White Cube, London. © Sam Taylor-Wood

+ Max Becher and the Irish artist Gerard Byrne, whose images are often accompanied by the most incontinent of supplements.[14] In addition to digital recoding and linguistic supplements, new forms will be invented here as well, even if pastiche will most often be their domain: one thinks of the *Five Revolutionary Seconds* or *Soliloquy* series of Sam Taylor-Wood, panoramic still photographs made by a special camera that rotates over time and through space, often restaging historical paintings, and which are most often accompanied, upon exhibition, by wall-mounted speakers spouting literal sound tracks (fig. 10). Here, it would seem, is a picture where the condition of "talking" has been taken as far as it can go, and where the complex axis, the fusion of both/and, perhaps cries out for a renewed dedication to disruption once more (the negation of the "not").

Thus, to paraphrase Krauss one last time, "[*Photography*] is no longer the privileged middle term between two things that it isn't. [*Photography*] is rather only one term on the periphery of a field in which there are other, differently structured possibilities."[15] That this is a cultural as opposed to merely aesthetic field is something that certain recent attempts to recuperate object-bound notions of medium-specificity seem in potential danger of forgetting. This is one reason why I have felt it necessary to recuperate the model of the expanded field, and to map its photographic dimension in this essay. I am not so much worried about the return of ideas of the medium in recent essays by Krauss or Hal Foster—in Krauss's work, this concern never really disappeared—for the idea of the medium that these critics are trying to explore seems fully in line with the expansions mapped in their own earlier work (in fact, seen in retrospect, "Sculpture in the Expanded Field" amounts to a profound meditation on what a medium in the era of postmodernism might be). But their breaking of a postmodernist and interdisciplinary taboo has let loose a series of much more conservative appeals to medium-specificity, a return to traditional artistic objects and practices and discourses, that we must resist.

The problem is not to "return" to a medium that has been decentered if not expanded. The problem, as Foster remarked upon Krauss's essay now quite a long time ago, is to resist the latent urge to "recentering" implicit in the expanded field model of the postmodern in the first place: In the "Expanded Field," Foster wrote, "the work is freed of the term 'sculpture' . . . but only to be bound by other terms, 'landscape,' 'architecture,' etc. Though no longer defined in one code, practice remains within a *field*. Decentered, it is recentered: the field is (precisely) 'expanded' rather than 'deconstructed.' The model for this field is a structuralist one, as is the activity of the Krauss essay . . . 'The Expanded Field' thus posits a logic of cultural oppositions questioned by poststructuralism—and also, it would seem, by postmodernism."[16] This problem is ours now too. If the photographic object seems in crisis today, it might now mean that we are entering a period not when the medium has come to an end, nor where the expanded field has simply collapsed under its own dispersal, but rather that the terms involved only now become more complex. For as I hinted earlier, it may be possible to envision other expanded fields for photography than even the one mapped quickly here, for example in the *spatial* (as opposed to *temporal*) expansion of the photograph we perhaps face in practices ranging from Louise Lawler to such younger artists as Rachel Harrison, Tom Burr, and Gabriel Orozco (think, for example, of the latter's *Extension of a Reflection* [fig. 11] or his work *Yielding Stone,* both from 1992). Given these potential expansions, we need now to resist both the "lure of the object" and the traditional medium in contemporary art. We should not retreat from the expanded field of contemporary photographic practice; rather we should map its possibilities, but also deconstruct its potential closure and further open its multiple logics. At any rate, when I first sketched my graph for the artist with which I began, Nancy Davenport, she quickly grabbed my pen and paper and began to swirl lines in every direction, circling around my oppositions and squares, with a look that seemed to say, "Well, what

Fig. 11. Gabriel Orozco (Mexican-American, born 1962), *Extension of a Reflection,* 1992. Chromogenic print, 16 × 20 in. (40.6 × 50.8 cm). Courtesy of Marian Goodman Gallery, New York

about these possibilities?" My graph was a mess. But the photographer's lines, while revolving around the field, had no center, and they extended in every direction.

1. Nancy Davenport, *Campus,* Nicole Klagsbrun Gallery, New York, 5 Mar. to 3 Apr. 2004.

2. Rosalind E. Krauss, "Reinventing the Medium," *Critical Inquiry* 25 (winter 1999): 289–305, an expanded version of which appeared as "Reinventing the Medium: Introduction to *Photograph,*" in George Baker, ed., *James Coleman* (Cambridge: MIT Press, 2003), 185–210.

3. Rosalind Krauss, "Sculpture in the Expanded Field" [1979], in her *The Originality of the Avant-Garde and Other Modernist Myths* (Cambridge: MIT Press, 1985), 277.

4. "The goal of all structuralist activity, whether reflexive or poetic, is to reconstruct an 'object' in such a way as to manifest thereby the rules of functioning (the 'functions') of this object. Structure is therefore actually a *simulacrum* of the object, but a directed, *interested* simulacrum, since the imitated object makes something appear which remained invisible, or, if one prefers, unintelligible in the natural object." Roland Barthes, "The Structuralist Activity," in *Critical Essays,* trans. Richard Howard (Evanston, Ill.: Northwestern University Press, 1972), 214–15.

5. Krauss's schema has been revisited recently by Anthony Vidler in an essay on contemporary architecture; see "Architecture's Expanded Field," *Artforum* 42, no. 8 (Apr. 2004): 142–47; and Anne Wagner has returned to it to critique it in a recent essay on 1970s sculpture; see "Splitting and Doubling: Architecture and the Body of Sculpture," *Grey Room* 14 (winter 2004): 26–45.

6. "Photography after art photography appears as an expanded rather than a diminished field," Solomon-Godeau wrote in "Photography after Art Photography," in *Art after Modernism: Rethinking Representation,* ed. Brian Wallis (New York: New Museum of Contemporary Art, 1984), 85.

7. George Baker, "Photography Between Narrativity and Stasis: August Sander, Degeneration, and the Decay of the Portrait," *October* 76 (spring 1996): 73–113.

8. Krauss, "Sculpture in the Expanded Field," 283.

9. Ibid., 283.

10. While Coleman would only be widely recognized for his "projected images" (the artist's term) in the 1990s, his first uses of the slide projection with voice-over date to the early to mid-1970s, e.g., *Slide Piece* (1972) and *Clara and Dario* (1975).

11. See Rosalind Krauss, " . . . And Then Turn Away," in Baker, ed., *James Coleman,* 177–78, 183: "The role of pastiche within postmodernism has long been an issue of particular theoretical concern . . . Ever since my first experience with Wall's *Picture for Women* (1979), a restaging of Manet's *Bar at the Folies-Bergère,* I have been interested in accounting *structurally* for this condition in his work." The expanded field explored in the present essay would seem to provide this structural explanation.

12. It is true that Wall invokes the "cinematic" quite often in discussing his images. And while all the axes of photography's expanded field open potentially onto cinema through the folding of narrative concerns into the photographic construct, Wall's cinematic images and their progeny need to be rigorously distinguished from that category of work that I am here calling "cinematic photographs." While such images hardly engage with the actual cinematographic motion of the "still film" or "projected image," they also refuse the singularity and unified nature of the *tableaux* of such photographers as Wall or Gregory Crewdson. Their engagement with cinema leads to an embrace of the fragment, of absence, discontinuity, and the particular phenomenology of what can be called "counterpresence." That said, it must also be admitted that Wall's aesthetic production is hardly monolithic, and like almost all of the artists under consideration here, many of his works—especially those conceived in series, as his *Young Workers* photographs (1978–83)—would belong to axes of photography's expanded field other than the primary one asserted here.

13. This is a term coined, I believe, by Douglas Crimp to account for similar work in the 1970s (his example is a film by Robert Longo); see "Pictures," *Art after Modernism,* 183. The reversibility of film still and still film is already fully recognized by Crimp in this 1979 essay (written, then, in the same year as Krauss's publication of "Sculpture in the Expanded Field").

14. On Byrne's work, still unfortunately underknown in the American context, I point the reader to my essay, "The Storyteller: Notes on the Work of Gerard Byrne," in *Gerard Byrne: Books, Magazines, and Newspapers* (New York: Lukas & Sternberg Press, 2003).

15. Krauss, "Sculpture in the Expanded Field," 284.

16. Hal Foster, "Re: Post," in *Art After Modernism,* 195.

PART THREE

OBJECTIVITIES

Some Object Histories and the Materiality
of the Sculptural Object

Malcolm Baker

The starting point for this paper is what I perceive to be a disjunction between, on the one hand, the way many spectators view art objects—what constitutes the lure of the object for at least some visitors to the art museum—and, on the other, the way art historians write about these objects. For many viewers one compelling attraction of the art object lies in the wonder at how a work was made. Sometimes articulated through the question, "However did they do that?" such a response might even involve an urge to play the role of the artist and to simulate imaginatively the act of making. The making of the art object and the material state of works of art have of course been addressed in the vast body of literature produced as the result of investigative conservation, as well as in museum exhibitions that have focused attention on processes of making.[1] However, these largely descriptive accounts and analyses of the physical features and condition of individual works usually constitute a discreet section of the bibliography that exists separately from the wider literature of art history. And in this wider literature the process of making the physical object, as opposed to the processes of invention and creation, remains often surprisingly absent. So this paper is concerned with a sense of unease—the unease that art historians, despite their protests to the contrary, feel with the making of art, with the physical specificities of process. But I should say at the outset that I am not advocating a simplistic return to the object, or what in some quarters might be seen as some sort of empirical safe haven after a period of stormy theoretical voyaging. Instead, I want to explore how and why, as I perceive it, our engagement with the making of the material art object is problematic.

This prompts a cluster of questions: How is our perception of the object conditioned by its material and its making? In what ways are we lured by the narratives of making, narratives that we are prompted to read on to an object by what we perceive to be the vestigial traces of that process? How might we as viewers, through such narratives, take pleasure in playing the vicarious maker? And to what degree are such narratives both articulated and shaped by the frameworks—whether textual or institutional—in which objects are contextualized?

Such questions are hardly unfamiliar. In one sense, art history has been constantly concerned with them. And yet so much of this is assumed or seen as

simply descriptive and so unproblematic. There are of course very significant ex-
ceptions to this. One might be the growing body of writing about the iconology
of materials, much of it by German scholars—the work already cited by Christian
Scheidemann and the exhibition catalogue that accompanied the 1992 Berlin ex-
hibition about Renaissance bronzes, *Von allen Seiten Schön,* for example—but also
conferences such as that recently held at Versailles devoted to the marble trade in
the seventeenth and eighteenth centuries.[2] Other examples of the developing in-
terest in these questions might include Pamela Smith's recent book *The Body of the
Artisan,* Michael Cole's study of Cellini, or Richard Kendall's writing about Degas's
pastels.[3] And the issue is situated in a theoretical context as an aspect of a rescued
formalism by Yves-Alain Bois in his *Painting as Model.* Arguing that "concepts must
be forged *from* the object of one's enquiry or imported *according* to that object's
specific exigency," Bois stresses the importance of "a scrupulous investigation of
the object's materiality" and insists on "the possibility of a *materialist* formalism,
for which the specificity of the object involves not just the general condition of its
medium, but also it means of production in its slightest detail."[4] In English the
one art historian whose work has addressed these questions not only as a central
concern but as part of the still wider issue of how we think and write about art is
Michael Baxandall. One possible model for thinking and writing about making is
his *Limewood Sculptors of Renaissance Germany.*[5]

Yet, with these and, it must be admitted, an increasing number of excep-
tions, most of the many publications and exhibitions about technique and making
are largely descriptive rather than analytical and interpretative. Conversely, many of
the more theoretically informed discussions of images and art objects skirt around
issues of material and technique. We have, as it were, "objecthood" without the ma-
terial object. It is therefore not entirely surprising that among the otherwise stimulating
and representative set of essays in Robert Nelson and Richard Schiff's *Critical Terms
for Art History*—a volume that articulates the current preoccupations within the dis-
cipline—there is no paper that addresses that issue of making.[6]

How, then, might we approach perceptions of material and making? How
might we engage with these narratives around making that, I suggest, play a more
central role in our perception of objects than is usually acknowledged? Perhaps be-
cause of the slippage between the two-dimensional image and its reproductions,
questions of facture and materiality have been easy to avoid, but that would seem
to be far harder to do with the three-dimensional sculptural object. At first sight
it might seem difficult to contemplate a work such as the early sixteenth-century

Fig. 1. Attributed to Master H. L. (German, active 1511–26), *Saint George*, early 16th century. Boxwood. Victoria and Albert Museum, London

boxwood figure of Saint George, attributed to the Master H. L. (fig. 1), without engaging with the insistent materiality of the sculptural object.[7] Carved in a conscious virtuoso manner and constructed of several pieces of wood, some of which retain their bark (left conspicuously visible on the back) in a way that alerts the viewer to the transformation of nature into art, such a sculpture makes process and facture integral to the way it is to be perceived as well as doing so in a way that is less obvious than it is with most paintings. So how has the materiality of the sculptural object been addressed?

One way into this is to look at how material and technique have been described and used in an object's history, to consider the frameworks of viewing and interpretation into which particular works have been set. In this paper I shall consider the histories—the afterlives—of three sculptures and the different ways that narratives of making have been both engaged with and effaced. And in looking at what I might call the reception of the art object's materiality, I shall draw on not only the responses articulated in both the art historical literature and the early sources in which these works are described, but also in the frameworks of museum display. My three examples have been chosen to illustrate these three different framings.

My first case concerns a series of reliefs of subjects from Ovid's *Metamorphoses*, associated with Guglielmo della Porta and known through versions in bronze, ivory, wax, and silver (fig. 2). In an article in the *Jahrbuch der Hamburger Kunstsammlungen*, Werner Gramberg linked these reliefs with various drawings by della Porta, so describing a familiar trajectory from drawing to sculpture.[8] Among other evidence cited by Gramberg was a report of a legal case in which della Porta's sons were in dispute about the contents of their father's estate in 1677. One party claimed that

Fig. 2. After Guglielmo della Porta (Italian, c. 1500–1577), *The Hunt of the Calydonian Boar*, c. 1600. Bronze. Victoria and Albert Museum, London

certain works had been wrongly removed from the workshop, including several reliefs in terracotta made by Jacob Cornelisz. Cobaert under della Porta's instructions and intended as models for versions of these compositions in silver and other materials (fig. 3). Indeed, numerous versions of these reliefs were being produced into the eighteenth century. What is clear from the terms used in the legal documents is that these terracottas had a particular role in an elaborate process of replication or what might be called a sculptural economy of the multiple. The complexity of the relationship here between drawing, model in terracotta, and casts in silver and bronze might suggest that the materiality of sculpture and the various stages in its design and making, when combined with this documentary evidence, would be a pressing concern. But the literature—on della Porta and on the later appropriations of his inventions—hardly deals with this. Even Jennifer Montagu, a sculptural historian acutely aware of the importance of material evidence, in her *Gold, Silver and Bronze* seems to skirt around this in her references to the case.[9] Nor does the literature engage properly with the issues of value and reception that are involved here. Indeed, the evidence from the court case becomes subservient to a series of arguments about either attributions or sources. Even though both the surviving works and the documentary sources offer the possibility of exploring the circumstances of sculptural production, materiality and process are largely marginalized in these discussions.

Fig. 3. Jacob Cornelisz. Cobaert (Dutch, active 1602–21), *The Hunt of the Calydonian Boar*, c. 1575. Terracotta, 5 × 9 ¾ in. (14 × 24.76 cm). Victoria and Albert Museum, London

But, as my second example—a somewhat neglected eighteenth-century

publication about sculpture—shows, the unease with, or ambivalence toward, the materiality of the sculptural object and the physical processes of making is not entirely the responsibility of the modern art historian. This early eighteenth-century publication—Matthys Pool's *Art's Cabinet* (1728)—is concerned with the ivory carvings of the Flemish sculptor Francis van Bossuit, who died in Amsterdam in 1692.[10] Although Bossuit worked in various media, he is known above all for his ivory figures and reliefs, such as those of Mars and David. Characteristic of these is the way the apparent softness of the flesh and subtle gradations of drapery suggest that the works have been modeled rather than carved, a quality further enhanced in the reliefs by the contrast with the vigorously punched backgrounds. Indeed, these small-scale sculptures work as representations by prompting the viewer not only to enjoy the sensuousness of these surfaces but also to ask about—or marvel at—how the material was shaped and used. Here too we see a marginalization, an effacement of the materiality of the sculptural, though more ambiguously so, since it is also to some degree celebrated.

Fig. 4. Matthys Pool (Dutch, 1670–1732), title page of *Cabinet de l'art de Schulpture,* 1728. Metal engraving. Victoria and Albert Museum, London

Pool's book reproduces some seventy works by Bossuit, both figures and reliefs, including some terracottas and boxwoods, though the majority are ivories. These images are prefaced by a title page showing one of Bossuit's *Kleinplastik* groups being carved by an allegorical figure of Sculpture in a composition adapted from a painting by Girolamo Pesci (fig. 4). The work by Bossuit that Pool substitutes for the bust included in Pesci's original composition is not, ironically, a sculpture carved from ivory or boxwood but instead a group modeled in terracotta, as we know from the captions to the two views of it that follow later. Here, then, the very materiality of sculpture is being denied through a distancing allegory, and

the process of making is ignored. The distancing of process continues in the plates that follow. While the distinction made between horizontally or vertically hatched grounds registers the difference between reliefs and figures in the round, the engravings translate the three-dimensional into the pictorial. The suggestion of multiple viewpoints through (in some cases) a succession of images, often showing figures from below, might seem to simulate the experience of viewing a small-scale figure (fig. 5). Yet even here the frequent introduction of clouds means that the sculptural is effaced and the material qualities are played down. The engraved text that comes between the title page and the plates, by contrast, stresses the materiality of the work. Here in the brief biography of Bossuit his skill as a carver is celebrated and much is made of his ability to carve the hard ivory as easily as if it were wax. But by asserting this, Pool (or whoever wrote the text) is dealing with the materiality of the sculpture and the process of its production by means of a trope. Making is thus at once acknowledged but also marginalized.

La même en racourci.

E.van B.I. B.G.D. M.P.S.
 LXXIX.

Fig. 5. Matthys Pool, "La même en racourci," from *Cabinet de l'art de Schulpture,* 1728. Metal engraving. Victoria and Albert Museum, London

From this it might seem, therefore, that the reluctance to engage fully with process seen in Gramberg's text seems also evident in an older tradition of writing about sculpture. If these questions of process, technique, material, and making have, then, proved difficult to address within discourses concerned with the aesthetic, we might expect that the materiality of the object might be foregrounded and indeed celebrated with the framework of display provided by the museum.

My third example concerns an early sixteenth-century German stone sculpture, the reception and interpretation of which from the 1860s onward may be tracked not only through its publication history, but also through both evidence about its display within in a museum and the photographs that have been taken of it at vari-

ous points in this trajectory. The figure of Saint John by Hans Daucher (fig. 6) may now be seen as a work commissioned during the early years of the Reformation at the very point when attitudes to images were shifting.[11] But the acquisition by the South Kensington Museum in 1864 of this "Statuette in stone of a youth with clasped hands, probably St. John the Evangelist, with an armorial shield at the foot" seems to

have been prompted in part by an interest in other qualities that were more central to what were understood as the proper concerns of a museum of art and industry or the industrial arts. One central role of the museum following its founding in 1852 was the explication of materials and processes, even though this was hardly the institution's sole purpose in its early days and the museum's agenda from the start was a more complex and even conflicted one. Nonetheless, in line with the institution's stated didactic purpose and commitment to processes of manufacture, the figure of Saint John was acquired primarily as an example of German stone carving, so complementing the substantial holdings of wood sculpture from the same period. Both showed the way these materials were used by carvers in early sixteenth-century Germany, as well as the preference shown for them in this culture. Within the framework of the museum's displays in the 1870s, such a work could be

Fig. 6. Hans Daucher (German, 1488–1538), *Saint John the Evangelist,* c. 1520. Limestone, height 32 in. (81.3 cm). Victoria and Albert Museum, London

read in terms of the outcome of a series of stages in a making process, as represented in the carving of a cameo, or as a parallel to the vase that was the proud result of Maestro Giorgio of Gubbio's technical expertise (fig. 7).[12] These were prompts that encouraged the nineteenth-century visitor to South Kensington to see works such as the figure of Saint John as an example of technical mastery in a particular material.

By 1902 the arms had been identified as those of the Nuremberg patrician family, Lamparter von Greiffenstein, and the figure associated with the name of

Fig. 7. Solomon Alexander Hart (English, 1806–1881), *Maestro Giorgio of Gubbio: The Kensington Valhalla*, c. 1870. Oil on canvas, 13 ⅞ × 34 ½ in. (26.4 × 87.6 cm). Victoria and Albert Museum, London

Tilman Riemenschneider. Fifty years later the connection was made with a letter from Hans Lamparter referring to the commissioning from an Augsburg sculptor of a memorial to his father, Dr. Gregorius Lamparter.[13] This was to have been erected in a church in Nuremberg, but Hans Lamparter was having second thoughts, having received reports of iconoclasm in the city. Already in 1928 the figure was attributed by Ernst Kris on stylistic grounds to the Augsburg sculptor Adolf Daucher, and subsequent discussion of the work favored a reattribution to Adolf's brother, Hans.[14] The concern with attribution and authorship, evident from 1902 onward, is also registered in the contexts in which the figure was displayed. During the early years of the twentieth century, the museum reorganized its collections, along with its administrative structure. While many of the other decorative arts museums on the continent that had been founded on the South Kensington model had been reconfigured to articulate histories of style and culture rather than narratives of making and materials, the South Kensington Museum—now renamed the Victoria and Albert Museum—chose to follow material divisions through the establishment of departments that dealt with, for example, Ceramics, Metalwork, and Textiles.[15] But since the technology involved in the production of these objects—the looms on which the textiles were woven, for instance—were now consigned to the nearby Science Museum, the V&A's displays were increasingly concerned with style, despite an apparent commitment to materials and processes of manufacture. The figure of Saint John formed part of the collections of the department of architecture and sculpture, and by 1914 was almost certainly among the Flemish and German sculpture in a variety of materials displayed in the new galleries designed by Aston Webb.[16] Here, then, the work was presented not in terms of material or processes of making but, surrounded by wood sculpture, as an exemplar of a national school.

Fig. 8. Photograph of the exhibition *Style in Sculpture*, 1948. Victoria and Albert Museum, London

After the Second World War a new sequence of primary galleries was established on the museum's ground floor in which the major works from the collection were organized according to period and style, though within these categories the individual case displays still reflected the divisions among the various departments. By 1960 the figure of Saint John had been placed in a gallery devoted to the Northern Renaissance, but prior to this it had been shown in a temporary exhibition, *Style in Sculpture* (fig. 8).[17] Planned in conjunction with an illustrated book, the newly taken photographs of which suggest the drama of sculpture (fig. 9), this exhibition consisted of works of European sculpture in different materials and from various countries from the Renaissance onward. Along with the marble Cupid long thought to be an early piece by Michelangelo and Rysbrack's model for the monument to Sir Isaac Newton, Daucher's Saint John was included in a selection of works intended to illustrate distinctive modes of sculpture in different materials. Ahistorical in its approach, the display was above all concerned with aesthetic effect and grounded in an essentialist notion of style. While it certainly played on the contrast between materials as well as on distinctions among modeling, carving, and casting—it might indeed be seen as a register of that interest in truth to materials in sculpture valued by contemporary British sculptors in the 1950s—it nonetheless dealt with the effects of different processes without making those processes of making and production its

Fig. 9. Detail of fig. 6, photographed in 1948

subject. So the figure of Saint John was placed against a wall, masking the evidence of its carving. The concern here was with abstract sculptural values rather than with material qualities.

During the 1980s a further shift took place. The Northern Renaissance galleries were reconfigured and a new thematic organization—one of the first in the museum to integrate different materials fully—took account of the approach developed in Baxandall's recently published *Limewood Sculptors of Renaissance Germany.* Baxandall's study offers a model of cultural history in which objects of the sort collected by the V&A might be situated and so serves as an alternative to narratives of stylistic development or authorship. But at one point he also discusses the Saint John figure in particular.[18] While Baxandall's interpretation of limewood sculpture makes issues of material and making central to his argument, this is not so with this figure in limestone. Instead, his discussion takes the evidence of the letter about the commissioning of the figure but, rather than considering the implications of this for the work's authorship, he focuses on the part of the document stating that, having commissioned the group, Lamparter then heard that the people of Nuremberg had become "headstrong" about images and started to destroy them. Using Lamparter's subsequent decision not to erect the Crucifixion group, Baxandall employs the figure's history as a telling register of shifting attitudes to images in Reformation Germany. In accord with this, the V&A's reworking of the gallery in the early 1980s places it within a display about images and devotion in south Germany around 1520. But in order to make this point effectively, it was necessary to draw attention to the way that the process of making had been interrupted. By placing the figure not against a wall but to be seen in the round, we tried to signal the significance of its fragmentary nature. It was also placed alongside other examples that illustrated the making, as

well as the reception of devotional sculptures, so bringing production and reception into conjunction. At this point the materiality of the sculptural object gets reintroduced, not as part of a discrete and merely descriptive narrative about sculptural technique and process, but integrated within a broader discourse of cultural history and response.

This is an unusual case but even here, in a museum purportedly concerned with both process and making, and so with the material conditions of production and the presence of the three-dimensional object, the materiality of the object has proved surprisingly elusive. Given that the museum as a generic type—and this museum in particular—might present themselves as being predicated on a recognition of the object's lure, we might expect the materiality of the object to be celebrated, or at least more obviously present, in the discursive frameworks that the institution constructs. It is as if in its presentation of such material objects, the art museum (in contrast with the museum of anthropology) adopts the dominant discourse of art history in which (as Karen Lang puts it) the work of the hand is accorded less value than the work of the eye. The materiality of the object is thus downplayed, even in the case of sculpture, where that materiality might seem so insistent.

In the case of some artists, of course, the material qualities of a work have received attention because they have been used (and are perceived) as signs of authorial identity and can thus be enfolded within a biographical narrative or a discussion of stylistic identity. In the case of Adriaen de Vries for instance, the processes of modeling and casting are thematized within the sculptures themselves and serve as signs of the author's distinction. The same might be said of Rodin and Giacometti, whose works are instantly recognizable from their apparently unfinished parts, the blanks and lacunae functioning as signature as much as the form of the figures. We might even recognize the paintings of van Gogh, in which the signature may be read in heavy impasto, ensuring that identity is materially inscribed. With artists like van Gogh, de Vries, Rodin, and Giacometti, recognition is made of the materiality of the art object in terms of (at least implicitly) the role of the viewer as a vicarious artist. This is, of course, the role that the spectator is invited to take on by the way the process of making has been staged and thematized very explicitly in the work—the object—itself. As viewers we are prompted to have the pleasure of working with the material in the imaginary, of constructing our own narratives of making.

But these are exceptions. While the material might constitute a significant part of the lure of the object, this is in the main only hinted at. Even in the case

of the sculptural object, where materiality and making may seem insistently present, these issues remain curiously elusive, not only in the texts of art history but also in those institutions supposedly concerned with the object in its tangible form. How, then, might we engage with the materiality of the object and the role that this plays in the object's lure? And how might we write about the processes of making in a way that is not simply descriptive but interpretative?

One strategy, already adopted by Baxandall, is to bring production and reception into conjunction, bringing more into play the spectator's responses to materials and making. In this way we might take account in our writing of the viewer's wonder at the process of making, of the transformation from nature to art. By this means we might also acknowledge more the viewer's desire to be a maker. It is this approach that underlies not only Baxandall's *Limewood Sculptors,* but also Svetlana Alpers's *The Making of Rubens,* and these two authors' collaborative *Tiepolo and the Pictorial Intelligence.*[19] In all these works the process of making is not treated separately and dealt with simply descriptively, but as part of a far more complex matrix in which making is understood in terms of its social connotations. This approach is more frequently employed, however, by a number of anthropologists whose discussions of processes and material may have some significant implications for art historians.

The issues are laid out vividly by Alfred Gell in his essay "The Technology of Enchantment and the Enchantment of Technology," which provides a theoretical framework for thinking about making, articulated with unusual and persuasive specificity.[20] Arguing for "a break with the aesthetic preoccupations of much of the existing anthropology of art," Gell suggested that we "recognise works of art, as a category, because they are the outcome of technical process, the sort of technical process in which artists are skilled." He therefore encourages us to be more attentive to "the enchantment which is immanent in all kinds of technical activity." Using the example of the elaborately carved Trobriand canoe-boards, Gell proposed that these are made "enchanted vessels of magical power" through the technical process of carving being construed magically. Here and in European art, "the attitude of the spectator towards a work of art is fundamentally conditioned by his notion of the technical processes that gave rise to it." Developing this further, he suggested that this relationship between processes of production and the spectator's response involves "a fundamental scheme transfer . . . between technical processes involved in the creation of a work of art and the production of social relations via art." For Gell, "magical technology is the reverse side of productive technology and . . . this magical technology consists of representing the technical

domain in enchanted form." While Gell's reference to magic may be easier to apply to the making and use of the Trobiand canoe-boards than to Hans Daucher's figure of Saint John, the way he links the process of making to the viewer's response is telling, in that it makes consideration of materials and making central to a discussion of a work's social meaning.

Despite Gell's argument for recognizing the significance of process, many studies by anthropologists of specific groups of made artifacts deal less with the making of objects than with the meanings accruing to them. But some anthropologists have succeeded in addressing the processes of making in a way that is not simply descriptive but seems alive to Gell's notion of the "enchantment of technology." They thus engage not only with the technologies of the process and the materials employed, but also with the social meanings of both. One such study is Janet Hoskins's essay entitled "Why Do Ladies Sing the Blues? Indigo Dying, Cloth Production, and Gender Symbolism in Kodi," in the volume *Cloth and Human Experience.* Hoskins examines the circumstances of producing indigo-dyed cloth, worn among the Kodi as ceremonial costume by both men and women and used for the "sails" that drag the "ships" to megalithic graves.[21] Her study pays close attention to the technicalities of cloth manufacture and the materials involved, especially the qualities of the indigo dye. But all of this is considered in terms of the ritual sand discourses that surround manufacture. These rituals involve songs and laments that establish a relationship between the "quickening" and "dampening" of dyestuffs, on the one hand, and, on the other, the conception and birth of a child, so exploring what Hoskins describes as "the metaphoric and metonymic relationship between cloth production and the production of children." What is striking about Hoskins's approach for an art historian is the way it engages with the materiality of what is being made—the judgment and skill involved in soaking the dye for just the right period of time, for instance—but at the same time takes account of affect and associations of the material. Hoskins is able to support her argument with some telling analogies between the terms used for stages in cloth production and those employed to describe the conception and birth of children.

While in the three cases I discussed earlier—the della Porta reliefs, Bossuit's ivories, and Daucher's Saint John—the materiality of the work was addressed at best ambiguously in three different frameworks; the process of making here is given a centrality that rests on its place within the culture. It might be argued that in the case of indigo dying among the Kodi, production was overtly and explicitly ritualized in a way that might be difficult to parallel in the making of art in Europe.

But might not such an interpretation of the social meaning of making offer a way forward for art historians seeking to engage more with the processes of making and the materiality of the object? In a sense, this was just what Baxandall was doing when he explored the associations that limewood had as a material in late fifteenth-century Germany. And still more recently, in her *The Body of the Artist,* Pamela Smith (significantly, perhaps, a historian of science) has attempted to recoup that sense of respect for the knowledge of materials and making that was lost with the Enlightenment. These and other studies suggest that a new attentiveness to making and materials is a feature of at least some recent art history. But in addressing an issue that art history, whether in its publications or its institutions, has been constantly wary of, perhaps we might usefully take account of some of these anthropological models. The narratives of making that viewers read into objects might thus be more explicitly acknowledged. Rather than being sidelined in a descriptive appendix, process and material might be accorded the significance that they have for many spectators. In this way art historians might engage with the materiality of making without taking refuge in the myths and allegories, such as the Pygmalion narrative, that serve to distance us from the processes of production and their meanings. By recognizing the centrality of these processes of metamorphosis, of transforming and shaping materials, we may pay proper due to what is surely an important component of the object's lure.

1. A notable example of this is the series of exhibitions mounted by the National Gallery, London, under the generic title *Making and Meaning*.

2. See Christian Scheidemann's paper in this volume. Volker Krahn, ed., *Van allen Seiten schön* (Berlin: de Gruyter, 1992).

3. Pamela Smith, *The Body of the Artisan: Art and Experience in the Scientific Revolution* (Chicago: University of Chicago Press, 2004); Michael Cole, *Cellini and the Principles of Sculpture* (Cambridge: Cambridge University Press, 2002); Richard Kendall, *Degas: Beyond Impressionism* (London and New Haven: Yale University Press, 1996).

4. Yves-Alain Bois, *Painting as Model* (Cambridge: MIT Press, 1990), xii and xix. The italicized words are given as in Bois's text.

5. Michael Baxandall, *Limewood Sculptors of Renaissance Germany* (London and New Haven: Yale University Press, 1980). For a discussion of Baxandall's approach see "Limewood, Chiromancy and Narratives of Making: Writing about the Materials and Processes of Sculpture," *Art History* 21 (1998): 498–530.

6. Robert Nelson and Richard Schiff, *Critical Terms for Art History* (Chicago: University of Chicago Press, 2003). My somewhat simplified argument about the marginalization of materials and process might be countered by many more examples of studies that engage with making, but the absence of this topic in Nelson and Schiff is telling in that this volume serves as a fairly accurate register of current concerns within contemporary Anglo-American art history.

7. For the most recent and fullest discussion of this figure see Norbert Jopek, *German Sculpture 1430–1540, a Catalogue of the Collection in the Victoria and Albert Museum* (London: V&A Publications, 2002).

8. Werner Gramberg, "Guglielmo della Porta, Coppe Fiamingo und Antonio Gentlii da Faenza: Bemerkungen zu sechs Bronzereliefs mit szenen aus Ovids Metamorphosen im Museum für Kunst und Gewerbe Hamburg," *Jahrbuch der Hamburger Kunstsammlungen* 5 (1960): 31–52.

9. Jennifer Montagu, *Gold, Silver, and Bronze: Metal Sculpture of the Roman Baroque* (London and New Haven: Yale University Press, 1996).

10. Pool's publication is discussed within the context of reproductions of Bossuit's work in "The Ivory Multiplied: Small-Scale Sculpture and Its Reproductions in the Eighteenth Century," in *Sculpture and its Reproductions,* ed. Erich Ranfft and Anthony Hughes (London: Reaktion Books, 1997), 61–78; and in Frits Scholten, "Een ijvore Mars van Francis: de beeldsnijder Van Bossuit en de familie De la Cour." I am currently preparing a fuller study of Pool's book and the circumstances under which it was produced.

11. Jopek, *German Sculpture,* 88–91. Although said here to have been attributed to Riemenschneider at its acquisition in 1864, it was at first described only as "German 16th century," and the association with Riemenschneider made first in 1902.

12. The museum's early concern with process and materials and these particular examples are discussed in Malcolm Baker and Brenda Richardson, eds., *A Grand Design: The Art of the Victoria and Albert Museum* (New York: Abrams, 1997), cat. nos. 18, 32, 35–38.

13. The changing views of the figure's significance and authorship may be tracked through the bibliography cited by Jopek, *German Sculpture,* 91.

14. Ernst Kris, "Notizen zu Adolf Daucher," *Beiträge sur Geschichte der deutschen Kunst* 2 (1928): 433–36.

15. For the significance of these changes within the institution's history see Anthony Burton, *Vision and Accident* (London: V&A Publications, 1997).

16. A separate section for such material is mentioned in the museum's 1914 guidebook, though this figure is not specifically mentioned.

17. For this exhibition and the place of the Saint John figure within it, see Baker and Richardson, *Grand Design,* cat. no. 64.

18. Baxandall, *Limewood Sculptors,* 71–72.

19. Svetlana Alpers, *The Making of Rubens* (London and New Haven: Yale University Press, 1995); Michael Baxandall and Svetlana Alpers, *Tiepolo and the Pictorial Intelligence* (London and New Haven: Yale University Press, 1994).

20. Alfred Gell, "The Technology of Enchantment and the Enchantment of Technology," in *The Art of Anthropology,* ed. Eric Hirsch (London and New Brunswick: Athlone Press, 1999), 159–86.

21. Janet Hoskins, "Why Do Ladies Sing the Blues? Indigo Dying, Cloth Production, and Gender Symbolism in Kodi," in *Cloth and Human Experience,* ed. Annette B. Weiner and Jane Schneide (Washington, D.C.: Smithsonian Institution Press, 1991).

Encountering the Object

Karen Lang

> If there is to be art, if there is to be any aesthetic doing and observing,
> one physiological pre-condition is indispensable: rapture.
>
> —Friedrich Nietzsche

I begin with an image and a scandal. The image is David Seymour's photograph of Bernard Berenson (1865–1959) casting a purportedly disinterested eye on Canova's well-known sculpture of Paolina Borghese as Venus (fig. 1). The scandal, proclaimed on the October 1986 cover of *Connoisseur* magazine, concerns Berenson himself. The caption to the photograph suggests a threat to the estimation of Berenson as "the incorruptible scholar," the connoisseur par excellence, the revered judge of Italian Renaissance art. Turning inside the cover, one discovers the shape of the controversy in the form of Colin Simpson's biography *Artful Partners.*[1] Using dealers' records and other correspondence, Simpson chronicled Berenson's Faustian pact with the American art dealer Joseph Duveen: for a 25 percent cut of the profits, Berenson used his inestimable reputation to certify the authenticity of Italian Renaissance paintings of dubious provenance. The scheme served both sides rather well: Simpson made it clear that Berenson and Duveen became rich while American magnates (the likes of Mrs. Horace E. Dodge, Mr. and Mrs. Henry Huntington, Samuel Kress, and Andrew Mellon), bilked

Fig. 1. David Seymour (American, born Poland, 1911–1956), *Bernard Berenson Looking at Pauline Borghese by Antonio Canova,* 1955. Black-and-white photograph. Published on the cover of *Connoisseur* (October 1986). Courtesy the Getty Research Institute, Los Angeles

of large sums of money, were none the wiser. In fact, according to Berenson and Duveen, these Americans were simply thrilled to be adding painted masterworks to their cultural capital.[2]

The Berenson scandal raises larger questions about art historical practice. Who constitutes the proper aesthetic judge? Is objectivity possible in the history of art? Is there an immanent, unitary truth—or singular meaning—in the work of art, a truth or meaning to be discovered by the connoisseur or the art historian? What about the relation between subject and object? Is the male Bernard gazing at the female Paolina all too typical (of course it is), if not telling?[3] In order to address the conceptual presumptions on which these questions rest, this essay offers a reflection on the basic assumptions and general character of art history. While I acknowledge, following the historian Allan Megill, "that accounts could be offered that yield more complex and historically specific views, reflection of the sort that I attempt here is important because there is a tendency for investigators . . . to miss precisely those features of a situation that are 'natural' to them." Reflecting on the basic assumptions and general character of art history through the figure of the connoisseur and notions of objectivity, "I hope to bring to light what would otherwise remain unexamined prejudice."[4]

Historically speaking, the humanist subject has been perforce male, a reasonable rather than a carnal subject, one distinguished by the eye rather than the hand, by the intellect rather than the senses.[5] The connoisseur is an exemplary humanist subject. Rather than succumb to the rapture of the senses, the connoisseur trains his eye on the decoding of the work of art, offering the "truth" of the image in the form of a correct attribution. To this end, connoisseurship depends on the primacy accorded to authorship in the history of art.[6] Listen to Sydney Freedberg as he describes Bernard Berenson in a 1989 issue of *The New Criterion:* "It was the conjunction in him of the finest, searching sensibility and the most precise weighing, measuring, and referential intelligence that made Berenson so extraordinary. In the history of art, such a conjunction of qualities defines a connoisseur, and *that,* as we have always recognized . . . was the most substantial part of his wide accomplishment, and the most influential."[7]

The connoisseur's exercise of reason—construed as exemplary judgment and objectivity in action—has lent to the history of art a certain scientific respectability. While connoisseurship accords rather well with art historical protocols of objectivity and disciplinarity, it pivots around a single mode of viewing. I want to argue for objectivity as a more complex affair than a Berenson-inspired form of

Sandro Botticelli. Filippino Lippi.

Fig. 2. Illustrations from Giovanni Morelli (Italian, 1816–1891), "Die Galerien Roms: Ein Critischer Versuch von Iwan Lermolieff," *Zeitschrift für bildende Kunst* 9 (1874): 10

connoisseurship would care to admit. In doing so, I will suggest that the lure of the aesthetic object requires two forms of viewing—a simultaneous presence and distance that reverberates around a still point of uncertainty within the subject and the aesthetic object.[8] I write, then, in order to reconceptualize objectivity rather than to disregard it.[9] Writing, as I do, from within the framework of the university (and of the discipline of art history in particular) necessitates the premise of objectivity even as, I would suggest, it begs a critique of the historical uses of this concept.

Berenson learned his technique from the Italian connoisseur Giovanni Morelli (1816–1891). Between 1874 and 1876 Morelli caused a sensation among art historians with a series of critical articles on Italian Old Master paintings in the Borghese gallery. Published in the German art history journal *Zeitschrift für bildende Kunst,* these essays appeared complete with what seemed rather curious illustrations (fig. 2).[10] Since Morelli believed "museums were full of wrongly attributed paintings, including works unsigned, painted over, or in poor condition, it was very hard to distinguish copies from originals."[11] In order to remedy this state of affairs, Morelli proposed an experimental method of scientific connoisseurship for the attribution of Old Master paintings from the same school.[12]

In the introduction to *Italian Painters* (a revised and expanded version of the material presented in his earlier essays), Morelli mounted a defense of his own position as well as a pernicious critique of his detractors, particularly the art historian Wilhelm von Bode, the young yet well-respected director of the Kaiser Friedrich Museum in Berlin.[13] Here the author presented the rudiments of his method in the form of an imaginary dialogue between an elderly Florentine gentleman and a young Russian sightseer. Meeting by chance outside the Pitti Palace, the two begin a conversation that immediately turns toward problems of art history and connoisseurship: The connoisseur, who looks at works of art incessantly,

develops an understanding of art based on the gallery, the elderly gentleman attests; the art historian, by contrast, who studies art from documentary evidence, misses the evidence of his own eyes, the evidence of the pictures themselves. It follows that whereas the connoisseur may develop his understanding of art the more he looks, his understanding, that is to say, of the works of the principal artists in their relation to works by different artists of the same school, all the book learning the art historian undertakes will only result in a general impression of works of art. Underscoring this distinction, the young Russian tells of the dismal pedantry of the European art history professor—an eyewitness account that only serves to strengthen the elderly Florentine's belief in the absolute necessity "for a man to be a connoisseur before he can become an art-historian."[14]

Instead of seeking a general impression, the connoisseur focuses on original pictures in order to ascertain the distinctive and characteristic forms of the artist. According to Morelli, the typical forms of the artist are most characteristic in those areas of a picture where the artist exerts the least conscious control. So rather than attending to, say, composition, color, or gesture, pictorial elements for which training, tradition, or convention will play a considerable role, the connoisseur attends to subjects like drapery, earlobes, or the shape of a hand, elements for which the artist will develop his own conventions more freely. It is important to underline that for Morelli, the typical forms of the artist were not simply external features, as his critics were wont to suggest. Instead, the external forms of the true artist, he wrote, "determined [as they are] by inward conditions," serve as signs of "deeper quality in a work of art."[15] As indications of particular "inward conditions" or character, the typical forms enable the connoisseur to move beyond the general impressions of the art historian.

Morelli's scientific connoisseurship not only accorded primacy to the eye. More strikingly, the effectiveness of his method rested on the connoisseur's long and careful study of authentic works of art. Indeed, the authentic work of art, or its photographic reproduction, was the starting point for Morelli.[16] As Morelli argued more than once, his famous schedules of typical forms—his repertoire of the earlobes, hands, and so forth of Old Master painters—were not intended as ends in themselves. Rather, as he put it, these basic forms "control the judgment which subjective impressions might lead us to pronounce."[17] Transposing these typical "objective" forms of the authentic work of an artist onto works of questionable provenance, the connoisseur could see for himself: either the hand corresponded to "the deeper quality" of a Botticelli—"with bony fingers—not beautiful, but al-

ways full of life"—or it did not.[18] Morelli's focus on seemingly insignificant details rather than on more weighty artistic features like composition or expression served him well in his quest to separate the authentic from the inauthentic, the hand of the master from that of the imitator. The many attributions he made of paintings in the principal Italian and German picture galleries were often revolutionary. To cite just one example, it was Morelli who attributed *The Sleeping Venus* in the Dresden Gallery to Giorgione—a painting hitherto catalogued as a copy by Sassoferrato of a picture by Titian.

Morelli was not alone in devising an interpretative method "based on taking marginal and irrelevant details as revealing clues." Arthur Conan Doyle and Sigmund Freud, Morelli's better-known contemporaries, used similar techniques.[19] The fact that Conan Doyle, Freud, and Morelli were medical doctors goes some way toward explaining their common focus on a medical model of semiotics. More to the point, tracing clues is part of a cultural history. As Carlo Ginzburg puts it: "Toward the end of the nineteenth century (more precisely in the decade 1870–1880), this 'semiotic' approach, a paradigm or model based on the interpretation of clues, had become highly influential in the field of the human sciences." Ginzburg contends that it is not by chance that a paradigm based on the interpretation of clues, itself slowly developing over several centuries, should come together at the end of the nineteenth century. After all, he wrote, this model "coincided with the emergence of an increasingly clear tendency for state power to impose a close-meshed net of control on society."[20] Indeed, the search for larger truths in reputedly incidental details would soon be deployed in the identification of citizens and criminals, processes which would include the use of fingerprints and police photographs.[21]

Medicine became the reference point for all the human sciences, and other conjectural methods, such as psychoanalysis or connoisseurship, became associated with it. Since these approaches relied more on the individual case than on the experimental method of Galilean science, they suffered from a marked decrease in the level of scientific content. Unlike the experimental scientist, who seeks "to measure and to repeat phenomena," the psychoanalyst and the connoisseur generalize from the study of individual cases.[22] Making an interpretative science out of mere conjecture eased this problem, as the freshly minted term "human sciences" lent an air of respectability to these new fields of study. For Ginzburg, Conan Doyle's *Sherlock Holmes* attests to the ways the interpretative methods of psychoanalysis and connoisseurship had caught the fancy of an entire society. Still, if the interpretative method of reading individual details made conjecture more scientific, and

less like divination (its originary impulse), it could never be considered truly sound by the standards of experimental science.

While the connoisseur was not in any danger, then, of being mistaken for an experimental scientist, Morelli's method was nevertheless criticized for being "mechanical, or crudely positivistic," for attempting to make the work of art an object of scientific, experimental method. Despite Morelli's success at reattribution, surely nobody "learns how to be a connoisseur or a diagnostician simply by applying the rules."[23] Certain factors, such as intuition, which cannot be measured quantitatively, play a steady role in making the conjectural leap from trace to attribution, from part to whole. Freedberg intimated as much when he noted the "conjunction of qualities" that comprise Berenson's penetrating mind.[24] In "Elements of Connoisseurship," Berenson himself distinguished between scientific connoisseurship and "the Sense of Quality," a sense that "does not fall under the category of demonstrable things." Listen to Berenson (the emphasis is his own): *The greater the artist, the more weight falls on the question of quality in the consideration of a work attributed to him.*[25] To be sure, the connoisseurship of Morelli and Berenson is more than an exercise in "scientific" classification and attribution. When considered as signs of a deeper, or even a transcendental, quality, the typical forms of an artist express a sense of artistic genius that is *a priori*—an indemonstrable sense of genius that does not exist independently of the work of art but is necessary for the work of art to be what it is.

It is important to note the way Berenson's "sense of quality," like Morelli's belief in the primacy of connoisseurship, emphasizes the work of art and the eye above all else. Here, "in a realm in which the authority of the connoisseur's eye reign's supreme," the work of art "can be fully appreciated and explained without reference to 'external' factors such as patronage or social function."[26] Mapping "the various trends of art history" in 1903, Aby Warburg placed Morelli, Bode, and Berenson together under the category of "enthusiastic art historians." These "hero-worshippers," he rebukes, protect "the peculiar characteristics of their hero either through delimitation or through extension in order to understand him as a logically coherent organism." For Warburg, this "neutrally cool form of estimation happens to be the original form of enthusiasm peculiar to the propertied classes, the collector and his circle."[27]

What Warburg calls the "neutrally cool form of estimation," the disinterest or detachment of the connoisseur, resembles the bearing of the experimental scientist. The connoisseur practices detachment in a double sense. First, he de-

taches the form of the work of art from its content. Second, he searches for inci-
dental forms as clues for attribution. As he dissociates the work of art bit by bit,
so he detaches himself from his experience of it, concentrating, then, not on a sen-
sual or bodily response, but rather on an intellectual response. This rational
detachment—from the aesthetic object itself and of the connoisseur from him-
self—makes connoisseurship "a solid craft."[28] Exercising his so-called "searching
sensibility," and the "weighing" and "measuring" of his "referential intelligence,"
Berenson demonstrates how the visual gives authority. Reason, then, operates in
concert with the visual in order to turn what is seen into an attribution.

Turning on the primacy of the visual, the constitution of the connoisseur's
authority rests on a collection of qualities similar to those required for the authority
of the ethnographer. James Clifford, in 1983, defined those qualities as presence in
front of the object, perceptual ability, "disinterested" perspective, and sincerity.[29]
In order to underscore the primacy of the visual, accounts of the connoisseur are
by and large written in the present tense.[30] Despite its frequent ahistorical—its
synchronic—pretense, connoisseurship is historically determined by the moment
of the connoisseur's encounter with the work of art he is studying.[31] Yet just as the
connoisseur's own body is left out of account, his vantage point on the object is
sufficiently generalized so as to offer a "'totalistic' presentation" of the object he is
describing.[32] Aping the stance of the experimental scientist, the connoisseur uti-
lizes objective and transcendental points of view to decode the work of art.
Acknowledging neither his own historical position nor the provisional nature of
his interpretation, the connoisseur constitutes his authority at the same time as his
written account closes in on itself.

Even as the Berenson scandal reveals the interest at the heart of one con-
noisseur's masquerade of disinterest, it demonstrates the constitution of the
connoisseur's authority. Lest we forget, Berenson made a fortune certifying Italian
Renaissance paintings for his rich American customers. If connoisseurship marks
an achievement of reason over sensual response, then objectivity represents a cor-
responding rhetorical achievement—a device through which to establish the validity
of the connoisseur's account. I have argued that connoisseurship presupposes a
kind of neutral, authoritative view. Although here the visual gives authority, a no-
tion underlined by the present tense of the connoisseur's account, in a seemingly
paradoxical rhetorical move the body of the connoisseur evaporates as the "truth"
content of his account, his attribution, materializes. The move I am suggesting
here involves a shift in perspective: the connoisseur must initially establish his au-

thorial presence, but then "shift to the standpoint of the impersonal agent."[33] As the connoisseur's physical and historical position slides into what Thomas Nagel has felicitously described as "the view from nowhere," the certainty of his attribution renders the object of his consideration, the work of art, into a kind of Baconian fact—an object free from all theory.[34]

This last point is rather wonderfully illustrated in a suite of photographs of Berenson in the Getty archives. These photographs show Berenson at work in the Villa I Tatti, studying photographs of Italian Renaissance paintings sent to him by his American customers.[35] By this point, Berenson's eye had acquired such authority that he no longer needed to be present in front of the original work of art. Putting his name to the photograph, Berenson attests to having "seen" the painting as well as to its correct attribution. Indeed, the signature "Berenson" signifies the historical person and the impersonal agent. Signing the photograph, Berenson registers the move from authorial presence to connoisseurial authority, as his signature, his testament to the authenticity of the painting represented in the photograph, moves the image into the precincts of the "true" and the "factual."

In order to articulate a bit more carefully what I intend by rhetorical objectivity it may be useful to consider the personification of history, *Historia* (fig. 3), from the Hertel edition, 1760, of Cesare Ripa's *Iconologia*. The image of *Historia* is "derived from the classical winged victory, who recorded the victor's deeds on a shield."[36] In this version *Historia* stands on the sure block of truth, composing her account on the wings of Time, who holds his attribute, the sickle, and the serpent ring of eternity. She turns away from the actual experience of events in order to conceive her "objective" description of them. As in Hegel's famous description of the Owl of Minerva, *Historia* records events after they have taken place: This is the point of view that accounts for the events of time and history from a vantage above or beyond these events. An account of history as impassioned perhaps, but as nonetheless objective.

Whether standing in front of the work of art or turning away from an event in order to record it, the connoisseur and the personification of history meet on the register of rhetorical objectivity. More specifically, connoisseurship rests on the overlapping concepts of absolute and procedural objectivity. In his introduction to *Rethinking Objectivity*, Megill noted how absolute and procedural objectivity "work to dispel subjectivity." In this way, absolute and procedural objectivity operate as devices for rendering representation, a written text, commensurate with presence—the presence of the aesthetic object in the connoisseur's account or the presence of the event in the historian's narrative. Absolute objectivity, "the view

CXXII. HISTORIA. 122.

*Discipulis Emahum profectis Christus apparet: Quærenti,
qualis inter eos sermo sit, Cleophas dixit: Tu solus comoraris Hie-
rosolymæ, et non nosti, quæ in ea facta sunt his diebus.*

I. Wangner. Sculps.

Die Geschicht.

Nach Emahus die Jünger gehn
die Frag entsteht, waß kurz geschehn.

Eichler. del. *Hertel. excud.*

Fig. 3. Designed by Gottfried Eichler the Younger (German, 1715–1770), engraved by Jacob Wangner (German, 1708–1781), *Historia*, 1760. Metal engraving, 6 × 9 ⅛ in. (15 × 23 cm). From *Des berühmten italiänischen Ritters Caesaris Ripae* (Augsburg: Johann Georg Hertel, 1758–60). Courtesy the Getty Research Institute, Los Angeles

Fig. 4. Photograph of *Virgin and Child in a Landscape*, 1490–1500, attributed to the School of Giovanni Bellini, bearing Bernard Berenson's signature and certification of the painting as an autograph work by Bellini. National Gallery of Art, Washington, D.C., Gallery Archives

from nowhere," presupposes "universal rational assent."[37] Absolute objectivity implies both the vantage point of the so-called omniscient eye, gazing down on all that transpires, and the point of view of every person—a common standpoint.[38]

The procedural sense of objectivity overlaps rather naturally with absolute objectivity in a shared claim for certainty. Whereas absolute objectivity is located on that imagined frontier where an individual judgment could be deemed universal, procedural objectivity supplies "the view from nowhere" with a set of equally impersonal procedures. Like Morelli's attention to earlobes or fingernails, the rules of procedural objectivity offer a means of standardization. Not surprisingly, procedural objectivity not only effects the standardization of objects; it also "brings with it a standardization of subjects"[39]—subjects who in an absolutely objective guise would be divested of all contours of individuality and historical specificity.

Kenneth Gergen has used the metaphor of the machine to describe the way "the appeal to objectivity" is used "to sustain and fortify the image of human functioning."[40] The image of the mechanical self also relies on the modality of vision: "One writes of the ideal relationship of the knower to the known as that of a mirror to its object, a picture to its subject. When functioning soundly, the mind of the mechanical self is a reliable visual record of the world."[41] Indeed, the ideal mind of the mechanical self is transparent to its object—no longer burdened with the idiosyncrasies of the individual, human mind, the mechanical mind renders the object or picture fully present in the same measure as the individual, human mind is rendered fully absent. Even if we agree that intuition plays a decisive role in the making of an attribution, we may nevertheless note the way intuition is simultaneously acknowledged and superceded in Sydney Freedberg's description of Berenson, for example: Here "the most precise weighing, measuring, and referential intelligence" suggests the manner reason operates to organize and unify perceptual data.

Berenson may have proceeded from the standpoint of absolute objectivity, operating as *if* his vision and his signature garnered absolute authority. Just as Berenson's signature on the photograph of an Italian Renaissance painting (fig. 4) registers the move from authorial presence to authority, so the connoisseur's account closes in on itself around its supposed truth claims—"one is correct in identifying this work as a Giovanni Bellini." In reality, however, a claim for absolute objectivity can never be made by a single individual. Adopting the viewpoint of the "omniscient eye" would require one to be subject and object of thought, to think and reflect simultaneously along a line of infinite regress. To put this another way, adopting the standpoint of the omniscient eye would require one think a thought, to make that thought into

an object on one's reflection, and so on, *ad infinitum*. Rather than the workings of an omniscient eye, the Berenson scandal demonstrates the ways objectivity is a process of knowledge production carried out by individuals as well as institutions.[42]

Connoisseurship may be insistent on a neutral, authoritative view, and yet, as David Seymour's photograph of Berenson makes clear, vision is always the view of someone from somewhere. To acknowledge our presence, to admit of a view from somewhere, is to raise the question of how the objects of our accounts are produced. Admitting of a view from somewhere opens up the connoisseur's truth claims to interpretation, as it invites us to take full measure of the fact that subjectivity is always a part of the objectivity paradigm. Indeed, "subjectivity is indispensable to the constituting of objects."[43] In closing, I would like to argue for a dialectical sense of objectivity. As I hope will become clear in what follows, dialectical objectivity is particularly apposite for the history of art.

In order to define what I intend by dialectical objectivity it may be helpful to consider Eric Fischl's painting of 1982, *The Sheer Weight of History* (fig. 5). Fischl sets our understanding off balance with a powerful re-description. Here time has flown away, leaving Historia—rendered as the famous sculpture of the sleeping hermaphrodite in the Uffizi Gallery—to fall face down on her block of truth. Although it might be argued that the sleeping hermaphrodite is not a version of *Historia,* for Fischl an aspect of the sheer weight of history is the art of the past: Pierre Bonnard's lush painting of 1900, *Siesta,* also uses the sculpture of the sleeping hermaphrodite as its point of departure.[44] Nevertheless, as Holland Cotter rightly noted, Fischl's relationship to art historical models is "cannily ambivalent."[45] At the same time as he deeply respects art history, Fischl brings his models up to date. Looking neither back to the past, which makes a symbolic appearance in *The Sheer Weight of History* in the form of portrait busts of Roman senators on the wall, nor toward the future, Historia as we encounter her on Fischl's canvas has lost her rational pursuit. If *Historia* of 1760 lends credence to the possibility of possessing the past in chronicle or narrative form, then Fischl, in my view, intimates the cultural and historiographical shifts that have transformed our relation to the past, and, along with them, our belief in an ability to contain and convey the past in a unitary form. *The Sheer Weight of History* underlines the condition of history as one of dispossession; at the same time, the painting powerfully demonstrates how modes of visual rhetoric and subjective investment seek to negotiate this condition.

Fischl makes note of the ways memory serves to bring the past to light. At the same time, he shows why, in spite of the most vigorous efforts of the histo-

Fig. 5. Eric Fischl (American, born 1948), *The Sheer Weight of History,* 1982. Oil on canvas, 60 × 60 in. (152 × 152 cm). The Downe Collection, New York

rian, the past remains forever lost to us in its plenitude. Like the small boy underneath the marble hermaphrodite who sucks his thumb in the absence of his mother's breast, we inhabit the rooms of history, dreaming of full possession as we write narratives that can only serve as substitutes—as parts for the whole. Resting on the block of truth, *Historia* indicates the possibility of the past through possession, a continuous flow of history that partakes of a unitary meaning—a "truth" of the past. Rendering history as the sleeping hermaphrodite, Fischl points to the possibility of rupture at the heart of subjectivity and objectivity, just as he indi-

cates our desire to repair this disruption. If *Historia* invokes the possibility of standing aside from events in order to record them "objectively," Fischl demonstrates our participation in a past we strive to order, collect, or otherwise represent.

The Sheer Weight of History registers the interdependency of objectivity and subjectivity. From the portrait busts carefully aligned on the wall to the small boy sucking his thumb underneath the marble hermaphrodite, Fischl holds together seeing and reflecting in a powerful image. The dynamic tension between the standpoint of someone, the artist, the boy, the viewer, and the sheer weight of a history rendered from the standpoint of no one in particular renders the canvas into a force field where objectivity and subjectivity collide and repel. Holding together subjectivity and objectivity, Fischl demonstrates, as did Wittgenstein, that there is no such thing as a private language. Just as the impossibility for an individual to achieve the "omniscient eye" demonstrates the fallacy of absolute objectivity, so the impossibility for a private language bares the ruse of a notion of absolute subjectivity. Similarly, even though the connoisseur may provide a painting with a correct attribution, the work of the art historian, who labors on behalf of interpretation, indicates the inability to provide the painting with an ultimate meaning. Morelli and Berenson may have tried to make a science out of art, yet art history trades in aesthetic objects, objects for which the truth claims of any interpretation nestle around a still point of uncertainty.

A dialectical sense of objectivity not only presumes the interdependency of objectivity and subjectivity, it also turns on two modes of viewing, a relay of presence and distance that is particularly appropriate for aesthetic objects. Aby Warburg remarked in a notebook of 1928: "The creation and the enjoyment of art demand the viable fusion between two psychological attitudes which are normally mutually exclusive. A passionate surrender of the self leading to a complete identification with the present—and a cool and detached serenity which belongs to the categorizing contemplation of things. The destiny of the artist can really be found at an equal distance between the chaos of suffering excitement and the balancing evaluation of the aesthetic attitude."[46] Warburg was not alone in recognizing that art required two modes of viewing. Nietzsche understood this before him, as did Wind in the 1920s.[47]

Most recently, J. Hillis Miller has discussed this idea in relation to literature. The aporia of literature, he explains, requires that one negotiate, or hold in tension, two modes of reading: reading *allegro* and reading *lente*. This directly relates to the viewing of works of art, which require the engagement and suspension of disbelief of reading *allegro*, and the critical, cognitive engagement of reading

lente. In accord with Nietzsche's understanding of aesthetic observation, reading *allegro* turns on rapture, a condition Hillis Miller wonderfully describes as "being forcibly drawn out of oneself into another realm"—a realm one might call the space of the aesthetic.[48] If art, like literature, requires that one hold in tension two modes of viewing, then it is art history that renders aesthetic space into a realm of cool idols—a disciplinary field in which the work of art is simultaneously revered and denatured through classification and modes of objectivity.

The point I should like to underline is not that connoisseurship or the intellect is the enemy of art, for one certainly experiences a work of art more fully when the mind can help guide the eye. Rather, the point is that art requires engagement. By focusing on an intellectual response, art history has denatured the work of art and our response to it. If we would believe Edgar Wind, then we would note how our discipline has made us all "something like unconscious Morellians."[49] Arguing for a dialectical sense of objectivity, I do not intend a reversal of the subject/object binary. I do not intend the revival of the personal voice or the marking of aspects of identity after their evacuation in art history's "objective" narratives, though I believe that opening up art history to a range of subjectivities and identity politics is important for several reasons, not least of which is the way this opening up places continuous pressure on the belief that a system of signification can represent an object or a person in its full presence.[50] Rather, I wish to underline the still point of uncertainty that lies at the heart of our endeavor. This creates, or is part of, the lure of the object—it is part of what drives us to know the object, or ourselves, though ultimately we cannot.

The still point of uncertainty in the image reminds me of why, at the end of the eighteenth century, Kant characterized the work of art as "purposive without a purpose." By purposive, he meant the way the aesthetic object displayed "a unified form in itself and in its structure," which was necessary in order for us to be able to perceive it as an object. By purpose, he meant an "external determination." "A purposive creation has its center of gravity in itself; one that is goal-oriented has its center of gravity external to itself; the worth of the one resides in its being, that of the other in its results."[51] As "purposive without a purpose," the work of art is equated with morality in Kant's philosophy. Like the human being, the work of art is not a means to an end, but an end in itself. Despite the ways the work of art may be pressed into service—in the connoisseur's account, in the art historian's narrative, or in consumer culture or advertising—in this view, the aesthetic object remains a stubbornly ethical presence in the age of global capitalism.

1. Colin Simpson, *Artful Partners: Bernard Berenson and Joseph Duveen* (New York: Macmillan, 1986). See also the appendix to Meryle Secrest, *Being Bernard Berenson* (New York: Holt, Rinehart and Winston, 1979), which lists instances when Berenson changed his mind about an attribution, reputedly for monetary gain. Claiming Simpson's and Secrest's ignorance of art history, Sydney Freedberg, in his essay "Berenson, Connoisseurship, and the History of Art," *The New Criterion* 7, no. 6 (Feb. 1989): 7–16, is quick to defend Berenson's *bona fides*. Freedberg's research into the evidence listed in Secrest's appendix disputes her claims, thus confirming for him "both the quality" of Berenson's connoisseurship "and the morality with which he practiced it" (14). Sir John Pope-Hennessy also marshaled the considerable weight of his academic credentials against Simpson's claims in "Berenson's Certificate," *New York Review of Books* (12 Mar. 1987): 19–20. On Berenson's relation to contemporary art and art history, see Mary Ann Calo, *Bernard Berenson and the Twentieth Century* (Philadelphia: Temple University Press, 1994).

2. On the use, publicity, and reception of "scientific" connoisseurship in America see Flaminia Gennari Santori, *The Melancholy of Masterpieces: Old Master Paintings in America 1900–1914* (Milan: 5 Continents Editions, 2003).

3. Feminists have actively challenged objectification and the objectivity paradigm. See, for instance, in order of appearance: Evelyn Fox Keller, *Reflections on Gender and Science* (New Haven: Yale University Press, 1985); Susan Robin Suleiman, ed., *The Female Body in Western Culture: Contemporary Perspectives* (Cambridge: Harvard University Press, 1985); Sandra Harding, *The Science Question in Feminism* (Ithaca: Cornell University Press, 1986); Susan Bordo, *The Flight to Objectivity* (Albany: State University of New York Press, 1987); Teresa de Lauretis, *Technologies of Gender* (Bloomington: University of Indiana Press, 1987); Mary Ann Doane, *The Desire to Desire* (Bloomington: University of Indiana Press, 1987); Catherine MacKinnon, *Feminism Unmodified* (Cambridge: Harvard University Press, 1987); Robin Schott, *Cognition and Eros: A Critique of the Kantian Paradigm* (Boston: Beacon Press, 1988); Griselda Pollock, *Vision & Difference: Femininity, Feminism and the Histories of Art* (London: Routledge, 1988); Mary Hawkesworth, "Knowers, Knowing, Known: Feminist Theory and Claims of Truth," *Signs* 14 (1989): 533–57; Alison Jaggar and Susan Bordo, eds., *Gender/Body/Knowledge* (New Brunswick: Rutgers University Press, 1989); Janet Wolff, "Reinstating Corporeality: Feminism and Body Politics," in *Feminine Sentences: Essays on Women and Culture* (Berkeley: University of California Press, 1990), 120–41; Mary Hawkesworth, "From Objectivity to Objectification: Feminist Objections," in *Rethinking Objectivity*, ed. Allan Megill (Durham, N.C.: Duke University Press, 1994), 151–77.

4. Allan Megill, "'Grand Narrative' and the Discipline of History," in *A New Philosophy of History*, ed. Frank Ankersmit and Hans Kellner (London: Reaktion Books, 1995), 152. Megill's scholarship has sharpened my understanding of the conceptual presumptions on which art history rests, as well as of the ways notions of objectivity define and shape the field of art history.

5. Consider the words of the anthropologist Johannes Fabian ("Ethnographic Objectivity Revisited," in Megill, ed., *Rethinking Objectivity*, 99): "Vision requires distance from its objects; the eye maintains its 'purity' as long as it is not in close contact with 'foreign objects.' Visualism, by instituting distance as that which enables us to know, and purity or immateriality as that which characterizes true knowledge, aimed to remove all the other senses and thereby the body from knowledge production (this, incidentally, is also a context in which the gender question needs to be raised). Visualism, nonetheless, needed some kind of materialization which it found in signs, symbols, and representation."

6. On authorship in art history, see Catherine Soussloff, *The Absolute Artist: The Historiography of a Concept* (Minneapolis: University of Minnesota Press, 1997).

7. Freedberg, "Berenson," 9.

8. The phrase "still point of uncertainty" comes from Linda Orr. In her book *Headless History: Nineteenth-Century French Historiography of the Revolution* (Ithaca: Cornell University Press, 1990), 160, she admonishes every writer to "leave a space to show how undefinable and traumatic her or his objects of study are, before rushing to explain them. Every work of history needs a moment of uncertainty, a moment given over to disarray, or rather, the still point of uncertainty." See also her essay "Intimate Images: Subjectivity and History—Staël, Michelet and Tocqueville," in Ankersmit and Kellner, eds., *A New Philosophy of History*, 89–107.

9. Cf. James Ackerman, "Two Styles: A Challenge to Higher Education," *Daedalus* 98, no. 3 (summer 1969): 855–69; Megill, ed., *Rethinking Objectivity*; Wolfgang Natter, Theodore Schatzki, and John Paul Jones III, eds., *Objectivity and Its Other* (New York: The Guilford Press, 1995); Wolfgang Iser, *The Act of Reading: A Theory of Aesthetic Response* (Baltimore: Johns Hopkins University Press, 1978); Richard Bernstein, *Beyond Objectivism and Relativism: Science, Hermeneutics, and Praxis* (Philadelphia: University of Pennsylvania Press, 1983); and Richard Rorty, *Objectivity, Relativism, and Truth* (Cambridge: Cambridge University Press, 1991).

10. These articles were published under the pseudonym of an unknown Russian scholar, Ivan Lermolieff, and an unknown German translator, Johannes Schwarze, both plays on Morelli's name. Morelli did not reveal his identity as the author of these essays until several years later. See Giacomo Agosti, "Giovanni Morelli in Galleria Borghese: Un Tentativo di Lettura di un Saggio Critico di Ivan Lermolieff," in *La Figura e l'Opera di Giovanni Morelli: Studi e Ricerche,* ed. Hans Ebert, Donata Levi, and Giacomo Agosti (Bergamo: Biblioteca Civica Angelo Mai, 1987), 55–108. An expanded version of these articles was included in *Kunstkritische Studien über italienische Malerei: die Galerien Borghese und Doria Panfili in Rom* (Leipzig: F. A. Brockhaus, 1890). Morelli's *Kunstkritische Studien über italienische Malerei: Die Galerien zu München und Dresden* was published by the same firm in 1891. These books, translated into English by Constance Ffoulkes, appeared in two volumes in 1892–93 as Giovanni Morelli, *Italian Painters: Critical Studies of their Works* (London: John Murray). For Berenson's application and extension of Morelli's method, see his "Rudiments of Connoisseurship," which was

written in the 1890s but not published until 1902 (London: G. Bell and Sons) in *The Study and Criticism of Italian Art,* second series; as well as his *Three Essays on Method* (Oxford: Clarendon Press, 1927). Exposing the mythology surrounding the Morellian method through careful research, especially the mythology of the coherence and primacy of his method of attribution, Carol Gibson-Wood, *Studies in the Theory of Connoisseurship from Vasari to Morelli* (New York: Garland, 1988), 239–40, demonstrates that it "could also be said that Berenson systematized into a pseudoscientific rigidity ideas which Morelli had rather wisely left unanalyzed."

11. Carlo Ginzburg, "Clues: Morelli, Freud and Sherlock Holmes," in *The Sign of Three: Dupin, Holmes, Pierce,* ed. Umberto Eco and Thomas Sebeok (Bloomington: Indiana University Press, 1988), 81.

12. On Morelli's method, see Carol Gibson-Wood, *Studies in the Theory of Connoisseurship,* 222–37; Margherita Ginoulhiac, "Giovanni Morelli: La vita, l'opera, il methodo critico," *Bergomum* 18 (1940): 51–74; Max Friedländer, *On Art and Connoisseurship,* trans. Tancred Borenius [1942] (Boston: Beacon Press, 1960), 163–171; John Pope-Hennessy, "Connoisseurship," in *The Study and Criticism of Italian Sculpture* (New York: Metropolitan Museum of Art, 1980), 11–38; and Edgar Wind, *Art and Anarchy* [1963] (Evanston: Northwestern University Press, 1985), 30–46. Recent critiques of the assumptions of the Morellian method include Hayden B. J. Maginnis, "The Role of Perceptual Learning in Connoisseurship: Morelli, Berenson, and Beyond," *Art History* 13 (Mar. 1990): 104–17; and Richard Wollheim, "Giovanni Morelli and the Origins of Scientific Connoisseurship," in *On Art and the Mind* (Cambridge: Harvard University Press, 1974), 177–201. Maginnis argues that "scientific connoisseurship" is a misleading term, especially since Morelli and Berenson's theories were predicated on an empiricist, picture model of vision and memory that cannot be squared with what we now know about the structure of the eye and its functioning.

13. "The view that certain skills and characteristics are necessarily associated with nationality is a theme that permeates Morelli's ideas about both art and art criticism. . . . Morelli regarded the inability to recognize authorship in paintings as a typically Germanic deficiency" (Gibson-Wood, *Studies in the Theory of Connoisseurship,* 191). Wilhelm von Bode admitted of the "Lermolieff mania," yet nevertheless called Morelli a "quack doctor" who "extolled his method with an air of infallibility" (cited in A. H. Layard's introduction to Morelli's *Italian Painters,* 3, 20). For Bode's estimation of Morelli, see his article, "The Berlin Renaissance Museum," *Fortnightly Review* 50 (1891): 506–15; and Manfred Ohlsen, *Wilhelm von Bode: Zwischen Kaisermacht und Kunsttempel* (Berlin: Gebr. Mann, 1995), chap. 5, "Freuden und Leiden," 103–31. On Morelli's opinion of Bode, see his thinly veiled comments in "Principles and Method," *Italian Painters,* 1–63; and extracts from the Morelli-Layard correspondence in Carol Gibson-Wood, *Studies in the Theory of Connoisseurship,* appendix 5, 277–87. On the particular scorn with which Berenson cast German art history, see his *Caravaggio: His Incongruity and His Fame* (London: Chapman and Hall, 1953), 86–87.

14. Morelli, *Italian Painters,* 15. On Morelli's views of art history versus connoisseurship, as well as

on the neglected history of his own aim to develop an "organic" history of Italian painting, see Gibson-Wood, *Studies in the Theory of Connoisseurship,* 219–37ff. Incidentally, Berenson, like Morelli, "was averse to the study of art history, which he regarded as . . . unrelated or inimical to the enjoyment of art" (David Alan Brown, *Berenson and the Connoisseurship of Italian Painting,* exh. cat., National Gallery of Art [Washington, D.C.: National Gallery of Art, 1979], 11).

15. Morelli, *Italian Painters,* 44–45. Richard Neer draws out the semiotic nature of connoisseurship in his essay, "Beazley and the Language of Connoisseurship," *Hephaistos* (1997): 7–30.

16. "As the botanist lives among his fresh or dried plants, the mineralogist among his stones, the geologist among his fossils, so the art-connoisseur ought to live among his photographs and, if his finances permit, among his pictures and statues" (Morelli, *Italian Painters,* 11). On the apparent contradiction between Morelli's stress on the importance of viewing works of art and his own decision to publish his views on art in a book, see Gibson-Wood, *Studies in the Theory of Connoisseurship,* 199–200.

17. Layard, "Introduction," 32.

18. Morelli, *Italian Painters,* 35.

19. Freud notes the similarities between the Morellian method and psychoanalysis in his 1914 essay, "The Moses of Michelangelo." See Jack Spector, "The Method of Morelli and Its Relation to Freudian Psychoanalysis," *Diogenes* 66 (1969): 63–83.

20. Ginzburg, "Clues," 86, 88, and 104.

21. Cf. Michel Foucault, *Discipline and Punish,* trans. Alan Sheridan (New York: Vintage, 1979); and Allan Sekula, "The Body and the Archive," *October* 39 (winter 1986): 3–63.

22. Ginzburg, "Clues," 92.

23. Ibid., 110.

24. Berenson acknowledged the role of intuition in connoisseurship. Witness his description under oath in 1929: "When I see a picture, in most cases I recognize it at once as being or not being by the master it is ascribed to; the rest is merely a question of how to try to fish out the evidence that will make the conviction as plain to others as it is to me." Cited in Harry Hahn, *The Rape of La Belle* (Kansas City, Mo.: Frank Glenn Publishing Company, 1946), 103; quoted in Gary Schwartz, "Connoisssership: The Penalty of Ahistoricism," *Artibus et Historiae* 18 (1988): 202.

25. Berenson, "Rudiments of Connoisseurship," 147–48. See also Henri Zerner, "Giovanni Morelli et la science de l'art," *Revue de l'art* 40–41 (1978): 209–15, who, *pace* Berenson, shows how Morelli was interested in the question of quality.

26. Gibson-Wood, *Studies in the Theory of Connoisseurship,* 247.

27. Cited in Ernst Gombrich, *Aby Warburg: An Intellectual Biography* [1970] (Chicago: University of Chicago Press, 1986), 143. See also Meyer Schapiro, "Mr. Berenson's Values," *Encounter* 16 (Jan. 1961): 57–65.

28. Edgar Wind, *Art and Anarchy*, 31. Wind even makes bold to suggest: "Whether you take Wölfflin, or Riegl and the Vienna School, or Roger Fry and Clive Bell, or Bernard Berenson, they methodically developed an exquisite skill in skimming off the top of a work of art without necessarily making contact with its imaginative forces, often even shunning that contact because it might disturb the lucid application of a fastidious technique" (23–24).

29. James Clifford, "On Ethnographic Authority," *Representations* 1, no. 2 (1983): 118–46; reprinted in his book *Twentieth-Century Ethnography, Literature and Art* (Cambridge, Mass.: Harvard University Press, 1988), 21–54. On the critique of ethnographic authority see, in addition to Clifford, Michel de Certeau, "Writing vs. Time: History and Anthropology in the Works of Lafitau," *Yale French Studies* 59 (1980): 37–64; Edward Said, *Orientalism* (New York: Pantheon, 1978); and George Stocking, ed., *Observers Observed: Essays on Ethnographic Fieldwork* (Madison: University of Wisconsin Press, 1983). See also Hal Foster, "The Artist as Ethnographer," in his *The Return of the Real: The Avant-Garde at the End of the Century* (Cambridge, Mass.: MIT Press, 1996), 170–203, which persuasively demonstrates how "the recent *self-critique* of anthropology . . . promises a reflexivity of the ethnographer at the center even as it preserves a romanticism of the other at the margins" (182). As Foster points out, this romanticism of the other has implications for the ethnographic turn in contemporary art since "the quasi-anthropological role set up for the artist can promote a presuming as much as a questioning of ethnographic authority, an evasion as often as an extension of institutional critique" (197).

30. Vincent Crapazano aptly describes the present tense as "a tenseless tense, if you will, which serves at once to give a feeling of time's flow and to permit generalizations." Vincent Crapazano, "Hermes Dilemma: The Masking of Subversion in Ethnographic Description," in *Writing Culture: The Poetics and Politics of Ethnography*, ed. James Clifford and George Marcus (Berkeley: University of California Press, 1986), 65

31. I am very closely paraphrasing Crapanzano (ibid., 51): "Despite its frequent ahistorical—its synchronic—pretense, ethnography is historically determined by the moment of the ethnographer's encounter with whomever he is studying."

32. "His is a roving perspective, necessitated by his 'totalistic presentation of the events he is describing. His presence does not alter the way things happen or, for that matter, the way they are observed or interpreted. He assumes an invisibility that, unlike Hermes, a god, he cannot, of course, have." (ibid., 53). Kenneth Gergen indicates how the use of elaborate detail produces a similar effect: "By furnishing minute detail, much of it irrelevant to the author's conclusions, the author demonstrates that observation is unbiased. In Freud's terms, the observer has properly demonstrated 'evenly hovering attention.'" (Kenneth Gergen, "The Mechanical Self and the Rhetoric of Objectivity," in Megill, ed., *Rethinking Objectivity*, 277). On apersectival objectivity, see also Lorraine Daston, "Objectivity and the Escape from Perspective," *Social Studies of Science* 22, no. 4 (Nov. 1992): 597–618; and Lorraine Daston and Peter Galison, "The Image of Objectivity," *Representations* 40 (fall 1992): 81–128.

33. Gergen, "The Mechanical Self," 280.

34. On the view from nowhere see Thomas Nagel, *The View from Nowhere* (New York: Oxford University Press, 1986); and Karl Popper, *Objective Knowledge: An Evolutionary Approach* (Oxford: Clarendon Press, 1972). On Baconian facts see Lorraine Daston, "Baconian Facts, Academic Civility, and the Prehistory of Objectivity," in Megill, ed., *Rethinking Objectivity,* 37–63; and, in a related vein, Peter Dear, "From Truth to Disinterestedness in the Seventeenth Century," *Social Studies of Science* 22, no. 4 (Nov. 1992): 619–31.

35. As Sydney Freedberg ("Berenson," 8) rightly remarks, the Villa I Tatti, the connoisseur's Italian home, "was meant, from a relatively early time in Berenson's career, to be a monument to himself and what he had accomplished. And, like most monuments, it was meant at the very same time to perpetuate *and* to supplant the actuality it recalled."

36. James Hall, *Dictionary of Substitutions and Symbols in Art* (London: John Murray, 1974), 154.

37. Megill, "Introduction: Four Senses of Objectivity," in *Rethinking Objectivity,* 2.

38. Cf. Evelyn Fox Keller, "The Paradox of Scientific Subjectivity," in Megill, ed., *Rethinking Objectivity,* 313–31.

39. Megill, "Introduction," 11.

40. Gergen, "The Mechanical Self," 266.

41. Ibid., 277.

42. On objectivity as a process of knowledge production, see Johannes Fabian, "Ethnographic Objectivity Revisited: From Rigor to Vigor," in Megill, ed., *Rethinking Objectivity,* 81–108; as well as his important early essay, "History, Language and Anthropology," *Philosophy of the Social Sciences* 1, (1971): 19–47.

43. Megill, "Introduction," 8.

44. Fischl responds to Bonnard's painting in an interview with Robert Enright, "Core Intimacies. Eric Fischl on the Art of Pierre Bonnard," *BorderCrossings* 17, no. 3 (1998): 56–61. Listen to Fischl: "Part of the problem is that artists of my generation were not educated. . . . Paying too much attention to history would just clog your mind, make you imitative instead of avant-garde. In fact it's incredibly disrespectful of the importance of history that we train people to be amateurs. I deeply resent the kind of flattery that replaced discipline. . . . Based on personal experience, I would say that there is a difference between painting and art. There are moments when you're looking at a work that is hundreds of years old and it's talking to you. You feel connected to the artist; he is transmitting a kind of truth, and it works today the way it worked then." Eric Fischl in an interview with Frederic Tuten, "Fischl's Italian Hours," *Art in America* (Nov. 1996): 79, 82. On "the weight of modernist discourse," Fischl "had to shrug off when he attempted to join the tradition of narrative realism" in painting; see Arthur Danto, "Formation, Success, and Mastery: Eric Fischl through Three Decades," in *Eric Fischl, 1970–2000* (New York: Monacelli Press, 2000), 11–24. (This quote is on pp. 15–16.)

45. Holland Cotter, "Postmodern Tourist," *Art in America* (Apr. 1991): 154. For Cotter (183), "Fischl might well become what one always suspected he could be: the painter of history whom we had long ago resigned ourselves to be doing without."

46. Warburg, *Handelskammer,* Notebook, 1928, 44. Cited in Gombrich, *Aby Warburg,* 253.

47. More recently see also Charles Taylor, "Understanding and Explanation in the *Geisteswissenschaften,*" in *Wittgenstein: To Follow a Rule,* ed. Steven Holtzman and Christopher Leich (London: Routledge & Kegan Paul, 1981), 191–210; and in a related vein, Giorgio Agamben, *The Man without Content* (Stanford: Stanford University Press, 1999).

48. J. Hillis Miller, *On Literature* (London: Routledge, 2002), 29. Using the term "the space of the aesthetic," I am following Marice Blanchot's conception of literature. See Marice Blanchot, *The Space of Literature* [1955], trans. Ann Smock (Lincoln: University of Nebraska Press, 1982), as well as *The Book to Come* [1959], trans. Charlotte Mandell (Stanford: Stanford University Press, 2003), especially chapter one, "Encountering the Imaginary," on Odysseus's encounter with the Sirens.

49. Wind, *Art and Anarchy,* 32.

50. On the latter, see the powerful essay by Cornel West, "The New Cultural Politics of Difference," in *Out There: Marginalization and Contemporary Culture,* ed. Russell Ferguson, Martha Gever, Trinh Minh-ha, and Cornel West (Cambridge: MIT Press, 1990), 19–36.

51. Ernst Cassirer, *Kant's Life and Thought,* trans. James Haden (1918; reprint, New Haven: Yale University Press, 1981), 312, 325.

The Object as Subject

Ewa Lajer-Burcharth

A few cooking utensils sit quietly on a stone ledge amid some raw ingredients for a simple meal (fig. 1). A shiny copper pan with a ladle stuck under the handle of its lid and a white glazed pitcher are at the core of this seemingly random arrangement, *with* the smaller objects—a mortar and a pestle, a pepper mill, and a blue-green casserole with a handle jutting forward into view—distributed around them in a harmoniously haphazard way. The vessels create a barely discernible rhythm of vertical forms. A knife, a piece of raw meat, a plucked chicken, some kidneys or gizzards, an onion, and a swag of white cloth are balanced on the very edge of the table to secure the illusion of depth—the sense of the objects emerging from within a space rather than simply appearing on the surface of the canvas—but, in their downward pull, they also provide a subtle planar effect of counterbalance to the upward verticals of the kitchenwares.

Featuring recognizable everyday objects rendered with an unassuming accuracy—no showiness, no feats of illusion, yet the object's presence unaccountably secured—Chardin's *Kitchen Table,* now at the Museum of Fine Arts, Boston, may be seen as the epitome of the painter's uncanny skills. It was Chardin's fidelity to the object, the unforced harmony of his composition, and the ease of his delivery—the legendary magic of his touch—that most impressed his contemporaries. In his *Dialogues sur les arts,* published in 1756, the critic and theorist Pierre Estève presented Chardin as "the most exact and true painter there is of the French school," able to capture "the most truthful nuances of the objects [bodies] with admirable accuracy."[1] Commenting on Chardin's still lifes exhibited at the Salon of 1763, Diderot exclaimed: "Oh Chardin! The colors crushed on your palette are not white, red or black pigment; they are the very substance of the objects. They are the air and the light that you take up with the tip of your brush and apply to the canvas."[2] Others, too, shared this high appreciation of Chardin's imitative gift, especially his superior use of color: "His eyes seemed to be like prisms capable of breaking down each object into its component tones, distinguishing the subtlest of transitions between light and shade," wrote the painter Renou in his eulogy of the artist.[3]

Immersed in the very materiality of the object, faithful to its physical makeup to the degree that produced the effect of confusion between the substance

Fig. 1. Jean-Siméon Chardin (French, 1699–1779), *The Kitchen Table*, c. 1755. Oil on canvas, 15 ⅝ × 18 ¾ in. (39.7 × 47.6 cm). Museum of Fine Arts, Boston. Gift of Mrs. Peter Chardon Brooks

of the thing and its image, capable of perceptual deconstruction and recomposition of the object on canvas through a magic use of color—these descriptions of the painter's method imply a peculiar, evidently unconventional intimacy with the painted object. Conveyed in these commentaries is the assumption that such a close engagement with the object amounted to a quasi-effortless mastery over it.

Yet, this mastery was not as easily achieved as these appraisals may seem to suggest. It is enough to take a closer look at the surface of the canvas of the Boston *Kitchen Table* to get a sense of the amount of effort apparently needed by the painter to get things right: for example, the mortar on the extreme right stands surrounded by a halo of pentimenti that indicates the ghostly presence of the objects originally painted in its place. The X-ray of the painting confirms this, revealing a bowl-shaped vessel and a standing dish to have been where the mortar is now,

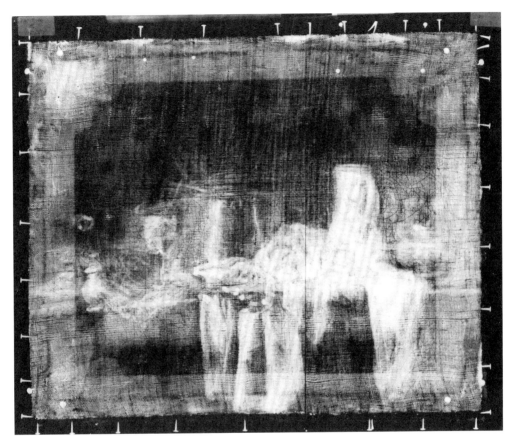

Fig. 2. X-radiograph of fig. 1

and further making visible a whole geography of doubt about the placement and choice of almost all other objects. (fig. 2) Thus the meat was originally placed on the piece of cloth at the very center of the image, while the now-central copper pot stood on the side, approximately where the meat is now. Both the mortar and the pepper mill had been to the left of their present locations. Other elements, such as the handle of the casserole, the lid of the pot, and the ladle were also placed differently. We see here the artist changing his mind quite considerably before settling on the final result, his extensive changes in the design necessitating substantial repainting. (The network of shrinking cracks around the objects that you can see on the canvas with a naked eye is due to Chardin's method of painting in layers without waiting for the paint to dry completely—an aspect that, too, may be linked to the unusually long time it took the artist to produce the image.)[4] The unforced

harmony of composition, with its casual organization of the objects, was, then, a result of a great deal of elaboration through trial and error.

Though making changes in the process of painting was common enough practice in the eighteenth century, such an extent of internal reorganization of the canvas was unusual. It is more surprising that our painting is not an example of the artist's early work, when the artist may be expected to rehearse different solutions. *The Kitchen Table* was painted about 1755, when Chardin was fifty-six and at the peak of his artistic capacities. Nor was the set of objects represented here by any means new to the painter. On the contrary, the key elements—the copper pot, the mortar, the blue-green casserole with a jutting handle—had appeared before in many of his paintings. They belonged to the artist—as both his props and his property[5]—and were featured in numerous paintings, some of them compositionally close to the Boston picture.[6] Like a proto-minimalist, Chardin works in series with variations, recycling elements from earlier pictures. One would expect him to have the art of composition at his fingertips. Yet, as the X-ray indicates, it proved to be a challenge.

How does such a glimpse behind the curtains of representation affect our perception of the image? More generally, how is the process of making, when we know anything about it, to figure in our account of its end result, the painted image? In the case in point, what do we make of so much hesitation in the artist's search for the final solution? Since it cannot be blamed on the artist's inexperience, it must be recognized as inherent in his approach to the task of painting—specifically the painting of still life—though it stands in some contrast to those flattering assessments of Chardin's craft that focused on his natural painterly ease and knack for deception. It is not that such extensive repaintings may simply be taken, as they have been, to indicate "the care Chardin took in arranging his composition."[7] Rather, they indicate that behind the material mastery of illusion, behind Chardin's uncanny capacity to render the "truth of the object," there may be a somewhat more complicated story, a more difficult negotiation.

This difficulty, it must be said, did not go unnoticed by Chardin's contemporaries. Thus Pierre-Jean Mariette, one of the very few eighteenth-century commentators who remained unseduced by Chardin's art, offered an unkind but interesting assessment of the painter's craft:

> One cannot deny that the paintings of Monsieur Chardin reveal too
> much fatigue and effort. His touch is heavy and undifferentiated. There
> is nothing easy about his brush; he expresses everything in the same

way, with *a kind of indecision* that renders his work too cold.... Lacking
a sufficient knowledge of drawing and unable to make his studies and
preparatory sketches on paper, Monsieur Chardin is obliged to have
the object he seeks to imitate continuously in front of him, from the
very first touch of his brush on canvas to its very last, which takes a
long time and would put off anyone other than him. Therefore, he al-
ways talks about how his work *costs him infinitely*. While he would like
to hide it, his work signals it against his will.[8]

The eager hostility of this assessment warrants some caution about its ac-
curacy. Yet, the theme of pictorial indecision that Mariette stressed accords well with
the material evidence of Chardin's doubts offered by his painting. Moreover, the
painter's excessive dependency on the object that Mariette suggested appeared also
in other testimonies from the period, such as that of Chardin's friend and supporter
Charles-Nicolas Cochin, though he gave it a more sympathetic spin. Rather than a
result of poor training or a lack of imagination, Cochin suggested perfectionism as
the reason for Chardin's difficulty of delivery. The painter's slowness and wavering
was, in Cochin's view, due to his "cruel severity in chastising himself, which is nat-
ural for an educated man who does not allow himself to take any liberties and who
is very difficult to please."[9] Even Diderot, otherwise more inclined simply to mar-
vel at Chardin's pictorial wizardry, recognized the painter to be a "severe self-critic"
who left many of his works incomplete.[10]

The master of illusion was then, as it turns out, also a kind of neurotic
avant la lettre. His legerdemain concealed painstaking effort, procrastination, dis-
satisfaction, and a frequent inability to complete the task of representation. Suggested
in these commentaries was a connection between the character of the painter and
his method, the issue of personality and affect appearing as factors responsible for
the idiosyncrasies of his process.

I would like to use this connection to open up the question of the object as
a problem or challenge for the painting subject. My argument is that Chardin's still
lifes call for a recognition of the object in terms different than a mere physical thing
or its more or less convincing imitation. Nor is this, in my view, a matter of an object
as an optical or perceptual phenomenon, as some of the nuanced modern readings of
Chardin propose. Rather, Chardin's still lifes—some of them, in any case—suggest a
kind of strange romance with the object as at once a material thing and an imaginary
spectral entity, something experienced on the psychic register, which is what renders

the process of its representation "infinitely complex."[11] In Chardin's molecular fidelity to the object—in the notion, if only metaphorical, that he may have painted with the stuff or flesh of the object itself[12]—we detect evidence of an attachment that may have been at once a stimulus and a very source of Chardin's difficulty.

To be more precise, I must say that I am not interested in explaining Chardin's difficulty through external circumstances, be it his putative lack of drawing routine or, one may imagine, the pressure of excessive praise under which he had to work; rather, I wish to examine the *form* this difficulty took on canvas, its aesthetic symptoms, as it were. Following Chardin's own recognition, reported by Mariette, that he painted at an immense price ("sa lui coute infiniment"), I want to focus specifically on the notion of cost in the process of visualizing the object. My point is that the object in Chardin reveals itself to partake in a kind of illusory game where the stakes are higher than the mere accuracy of rendition, where the subject—beginning with the subject who produces the illusion—seems to be at issue.[13]

Fig. 3. Pieter Claesz. (Dutch, 1597–1661), *Still Life with Clay Pipes*, 1636. Oil on panel, 19 ¼ × 25 in. (49 × 63.5 cm). State Hermitage Museum, St. Petersburg

In the common sense of the term, Chardin's indebtedness manifests itself most obviously in relation to the tradition of seventeenth-century Dutch still life. His paintings—and *The Kitchen Table* is no exception—take up some of these classical tropes of still life but instill in them a different sense of purpose. It has been observed that in regard to his Dutch predecessors, Chardin gives up on the circumstance and cedes the central place to the object itself.[14] Yet, this is not simply a question of privilege or a more focused attention to the object. It is that Chardin's mode of staging it, a subtle transformation of the earlier mise-en-scènes, implies an altogether different relation to the object. Thus, as deployed in *The Kitchen Table* the standard device of placing things on the edge of a table so as to provide a sense a depth (as in Pieter Claesz.'s *Still Life with Clay Pipes*) makes the sense of risk involved in such

placement come to the fore (fig. 3). Placed precariously on the ledge, the knife, the piece of raw meat, the plucked chicken, the suspended cloth are multiplied beyond the necessity of illusion to produce the effect in this arrangement of opening up, a sense of material excess leaking out of the prescribed field of representation.

How different a lesson one could learn from the Dutch may be illustrated by the work of Chardin's younger and emulating contemporary Anne Vallayer-Coster. In her exquisite *Still Life with Ham, Bottles and Radishes* (fig. 4), the tightness of the composition endows a similar grouping of objects with a sense of belonging, stability, and evident utility—see the knife firmly stuck in the ham to demonstrate its function. Things are put *together* and stay there; only the hair-thin ends of the radishes venture out. By contrast, Chardin's compositions often tend to turn things inside out. This may be more or less literal, as in his numerous early still lifes with the motif of the copper cauldron turned over

Fig. 4. Anne Vallayer-Coster (French, 1744–1818), *Still Life with Ham, Bottles and Radishes*, 1767. Oil on canvas, 17 ¾ × 21 ½ in. (45 × 54.6 cm). Staatliche Museen zu Berlin, Gemäldegalerie

on its side—for example, one of 1734, now in the Musée Cognacq-Jay in Paris; or, more pronouncedly, as in the *Kitchen Still Life with Loin of Mutton* (fig. 5), in which a piece of raw meat placed on white cloth cascades down as if the overturned copper pot had just spilled its uncooked contents. One could say that in such examples Chardin activates the standard tropes of still life from within and, due to its internal dynamism, the resulting arrangement actually describes what the composition *does* as opposed simply to how it *looks,* the action of pulling the image inside out, almost disgorging it.

Disgorgement comes to mind because of the comestible nature of the displayed objects but also because of the violence they represent or are marked by: the flayed meat and, in the Boston painting, the chicken with its throat cut, its head dangling sadly on a long neck, its insides taken out, the white cloth slightly

Fig. 5. Jean-Siméon Chardin, *Kitchen Still Life with Loin of Mutton*, 1732. Oil on canvas, 16 ½ × 13 ⅜ in. (42 × 34 cm). Musée Jacquemart-André, Paris

Fig. 6. Detail of fig. 1

stained by blood. We are far from the tactfully vanitative signifiers of decay in Dutch still life, such as the bees and the caterpillars marking discreetly the inevitable erosion of life in the paintings of Balthasar van der Ast.[15] In the Chardin, death enters the image more explicitly. But more important, it penetrates the very process of painting. Thus, while the project of the seventeenth-century painters was marked by a thorough separation from the suggested intrusion of death on live matter—the eating away of life in van der Ast had nothing to do with the painter's own process—in Chardin, painted death becomes inseparable from the painting. (Incidentally, it is only in 1756, precisely at around the time when *The Kitchen Table* was painted, that the notion of death enters the French terminology for still life, and what had previously been designated as *vie coye,* or *nature reposé,* becomes *nature morte.*)[16]

Look at the way Chardin painted the throat and the neck of the chicken, like a mottled wound, slightly blurred (fig. 6). Though the term "relaxed focus" has been used to describe this type of blurring in Chardin, there is nothing relaxed about it.[17] It looks as if blood has been mixed with the pigment here, as if the painter, as Diderot would put it, indeed dipped his brush in the dead chicken's flesh. Then there is the meat: tilted forward, the white smudges of the bone conveyed through unblended

strokes of gray and red, with some dabs of pinkish-red in between. (Obviously Soutine would look attentively at such instances of raw painterly bravura.) In the sticky chewiness of Chardin's marks there is a kind of inside-outness that echoes the reversibility of the composition suggested by the arrangement of some of the objects on the edge of the ledge, as if the surface of the canvas threatened to suck them back in. The idea of ingestion implied by the displayed food thus moves back and forth between the possibilities of eating and being eaten.

This is, then, how Chardin's object speaks of the costs involved in fleshing it out. We may call it an object porous to the subject—not in the sense of marking the painter's voluntary complicity with the depicted world (as Norman Bryson has argued in relation to Chardin's genre scenes),[18] but as implying a far more dangerous play with the visual field that appears to have a haptic capacity to catch and retain the subject. In other words, Chardin's handling of paint points to the possibility of the object as a trap for the painting hand. His touch often seems both to bring the thing into the visual field, the sphere of legibility, and to draw back into the object, entangled in its midst.

This is evident in the painter's habit of approximation of the object's material presence through open-ended, uncontoured forms. He often dabs the pigment on, sometimes with a finger, to create the effect of crusting. Diderot succinctly described its effect: "Come close, and everything becomes blurred, flattens and disappears; stand back and everything is re-created and takes shape again."[19] You can see what he is talking about when you look at the detail of the melon with the pile of creamy dabs balanced on top of its wedge, its rind a crust of whites and greens produced by layered hatchings (*Cut Melon*, 1760, private collection); or at the cup of tea from its pendant, *The Jar of Apricots* (fig. 7), with the saucer's edge dissolving in a mist.[20] (Gilles Deleuze's description of the sense of things manifesting itself in the "faint incorporeal mist that escapes [their] bodies" comes to mind.)[21]

Often enough these formal aspects have been described in terms of unity of the haptic and the optic in Chardin's vision. Jonathan Crary, for example, takes Chardin to exemplify the last moment in the classical vision wherein different modalities of sensory experience were understood to belong together in one indivisible body of knowledge. Notwithstanding some resemblance to Cézanne, what Chardin paints, according to this view, is not the instability of optical experience but a stable structure of knowledge and relations behind it.[22]

Yet, I think that Chardin's technical procedures call for a different kind of exegesis. From the point of view of the painter, the two modes of looking described

Fig. 7. Jean-Siméon Chardin, *The Jar of Apricots*, 1758. Oil on canvas, 22 ⅜ × 20 ⅛ in. (57.2 × 50.8 cm) oval. Art Gallery of Ontario, Toronto

by Diderot—up close or at a distance—are not just options for a disinterested viewer to choose from; they are a necessity of the painter's procedure. It is mostly up close that the painter experiences his vision of an object when he paints it, his hand on the canvas, his eyes close to its surface—an activity that eventually blinded Chardin due to the noxious lead in the oil pigments—with an occasional drawing back to gauge the effect of his labor from a distance. The questions he confronts are: How much detail is enough; how much approximation too little? When would a saucer seem delightfully aerated, and when would it simply look unfinished or interrupted? The delicate nature of this negotiation is made clear by the examples of the arguably less successful works, such as the apples in the *Still Life with the Faience Pot* (1764) from the National Gallery of Art in Washington, that make one think of the heavy-handedness of Chardin's touch evoked by Mariette.

This *is* indeed different from the Cézannian doubt—it is not about documenting perception as an endless, open-ended process; it is a risky game of finding the threshold of the visible right before it dissolves into the invisible. The point is that touch and sight are not experienced as unified in this process (though they may appear to be so for the viewer looking at the finished canvas from the distance). The making of an image implies a split: to touch is to be up close; to see is to be at a distance.

This back and forth movement—toward and away from canvas—describes a hazardous trajectory in which both an object and a subject are at risk of incompleteness: incompleteness as a threat of invisibility for the object (the underarticulated

object that fails to "take," to make an appearance on the stage of representation); and incompleteness as a challenge to the painter confronted with the specter of failure to make it appear on canvas, to pull the image off. This is what Chardin's apples illustrate: they are not delivered as totalities of perception; the kind of consciousness they imply is not that of a unified mind but of a split perception of a painter at work. The sense of difficulty involved in this work manifests itself in ways in which the object cuts the field of the subject, and vice versa, the smudge of touch interrupting the edge of the cup, its fullness thus available *only* at a distance. It is, then, an image not of doubt but of the painting subject's debt drawn on the object.

Nowhere are the violent implications of this debt more explicitly spelled out than in Chardin's notorious painting of *The Skate* (fig. 8). The whole composition revolves here around the eviscerated body of the fish suspended on a hook, its voided

Fig. 8. Jean-Siméon Chardin, *The Skate (or The Ray)*, 1725–26. Oil on canvas, 44 ⅞ × 57 ½ in. (114.5 × 146 cm). Musée du Louvre, Paris

inside shown in all the details of its glistening horror. The power of this horror—which this painting solicits and expects, with the cat alarmed by the oysters (a not-so-veiled reference to the feminine body) acting as the displaced figure of the (male) viewer's fright—has to do with the anthropomorphic dimension of the fish: her "face" appearing right above the eviscerated cavity, with its Mona Lisa smile, and its "eyes" (which are in fact its gills) staring out. This "physiognomic" presence is then another instance of inversion—her real eyes are actually on the other side—that underwrites the whole composition.

Two things about it are worth emphasizing. One is the way in which *The Skate* makes evident the structural centrality of the trope of representation as evisceration in Chardin's vision. It literalizes the violence entailed by the visualization of the object—the idea of the replete object as a possibility underwritten by an inherent threat—that informs Chardin's work as conveyed, albeit more subtly, by the far quieter Boston still life. The eviscerated skate is then a figure of the "cost" of painting, that is, of the loss incurred by the object and subject in paint.

Secondly, what *The Skate* makes clear is the bodily dimension of that cost. You guessed it: castration is in the air. It comes as no surprise that in French, the name of the fish, "la raye," has explicit sexual connotations; thus as the *dictionnaires* from the period inform us, in eighteenth-century popular parlance it referred to both the parting between buttocks, male and female alike, and female genitals.[23] Yet, I would insist that it is not a genital loss that is evoked here but rather an idea of loss that, as Lacan never tired of repeating, every subject experiences upon entry into the realm of language. *The Skate* at once embodies this loss—the sense of becoming visible only at the cost of losing one's sense of bodily plenitude—and situates it in relation to the process of painting, as experienced by Chardin. More specifically, *The Skate* embodies the fraught nature of the relation between the object and the subject that we detected in Chardin's art (the pleasure and threat of reciprocity). As psychoanalytic theory insists, all relations to the object are always "about" the subject. Thus Lacan has noted that, in psychic life, all the positions implied by the object are occupied by the subject, that there is an imaginary reciprocity between one and the other.[24]

But, we may ask, what happens when the object usurps the position of the subject? The disemboweled skate may be seen to capture the sense of Chardin's relation to the object as a kind of bilateral indebtedness, both good and bad (to put it quaintly) for the thing and its painter alike. Thus the "mouth" of this horrific creature, at once rising (like a specter) and hanging, gives the slippage between the

notion of eating and being eaten that underwrites Chardin's still life another grue-some spin: it reveals that the associative distance between ingestion and incorporation is short. (This is Melanie Klein's emphasis as well.)[25]

It comes as no surprise that *The Skate* was a painting of particular impor-tance for Chardin: it was one of the pendants that constituted his admission pieces for the Academy, which is to say, his entry ticket to the institutional space of paint-ing as a codified language. Interestingly enough, it was presented by Chardin as a gambit. Rather than making an official submission, Chardin placed *The Skate* to-gether with *The Buffet*—a far more conventional emulation of the Dutch—in the hallway leading to the room where the academicians assembled. One of them, Nicolas de Largillière, himself a portraitist and still-life painter, not suspecting Chardin's ruse, took the paintings to be by a Flemish master. When Chardin re-vealed himself to be the author of these works, he was elected and received as a full member of the Academy on the same day.[26]

It is curious to note how congruent this story is with the pictorial logic of Chardin's submission. Like the skate, Chardin staked his professional fate on a kind of sacrifice, a momentary renunciation of authorship, in order to enter the insti-tutional field of painting. In more than one sense then, *The Skate* is a pawn, an image of a symbolic ransom, both the trophy and the price of representation as a code. As such, it points to another group of works where Chardin commented on the mortifying powers of painting: the still lifes with the dead game. Throughout his career, Chardin repeatedly returned to this type of image and, in the process, he entirely reinvented the subgenre of the hunting-trophy piece. This reinvention, in a nutshell, amounted to the infusion of the image with an affect unwarranted by the genre, a lyrical presentation of death that displaced all other traditional con-cerns that had framed the trophy picture as a genre.

The difference in Chardin's approach becomes clear when compared to that of his contemporary Jean-Baptiste Oudry. The latter's *Hare and Leg of Lamb* (fig. 9), which aimed at the highest degree of verisimilitude—in its contrasts be-tween the glistening fat of the meat and the furry pelt of the animal—is a trophy of both the hunter and of the painter eager to demonstrate his skills. The success of this demonstration relies on the invisibility of the artist's hand: for the *trompe l'oeil* effect to succeed, the traces of its production must be carefully hidden. The idea of the painter's control—of the represented object, and of the viewer who must be tricked into the belief in its presence—is preponderant. Something else entirely happens in Chardin's *Dead Hare with Powder Flask and Game Bag* (fig. 10). There

is a kind of pathos to this presentation, a sense of violence combined with empathy for the hare. It is not simply that the artist's traces are here more visible or more frankly acknowledged. It is that the painting declares a kind of affinity between the painter and the dead animal, the process of representation itself being likened to a hunt in which the painter is both the controlling hunter and the hare.

Thus, in contrast to the careful and firmly anchored arrangement in the Oudry, in the Chardin the space of representation is unstable, as is the position of

the animal corpse within it. Its body twisted, its legs indecorously splayed, the hare threatens to slide off the ledge at the very place where the artist's interest in securing the illusion of space seems to have momentarily slackened. (The ledge loses its edge and disappears halfway through the painting.) Rather than simply hanging down or resting on the ledge, the hare seems embedded in the very structure of the painting, not only a product of illusion but part of its very mechanism. Where Oudry's animal was displayed as a separate, self-enclosed entity, Chardin's hare is still half buried in the field of representation, at once enveloped by the soft materiality of its fold and floating on its surface. The quasi-monochrome tonality of the painting, which is just like hare's fur, enhances this effect of reciprocity or identification. (One is reminded here

Fig. 9. Jean-Baptiste Oudry (French, 1686–1755), *Hare and Leg of Lamb*, 1742. Oil on canvas, 38 ⅝ × 28 ¾ in. (98 × 73 cm). The Cleveland Museum of Art. John L. Severance Fund

of Diderot's anecdote about Chardin being unable to finish a still life when the dead rabbit had gone bad and he could not find another that would match the tonality of the one already started.)[27]

Similarly, a lack of precise location and the sense of abandonment this implies permeates the *Dead Hare with Powder Flask and Game Bag*, where the rabbit's corpse has been thrown across an otherwise unmarked and undifferentiated

space—neither a pantry nor the abstract space of the *trompe l'oeil,* but a more opaque, temporal spatiality of the process in which the body emerges into vision yet fails to take its place.[28]

Cochin left us an account of Chardin undertaking to paint a rabbit for the first time: "He wanted to depict it with the greatest veracity in all respects, yet tastefully, giving no appearance of servitude that might make its execution dry and cold. He never painted fur. He realized that he should not paint it hair by hair or reproduce it in detail."[29] As this re-

port makes clear, Chardin was trying precisely not to do the kind of thing that Oudry did, which was for him a symptom of an excessive dependence on the object or a lack of taste. Yet, in his own approach, there was, too, a kind of dependence, though of a different kind. It manifested itself in his very mode of painting, marked not by servitude but by a visible bonding. Look up close at the Louvre *Hare:* instead of the animal's hair you will see a flurry of the painter's brushstrokes that verge on over-elaboration, that are agitated especially in the area of the chest and the loin, places where the painter seems to have forgotten himself in his process, buried himself in it, his brush burrowing and sniffing like a hunter's dog. The snare resting in the

Fig. 10. Jean-Siméon Chardin, *Dead Hare with Powder Flask and Game Bag,* 1728–30. Oil on canvas, 38 ⅝ × 30 in. (98 × 76 cm). Musée du Louvre, Paris

hare's underbelly, an instrument of its passion, as it were, echoes in the wisps of brushstrokes hovering about—presumably loose hay—driving home the analogy I have been suggesting between the hunter's snares and the trap of paint. Hanging on its hook, the hare may thus be likened to a painting hanging on the wall. We are reminded that Chardin was in charge of the *accrochage,* that is, the hanging of the picture during the Salon exhibitions at the Louvre, a responsibility he performed for almost twenty years, from 1755 to 1774.[30]

Fig. 11. Jean-Siméon Chardin, *Two Rabbits, a Pheasant, and a Seville Orange on a Stone Ledge,* 1755. Oil on canvas, 19 ½ × 23 ⅜ in. (49.5 × 59.5 cm). National Gallery of Art, Washington, D.C. Samuel H. Kress Collection

Fig. 12. Nicolas de Largillière (French, 1656–1746), *Partridges in a Niche,* 1680–85. Oil on canvas, 28 ⅛ × 23 in. (71.5 × 58.5 cm). Musée du Petit Palais, Paris

Perhaps the most eloquent and strangely moving are the paintings of dead game flung over the ledge, a type of composition adopted from the displays of edible things, done mostly in the 1750s and 1760s, such as *Two Rabbits, a Pheasant, and a Seville Orange on a Stone Ledge* (fig. 11); and *Rabbit and Two Thrushes* (Musée de la Chasse, Paris). The intimate lyricism of these scenes is striking: note the tenderness with which Chardin gently deposited the corpses on the stone ledge, the pheasant's leg almost caressing the dead rabbit's body, the corpses of two birds softly nested in the cavity of the rabbit's underbelly. What we witness here—and this is where the originality of these paintings resides—is a collapse of the elaborate architecture of showiness typified by such depictions of the hunting trophy as *Partridges in a Niche* by the doyen of the genre, Nicolas de Largillière (fig. 12). The artfulness of this tradition of representation is of no interest to Chardin. Instead he *deflates* the trophy—the notion of detumescence rather than castration comes to mind. The artist's signature carved in stone on the ledge of these representations—again a standard trope of still-life painting—acquires here an ambivalent air. What does it mean to be signing your name under these

depositions of dead flesh? Are these tokens of a pictorial triumph or a gruesome reminder of the painter's costs?

Lastly, let us very briefly consider two small but important paintings by Chardin that take up differently the concern with the costs of representation I have discussed. *The Draughtsman* (c. 1738) describes a kind of fixation on the object that

Fig. 13. Jean-Siméon Chardin, *The Draughtsman*, c. 1738. Oil on wood, 7 ⅝ × 6 ⅞ in. (19.5 × 17.5 cm). Nationalmuseum, Stockholm

Fig. 14. Jean Siméon Chardin, *The Monkey Painter*, 1735–40. Oil on canvas, 11 ¼ × 9 ¼ in. (28.5 × 23.5 cm). Musée du Louvre, Paris

played a key role in artistic training in the eighteenth century (fig. 13). Chardin denounced the tediousness of artistic education in his well-known tirade that Diderot reported in his introduction to the Salon of 1765. "The chalk holder is placed in our hands at the age of seven or eight," he recounted, and then the young artists spend entire years having to copy the art of others before being allowed to draw after nature. Such postponement was, in his view, unfortunate because of the tremendous challenge posed by the process of imitation and because it added difficulty to the career of the artists already marred by the tremendous difficulty of earning a decent living. Yet, Chardin also stated: "Those who've never felt art's difficulty will never produce anything of value; those who, like my son, feel it too early on, produce nothing at all; and rest assured that most of the high posts in our society would remain empty if one gained access to them only after trials as severe as those to which we [the artists] must submit."[31]

The Draughtsman is an image of these "severe trials" that the young artists must endure. Seated on the floor, bent over a sheet propped on a portfolio, his legs apart, the young man seems entirely consumed by his task. The cost of his devotion to the object is evident not only in his pose, but also in his garb: the prominent red hole on his back is not just a mark of his poverty but also a kind of wound.

The tone of Chardin's second commentary on artistic process, *The Monkey Painter* (fig. 14), is, on the other hand, resolutely comic. It is a carica-

ture of the notion of the artist as an imitator. The simian transposition of the painter was not invented by Chardin—Teniers and Watteau had taken it up—but it resonates with new meaning in the context of his own practice. Attired with mock elegance in a gold-trimmed coat and a feathered hat, Chardin's monkey-painter is confronted with a choice between imitating a statuette of a putto standing on the table or some everyday objects, the kind of kitchenwares Chardin himself painted, lying about the studio floor. He is, however, looking straight out, possibly at his own

reflection in the mirror. As it has been suggested, this may be a self-portrait (faint contours of the monkey's own features have been recognized on the canvas), but, if so, it is definitely an ironic one. Since irony is, among other things, a safe mode of posing questions, *The Monkey Painter* may be seen as Chardin's query about himself, a satirical rephrasing of the very question that haunted Chardin's practice as a painter of still life: am I the painting subject or the object that I paint? Thus, this caricature may be seen as a comic version of the argument formulated in *The Skate* about the subjective loss involved in the process of making an image, visualizing as it does the dehumanizing aspect of painting, the notion that the project of imitation is not only tedious but may be a menace to artistic subjectivity.

Fig. 15. Jean-Siméon Chardin, *Self-Portrait with Pince-nez*, 1779. Pastel, 16 × 12 ¾ in. (40.5 × 32.5 cm). Musée du Louvre, Paris

The arguments that these two paintings suggest about the inherent difficulty as the defining feature of art-making, and about the connection between the image of the object and the painter's self, seem to confirm the understanding of Chardin's work that I am presenting here. Contrary to René Démoris's suggestive reading of Chardin as a painter who dwells in the paradise of preverbal fullness, whose work fleshes out the zone of the senses protected from the irruption of language, Chardin's work seems, rather, to be about the costs of straddling two spheres, about the engagement with the object that opens up the boundaries of the subject, that implies loss.

Such a notion of the loss of self through representation underwrites one of Chardin's last self-portraits, done in pastel, to which the artist resorted when his sight deteriorated (fig. 15). Here the artist has turned away from his easel to cast a somewhat blurry glance at his viewer from above the eyeglasses sliding down his nose. It is the way his face seems about to slide down as well, with the dense pattern of hatchings simultaneously securing his features and threatening to lift them, that is interesting here. A kind of flaying—a defacement—is thus being produced, not unlike the physiognomic loss in Chardin's drawing of the wild boar—*pace* Mariette, Chardin did know how to draw—where the animal's features are buried under a flurry of strokes.[32] The red crayon gripped firmly, almost demonstratively, in Chardin's hand contributes to this discomfiting suggestion. Sparkling on the tip of the crayon are some material traces of the object that has just been depicted, or undone: the painter himself.

1. "Les nuances les plus vrais des corps sont saisies par M. Chardin avec une justesse admirable." Pierre Estève, *Dialogues sur les arts* (Amsterdam: Chez Duchesne, 1756), 29–30, 31. All translations are mine unless stated otherwise.

2. "Ô Chardin, ce n'est pas du blanc, du rouge, du noir que tu broies sur ta palette; c'est la substance même des objets, c'est l'air et la lumière que tu prends à la pointe de ton pinceau, et que tu attaches sur la toile." Denis Diderot, "Salon de 1763," in *Oeuvres,* 6 vols., ed. Laurent Versini (Paris: R. Laffont, 1994–97), 4:265.

3. [Antoine] Renou, *Memorial Address on Chardin,* 1780, cited in Pierre Rosenberg, *Chardin,* trans. Helga Harrison (Geneva: Skira; New York: Rizzoli, 1991), 98–99. Charles-Nicolas Cochin also noted that "He painted his pictures over and over until he had achieved that breaking down of tones produced by the distance of the object and the reflections of all the surrounding objects, until he finally achieved this *magical harmony* which so distinguished his work." "Essai sur la vie de M. Chardin," 1780, published in English translation in Marianne Roland Michel, *Chardin,* exh. cat. (Paris: Hazan, 1994), 269, italics mine.

4. Conservation report on file at the Museum of Fine Arts, Boston.

5. For identification of some of Chardin's household objects, see Marie-Laure Rochebrune, "Ceramics and Glass in Chardin's paintings," in *Chardin,* exh. cat. (London: Royal Academy of Arts; New York: Metropolitan Museum of Art, 2000), 37–53.

6. E.g., *Tinned Copper Pot,* 1734–35, Detroit Institute of Art; *Copper Pot,* private collection, Paris (Pierre Rosenberg and Renaud Temperini, *Chardin: Suivi du catalogue des oeuvres* [Paris: Flammarion,

1999], cat. no. 146); and *Copper Pot with Casserole,* Mauritshuis, The Hague.

7. Eric M. Zafran, *French Paintings in the Museum of Fine Arts in Boston* (Boston: Museum of Fine Arts, 1998), vol. 1, cat. no. 35.

8. "[I]l faut en convenir, les tableaux de M. Chardin sentent trop la fatigue et la peinne. Sa touche est lourde et n'est point variée. Son pinceau n'a rien de facile; il exprime tout de la même manière, et avec *une sorte d'indécision,* qui rend son ouvrage trop froid. . . . Faute d'être assez foncé dans le dessein et de pouvoir faire ses études et ses préparations sur le papier, M. Chardin est obligé d'avoir continuellement sous les yeux l'objet qu'il se propose d'imiter, depuis la première ébauche jusqu'à ce qu'il ait donné les derniers coups de pinceau, ce qui est bien long et capable de rébuter tout autre que lui. Aussi, a-t-il toujours à la bouche que le travail *lui coute infiniment.* Quand il voudroit le cacher, son ouvrage le déceleroit malgré lui." Pierre-Jean Mariette, *Abecedario,* 12 vols. (Paris: J. B. Dumoulin, 1851–53), 2:359–60, italics mine.

9. Cochin, "Essai sur la vie," 269.

10. "[U]n juge si sévère de lui même." Diderot, "Salon de 1769," in *Oeuvres,* 4:844.

11. Jacques Lacan, *Le Séminaire de Jacques Lacan. Livre IV: La Relation d'Objet* (Paris: Seuil, 1994), 27. The question for us is, of course, what kind of complexity it is in Chardin's case.

12. "And this Chardin, why does one take his imitations of inanimate things for nature itself? It is because *he creates flesh* when he pleases" (Et ce Chardin, pourquoi prend-on ses imitations d'êtres inanimés pour la nature même? C'est qu'il fait de la chair quand il lui plaît.) Diderot, "Essais sur la peinture," in *Oeuvres,* 6:476.

13. For discussion of the illusory game between the subject and object, see Lacan, *Le Séminaire,* esp. 26–30.

14. René Démoris, "La nature morte chez Chardin," *Revue d'esthétique* 22, no. 4 (1969): 369.

15. E.g., his *Still Life with Fruits and Flowers,* 1620–21, Rijksmuseum, Amsterdam.

16. Charles Sterling, *Still Life: from Antiquity to the Twentieth Century,* 2nd revised edition (New York: Harper and Row, 1981), 64.

17. Norman Bryson, *Looking at the Overlooked: Four Essays on Still-Life Painting* (Cambridge: Harvard University Press, 1990), 167.

18. Ibid., and Norman Bryson, *Word and Image: French Painting of the Ancien Regime* (Cambridge: Cambridge University Press, 1983), 118.

19. "Approchez-vous, tout se brouille, s'aplatit et disparaît. Eloignez-vous, tout se recrée et se reproduit." Diderot, "Salon de 1763," in *Oeuvres,* 4:265.

20. Diderot noted (ibid.): "Sometimes it is as if a mist has been blown onto the canvas; and sometimes as if a light foam has been thrown over it." (D'autres fois on dirait que c'est une vapeur qu'on a soufflée sur la toile; ailleurs, une écume légère qu'on y a jetée.)

21. Gilles Deleuze, *The Logic of Sense,* trans. Mark Lester, ed. Constantin Boundas (New York:

Columbia University Press, 1990), 10.

22. Jonathan Crary, *Techniques of the Observer: On Vision and Modernity in the Nineteenth Century* (Cambridge: MIT Press, 1990), 62–66.

23. According to the eighteenth-century *Dictionnaire de Furetière,* "On appelle populairement la raye le cul, la séparation qui est entre les deux fesses." Cited in René Démoris, *Chardin, la chair et l'objet* (Paris: Olbia, 1999), 32.

24. "Thus it is the identification with the object that is at the basis of all relations [of the subject] to it." Lacan, *Le Séminarie,* 26.

25. See, for example, Klein's "Contribution to the Psychogenesis of Manic-Depressive States" (1935), in *The Selected Melanie Klein,* ed. Juliet Mitchell (New York: Free Press, 1986), 116–45.

26. The anecdote about Chardin's admission was told by Cochin in "Essai sur la vie," 268. The best discussion of Chardin's complex relation to the Academy can be found in Philip Conisbee, *Chardin* (Lewisburg, N.J.: Bucknell University Press, 1985).

27. Diderot, "Salon de 1769," in *Oeuvres,* 4:844.

28. Philadelphia Museum of Art; reproduced in *Chardin* (see note 5, above), cat. no. 20.

29. Cochin, "Essai sur la vie," 268.

30. See "Chronology," *Chardin,* 22–24.

31. Chardin's tirade was reported by Diderot in the introduction to his "Salon de 1765." See *Diderot on Art,* 2 vols., ed. and trans. John Goodman (New Haven: Yale University Press, 1995), 1:5. The painter is referring to the well-known failures of his son, who was also a painter and who was to die, most probably by suicide, in 1772.

32. *Head of Wild Boar,* c. 1725, Nationalmuseum, Stockholm.

PART FOUR

LOST AND FOUND

The Surrealist Situation of the Photographed Object

Margaret Iversen

In her article "The Photographic Conditions of Surrealism" (1981) and the closely related catalogue essay "Photography in the Service of Surrealism" (1986), Rosalind Krauss argued that the Surrealists' manipulations of the photographic image introduced a textual-like spacing into the domain of photography that is otherwise "a declaration of the seamless integrity of the real."[1] Following Jacques Derrida, she gave "writing" the role of deconstructing the illusion of immediacy in the realm of speech or imagery. Visual forms of "writing," such as spacing and doubling, which foreground the constructedness or artifice of the image, destroy photography's illusion of "simultaneous presence."[2] This illusion is especially compelling in the case of photography because of its indexical nature; it has, so to speak, photochemical credentials to back up claims to presence and representational truth. Krauss argued that the Surrealists' handling of the photographic image amounts to a range of writerly techniques aimed at subverting these claims. These include double exposure, negative printing, solarization, *brûlage,* and strange points of view.

One technique rarely used by Surrealist photographers, however, is photomontage, and it is the model of photography as writing par excellence.[3] It gives us a vision of reality with interpretation built in, and it achieves this by arranging discontinuous fragments of photographs on a plain ground. Montage is the ultimate in a premeditated, constructed, artificial, semiotic use of photography. Krauss argues persuasively that the Surrealists managed to achieve the effect of montage while keeping the skin of the photographic print intact. By so doing, they produced "an experience of the real itself as sign, as fractured by spacing."[4] Spacing "makes it clear that we are not looking at reality, but at the world infested by interpretation or signification, which is to say, reality distended by the gaps or blanks which are the formal preconditions of the sign."[5] The *cloisonné* of the solarized print that isolates elements without scissors and paste is testimony to this, as is the technique of doubling, produced in the studio or with mirrors or "found frames."[6] Doubling, says Krauss, is the signifier of signification: it turns the raw material of signification into something we recognize as deliberate or intentional.[7]

I have reviewed Krauss's theory of Surrealist photography at some length, partly because of its inherent explanatory power and partly because it effectively

has no competitors.[8] My aim in this paper will be to offer an alternative to her semiotic reading of Surrealist photography while maintaining her critique of any theory or use of the medium that encourages the illusion of its transparency and mimetic realism. I do this by challenging her account of photographic indexicality as serving to affirm the truth of representation, that is, its correspondence to fixed and stable referents. For Krauss, photography's undeniable indexical character is problematic as it apparently links the image to its object in a causal, immediate way. Yet her implicit equation of indexicality and photographic realism is unfounded, for there is nothing intrinsic to the idea of the indexical trace that determines it as a realistic image. Krauss's compression of indexicality and iconicity is surprising coming from one who wrote an early piece on the logic of indexicality, Duchamp, and abstract installation art in the seventies.[9]

L'indice, the closest French equivalent of index, is not a term much used by the Surrealists. However, André Breton's well-known pronouncement in *L'Amour fou* about how "interpretative delirium begins only when man, ill-prepared, is taken by a sudden fear in the forest of symbols," varies Baudelaire's *forêt de symboles* with *forêt d'indices.*[10] This would seem to indicate a shift on Breton's part, toward a more materially grounded sign or imperative signal than offered by the poetic symbol. Further, the central section of that book features an automatically written poem called "Tournesol," meaning sunflower and litmus paper, both of which have an obvious indexical character.[11] Yet if the term index doesn't feature prominently in the Surrealists' texts, they nevertheless deployed a number of strategies and innovative practices that come under the general heading of the indexical sign. A study of these will complicate our notion of indexicality. At the same time it will explain those characteristic features of Surrealist photography that Krauss attributes to a practice of making the photographed world look convulsed with meaning. My expanded sense of indexicality will also unify the apparently divided field of Surrealist practice, split between manipulated and straight photography.

In "The Surrealist Situation of the Object" (1935), Breton called on poets and painters to incorporate in their work the "precision of sensible forms." Breton's Hegelian inheritance ensured that he understood the particularly acute problem of the visual arts in the post-Romantic period when, for Hegel, material things prove inadequate to the task of conveying thought. Poetry is better suited, but it runs the risk of becoming introspective and abstract. To counter this, it has dialectically to include its other. As Breton put it, "In the measure that poetry tends in time to predominate over the other arts, Hegel's magnificent analysis revealed

that it increasingly manifests, contradictorily, the need to attain the precision of sensible forms."[12] The Surrealist poet is therefore obliged to go walking in the world of devalued, accidental things, epitomized by the flea market, dispersing himself amongst them and gathering them in. Breton emphatically demonstrated the fruits of this practice with his *objets poèmes,* assemblages of text punctuated by small *objets trouvés.* It is worth mentioning in this context that anonymous photographs were among the objects found by chance, which, as Dawn Ades noted, were garnered from their hunting grounds in the street, junk shops and markets, popular and scientific magazines and elsewhere.[13]

Breton notes the position of painting in a world where photography has taken over the mimetic function of representation. This situation forces Surrealist painting to retreat to the domain of inner perception. Yet this does not mean that painting detaches itself from external reality. As Breton insists, there is no such thing as "spontaneous generation" in mental reality any more than in physical reality.[14] Rather, "the creations of the Surrealist painters that seem most free can naturally come into being only through their return to 'visual residues' stemming from perception of the outside world."[15] These residues are the product of over-determination, a condensation of formerly dissociated thoughts and visual impressions, giving them an unusual density and opacity. They found their most persuasive artistic expression in the found object and, paradoxically, the photograph—and especially photographs of found objects, such as Man Ray's photograph of the slipper-spoon in *L'Amour fou.* Breton's conception of objective chance governing the encounter with the found object is indebted to his reading of Freud's *Beyond the Pleasure Principle.*[16] This is particularly evident in one of Breton's formulations: "Chance would be the form taken by external reality as it traces a path *(se fraie un chemin)* in the human unconscious."[17] Margaret Cohen has pointed out that the verb *frayer* is used by the French translator of *Beyond the Pleasure Principle* to render Freud's term *Bahnung* (facilitation), which has to do with laying down a permanent trace of an excitation—a psychic index.[18] Clearly, the "object" in Breton is not conceived of as an ordinary empirical object, but rather something more like the object of desire or a traumatic encounter. Breton mobilized Freud on dreams and on trauma in order to give the Hegelian dialectic a more materialist texture; for him, the mind must be furnished with impressions, traces of the real, in the same measure as the world is penetrated by thought, it being understood that "only the perception of the outside world had permitted the involuntary acquisition of the materials which mental representation is called up to use."[19]

In an important early essay, "Introduction to the Discourse on the Paucity of Reality" (1924), Breton railed against the impoverishment of reality imposed by clichéd ordinary language and poetic tropes. He aimed to extend reality with a kind of literature that would be both imaginative and verifiable. To this end, he proposed fabricating and putting into circulation objects met with in dreams. He describes one such dream encounter: in the open-air market near Saint-Malo, he found a book with a spine made out of a wooden gnome whose white beard was cut in the Assyrian fashion.[20] Breton didn't tell us anything about the probable circumstances of his life that produced this bearded dream-book, but it puts me in mind of the botanical monograph in Freud's dream, which he spots in a shop window, which precipitates a dream of extraordinary complexity.[21] Unlike Breton's, however, the book in Freud's dream is a case of an ordinary object, encountered by chance, being seized upon by the unconscious, where it sprouts many tendrils of associations. Another case is the story told by Breton about Giacometti's sculpture *Invisible Object* (1934), which had an indifferent face until he found a metal mask in a flea market. Breton notes that before this lucky find "there was lacking any reference to the real, something to lean on in the world of tangible objects."[22] But the mask is far more than just tangible, for it turns out to have provoked in Giacometti latent anxieties about death. These examples illustrate the twin poles of a reciprocal movement practiced by the Surrealists, both to objectify the subjective and to subjectify the objective. Breton looks forward to the moment when poetic creations take on this tangible quality so that they may effect a "peculiar shifting of the boundaries of the so-called real."[23]

A new translation of Breton's "Discourse" was published in *October* in 1994. It was introduced by an article called "Surrealist Precipitates: Shadows Don't Cast Shadows" by Denis Hollier, in which he considers the cast shadow as exemplary of the type of sign admired by the Surrealists. The shadow, he argues, is "rigorously contemporary with the object it doubles, it is simultaneous, non-detachable, and, because of this, without exchange value."[24] As Hollier notes, the shadow is the clearest example of an indexical sign. The index is a sign that is "less a representation of an object than the effect of an event."[25] This, he says, citing Breton, is what gives it a "circumstantial—magic dimension" ("circumstantial" meaning the opposite of magical, that is factual, non-essential, everyday).[26] For Hollier, works such as Jean Arp's *Bell and Navels* (1931), which incorporate real shadows, "open the internal space of the work to the context of reception, mixing it with that of the beholder."[27] The literary equivalent of the cast shadow, says Hollier, is the first person: "The I opens up language to its performative circumstances. The unfolding of Breton's autobio-

graphical texts, such as *Nadja,* was just as much unanticipated by the author as it was for the reader."[28] Both follow the narrative. *Nadja* doesn't have a dénouement; rather, as Breton says, it has "a door left ajar."[29]

The "descriptive realism" of the novel is here replaced by what Hollier calls "performative realism." This anti-literary activity is directed against the novel. In the "Discourse on the Paucity of Reality," Breton urged writers to speak for themselves, rather than inventing sham human beings, while in *L'Amour fou* he recommended recording experiences as in a medical report: "No incident should be omitted, no name altered, lest the arbitrary make its appearance."[30] For him, the realist novel is only real-ish; it suffers from a paucity of reality. Breton's texts, by contrast, have characters who exist and who have proper names. They are also liberally "illustrated" with photographs. In the introduction to *Nadja,* Breton says that the photos are included to relieve him of the necessity of writing tiresome descriptive passages, but Hollier points out that, along with the first person and narrative inconclusiveness, they effect an "indexation of the tale."[31]

Apart from this brief reference to the photographs in *Nadja* and a citation of Breton's observation that automatic writing is to invisible objects what photography is to visible ones, Hollier does not reflect further on what implications these thoughts on the index might have for rethinking Surrealist photography or photography in general. This absence is partly supplied by Jeff Wall's essay "Marks of Indifference" (1995), an interpretation of conceptual photography as a parody of photojournalism in terms that recall Hollier's discussion of performative realism. For example, Wall argues that Robert Smithson's exposure of Minimalism's "emotional interior" "depends on the return of ideas of time and process, of narrative and enactment, of experience, memory and allusion." Smithson's work, he notes, is in part self-portraiture—that is, performance.[32] And, of course, Smithson's format in, for instance, *A Tour of the Monuments of Passaic, New Jersey* (1967), could have been inspired by Surrealist texts, involving as it does rather delirious first-person reportage of perambulations combined with deadpan photographic illustrations of discoveries made en route.[33] Rather than a parody of photojournalism or travel writing, as Wall and others maintain, Smithson's texts might profitably be seen as a parody of texts by Breton or Louis Aragon that record the encounter with the revelatory object in the streets of Paris, transferred to the barren post-industrial landscape of New Jersey. (Incidentally, Smithson owned a copy of *Nadja.*)

This reading of Surrealist documentary-type photography clears it of the charge that it creates the image of reality as simultaneous presence. There is no

question of it being a certificate of presence, for as Hollier says of the shadow, indexicality "crosses the work like the ephemeral wake of time."[34] This was also central to Barthes's conception of the temporality of the photograph. He understood the medium in general as an emanation from a past reality—a "that-has-been."[35] But this applies more acutely to the specificity of the photo-document associated with an ephemeral performance. The photo-document as performative realism follows the event, not knowing the conclusion in advance. In the first "Manifesto of Surrealism," written the same year as the "Discourse" (1924), Breton said of automatic writing that "to you who write, these elements are, on the surface, *as strange to you as they are to anyone else.*"[36]And this holds true as well for the experimental techniques used by Surrealist artists.

This brings us neatly to the subject of Surrealist manipulated photography. How can it be construed as indexical? Here again, our strategy will be to show how the indexical sign functions within Surrealist theory and practices. My argument here links indexicality to involuntariness, rather than mimesis. Mimetic realism is a set of conventions governing visual representation that allows the viewer to imagine the picture as something like a view through a window; photography, like painting, can participate in these conventions or not. In his "Ontology of the Photograph," André Bazin exaggerated the bond between indexical image and object to the point of identification, yet he also made a crucial point: "No matter how fuzzy, distorted, or discolored, no matter how lacking in documentary value the image may be, it shares, by virtue of the process of its becoming, the being of the model of which it is the reproduction; it is the model."[37] The slippage in this passage from fuzzy image to identity is clearly unjustified and Bazin further distorts the relation by declaring that the photograph gives us "the object freed from the conditions of time and space that govern it."[38] This is the very definition of "presence." Nevertheless, Bazin's remarks about the fuzzy image suggest that indexicality offers a kind of representation other than mimetic. In Charles Sanders Peirce's typology, the index is classified on the basis of its mode of inscription, that is, the close connection between the sign vehicle and the object. In his scheme, it is the icon that signifies by virtue of resemblance, and so photography is classed as a hybrid type of sign, part index, part icon.[39] But it is presumably capable of emphasizing either aspect.

Man Ray's exploration of what he called the Rayograph is an exemplary case of a type of photography that takes advantage of the aniconic-indexical aspect of the medium (fig. 1). In "Notes on the Index," Krauss observed that the Rayograph "forces

the issue of the photograph's existence as an index." She described the images result-ing from putting objects directly onto light sensitive paper as the "ghostly traces of departed objects."[40] Man Ray himself put it beautifully: he called the Rayograph "a residue of an experience . . . recalling the event more or less clearly, like the undis-turbed ashes of an object consumed by flames."[41] Although the Rayograph may be

classed as a studio trick, an in-stance of what Steve Edwards has disparagingly called "gizmo Surrealism," it is a trick that is destructive of the traditional craft of photography and in-volves a good deal of chance.[42] Rather than language-like, Man Ray's more experimental photography might be better understood as aiming at the "the look of chance." If one can take Man Ray's word for it, the techniques of solarization and the Rayograph were discovered by chance. The doubly exposed portrait of *La Marquise Casati* (1922) was, he claimed, also an accident. In "Photography is Not an Art," Man Ray listed what he considered his ten best photographs. Topping the list is "an accidental snap-shot of a shadow between two other care-fully posed pictures of a girl in a bathing suit."[43] A photogra-

Fig. 1. Man Ray (French, 1890–1976), *Rayograph (Gyroscope, Magnifying Glass, Pin)*, 1922. Gelatin silver print (photogram), 9 3/8 × 6 15/16 in. (23.8 × 17.6 cm). The Museum of Modern Art, New York. Gift of James Thrall Soby. © 2005 Man Ray Trust / Artists Rights Society (ARS), New York

pher of great technical mastery, Man Ray quipped that he had learned "to produce accidents at will."[44] In my view, photography was one of the many techniques the Surrealists used to circumvent intentionality, allowing the agency of chance to bring about the unexpected. As with Masson's automatic drawings or Max Ernst's *frottages* or the Involuntary Sculptures photographed by Brassaï, the image precedes the idea

or, better, the process precedes the image. This is perhaps why Breton believed that the "blindness" of the camera gave it access to unconscious material normally only accessible to automatism and dream.[45] Ann Banfield has discussed this aspect of the photograph, noting that "what the photograph is sensible of can be outside the ego, a thought unthought, unintended, involuntary and without meaning."[46]

Indexicality is a persistent theme in Krauss's work, mostly as the object of critique. Krauss normally associates the index with Derridian presence and the Lacanian imaginary. Her "Notes on the Index" from 1977, however, is a qualified exception. There the indexical installation work of the seventies is said to invoke "sheer physical presence" as a way of short-circuiting "the more highly articulated languages of aesthetic conventions." The indexical sign, including the photograph, "heralds a disruption of the autonomy of the sign. A meaninglessness surrounds it which can only be filled by the addition of a text."[47] Its regressive aspect, "its reduction of the conventional sign to the trace," is redeemed in her eyes by the inclusion of a supplemental text. Of course, this might also serve to characterize the situation of Surrealist photography, so much of which was originally embedded in the pages of periodicals or books. Yet, instead of opposing the mute photograph and compensatory text, my argument suggests that the Surrealists regarded both as hypersensitive recording instruments. As Man Ray said, "photography is not limited to the role as copyist. It is a marvelous explorer of the aspects that our retina never records."[48]

"Automatic writing is to invisible objects what photography is to visible ones." This Bretonian formula can be read two ways, but its context makes clear that it intends to take photography as a model for writing, and not the other way around.[49] Krauss understands photography on the model of the theory of signification established by Saussure and elaborated by Derrida. But this model does not sit easily with the value the Surrealists set on involuntariness or the weight they gave to the object.[50] The theorist of the index, Charles Sanders Peirce, had a background not in theoretical linguistics, but in chemistry and physics; one of the few books he published in his lifetime was *Photometric Researches*.[51] As a consequence, his theory of the sign was not limited to systems of communication, but included all kinds of manifestations that could be taken for signs, including symptoms, shadows, sunflowers, oxidation, and any involuntary trace of an action or condition.

Barthes's *Camera Lucida,* which revived interest in the indexical aspect of the medium, was, I believe, symptomatic of something like the Hegelian dialectic I described earlier. In the late 1970s, the theories of Benjamin, Deleuze, and Baudrillard were mobilized, mostly in the pages of *October,* to advance the idea of

photography as the paradigmatic simulacrum, the copy without an original, which strips images off the world of things so that they circulate as pure sign-images. The point of this, as Krauss put it in "Reinventing the Medium" (1999), was to mimic the condition of non-art, like the commodity or advertising, "in order to critique the unexamined pretensions of high art," such as originality and autonomy.[52] In keeping with this project, art practices that foregrounded photography's simulacral quality, such as Sherrie Levine's appropriations or Cindy Sherman's film stills, were championed. After *Camera Lucida,* critics and artists shifted their ground: Hal Foster, for example, proposed his interpretation of Warhol's photo silk screens as both simulacral and as indexically touched by the real. Sherman's later work probed disgusting substances and abject scenarios and, incidentally, made explicit reference to the Surrealist photography of Hans Bellmer.

In an article called "The Index and the Uncanny," Laura Mulvey implicitly confirmed the dialectic of the simulacral and the indexical when she suggested that the current revival of interest in the indexicality of the photograph is related to the development of digital photographic technologies.[53] Digitalization dis-indexes the photograph: there is no prior existent, no moment of exposure, no split temporality of the now of the image and the then of the event. The virtual, constructed, digital image brings back into focus the issue of indexicality. The ubiquity of the simulacrum in the age of visual culture calls, contradictorily, for the object.

1. Rosalind Krauss, "The Photographic Conditions of Surrealism," *October* 19 (winter 1981): 3–34. My references are to the version printed in Krauss, *The Originality of the Avant-Garde and Other Modernist Myths* (Cambridge: MIT Press, 1985), 107. See also "Photography in the Service of Surrealism," in R. Krauss, Jane Livingstone, and Dawn Ades, *L'Amour Fou: Photography and Surrealism* (London: Hayward Gallery, 1986), 155–94.

2. Ibid., 107. For a clear account of Derrida's pertinence to the critique of photography, see David Phillips, "Photo-Logos: Photography and Deconstruction," in M. Cheetham, M. A. Holly, and K. Moxey, *The Subjects of Art History: Historical Objects in Contemporary Perspectives* (Cambridge: Cambridge University Press, 1998), 155–79.

3. There are exceptions. See Dawn Ades, *Photomontage* (London: Thames and Hudson), 1976.

4. Krauss, "Photographic Conditions," 109; and Krauss, "Photography in the Service of Surrealism," 25.

5. Ibid., 23.

6. See Krauss, "Nightwalkers," *Art Journal* 41, no. 1 (spring 1981): 33–38. This essay on Brassaï mainly

concerns the way the photographer deploys mirrors and frames with the frame of the image to create a collage-like effect or more generally, to "establish the surface of the photograph as a representational field capable of representing its own process of representation" (37).

7. Krauss, "Photographic Conditions," 110; and Krauss, "Photography in the Service of Surrealism," 26.

8. The main challenge to the interpretation of Surrealist photography advanced by *L'Amour Fou* comes from those who focus attention on the intersection of Surrealist photography and the documentary tradition. See, for example, Ian Walker, *City Gorged with Dreams: Surrealism and Documentary Photography in Interwar Paris* (Manchester: Manchester University Press, 2002).

9. Krauss, "Notes on the Index: Seventies Art in America," *October* 3 (spring 1977): 68–81; and "Notes on the Index: Seventies Art in America (Part 2)," *October* 4 (fall 1977): 58–67. That there are discourses that endeavor to cement this relation is undeniable, as Victor Burgin remarked, "It is logocentric longing which is expressed in the "window-on-the-world" realism of the great majority of writers on photography." In "Photographic Practice and Theory," *Thinking Photography*, ed. Victor Burgin (Basingstoke: Macmillan, 1982), 55.

10. André Breton, *L'Amour fou* (Paris: Gallimard, 1937), 22; André Breton, *Mad Love,* trans. Mary Ann Caws (Lincoln and London: University of Nebraska Press, 1987), 14.

11. Originally published as "La Nuit du tournesol," *Minotaure* 7 (1935).

12. Breton, "The Surrealist Situation of the Object," *Manifestoes of Surrealism,* trans. Richard Seaver and Helen R. Lane (Ann Arbor: University of Michigan Press, 1972), 259–60. See also André Breton, "The Crisis of the Object" (1936), in *Surrealism and Painting,* trans. Simon Watson Taylor (London: Macdonald, 1972), 275–80. The part Salvador Dalí played in Breton's turn to the object is crucial but too complicated to take up in this context. See Haim Finkelstein, "Surrealism and the Crisis of the Object" (Ann Arbor: UMI Research Press, 1979).

13. Dawn Ades, "Photography and the Surrealist Text," "in Krauss, Livingstone and Ades, *L'Amour Fou,* 55.

14. Breton, "The Surrealist Situation of the Object," 273.

15. On more than one occasion Breton used the phrase "visual residues," suggestive of Freud's "day's residues" from *The Interpretation of Dreams.* See ibid., 273.

16. Sigmund Freud, *Beyond the Pleasure Principle,* in *The Standard Edition of the Complete Psychological Works of Sigmund Freud,* ed. James Strachey, 24 vols. (London: Hogarth Press, 1953–74), 14:237–58.

17. Breton, *Mad Love,* 25.

18. Margaret Cohen, *Profane Illumination: Walter Benjamin and the Paris of Surrealist Revolution* (Berkeley and Los Angeles: University of California Press, 1993), 138.

19. Breton, "The Surrealist Situation of the Object," 277. It is necessary to stress this point since some of Breton's statements about painting "referring to a purely internal model" can be easily misinterpreted. See "Surrealism and Painting" (1928), in *Surrealism and Painting,* 4.

20. Breton, "Introduction to the Discourse on the Paucity of Reality," trans. Richard Sieburth and Jennifer Gordon, *October* 69 (summer 1994): 133–44. From Breton, *Point du Jour* (Paris: Editions Gallimard, 1970).

21. Sigmund Freud, "Dream of the Botanical Monograph," in *The Interpretation of Dreams,* in *The Standard Edition,* 5:169ff. This dream appears in the section "Recent and Indifferent Material in Dreams."

22. Breton, *Mad Love,* 30.

23. Breton, "Introduction to the Discourse on the Paucity of Reality," 141–42.

24. Denis Hollier, "Surrealist Precipitates: Shadows Don't Cast Shadows," trans. Rosalind Krauss, *October* 69 (summer 1994): 114.

25. Ibid., 115.

26. Ibid., 117.

27. Ibid., 124.

28. Ibid., 129.

29. André Breton, *Nadja,* rev. ed. (Paris: Gallimard, 1964), 18; André Breton, *Nadja,* trans. Richard Howard (London: Penguin, 1999), 18.

30. Breton, *Mad Love,* 39.

31. Hollier, 126.

32. Jeff Wall, "'Marks of Indifference': Aspects of Photography in, or as, Conceptual Art," in *Reconsidering the Object of Art,* ed. Ann Goldstein and Anne Rorimer (Los Angeles: Museum of Contemporary Art; and Cambridge and London: MIT Press, 1995), 255.

33. Robert Smithson, "The Monuments of Passaic, New Jersey," in *Robert Smithson: The Collected Writings,* ed. Jack Flam (Berkeley and Los Angeles: University of California Press, 1996).

34. Hollier, 115. This preference for "use value" over "exchange value" is interesting given Marx's view, reiterated by Baudrillard, that capitalism destroys use value in favor of exchange value.

35. Roland Barthes, *Camera Lucida: Reflections on Photography,* trans. Richard Howard (New York: Hill and Wang, 1981) (trans. of *La chambre claire: Note sur la photographie,* 1980).

36. André Breton, "Manifesto of Surrealism" (1924), in *Manifestoes of Surrealism,* trans. Richard Seaver and Helen R. Lane (Ann Arbor: University of Michigan Press, 1969), 24.

37. André Bazin, "The Ontology of the Photographic Image," *What is Cinema?* (Berkeley and Los Angeles: University of California Press, 1967), 1:14.

38. Ibid.

39. Charles Sanders Peirce, "Icon, Index, Symbol," in *Collected Papers: Vol. II: Elements of Logic,* ed. C. Hartshorne and P. Weiss (Cambridge: Harvard University Press, 1931), 159ff.; and "Logic as Semiotic: The Theory of Signs," in J. Buchler, ed., *The Philosophy of Peirce: Selected Writings* (New York: Harcourt Brace, 1940), 98–119.

40. Krauss, "Notes on the Index" (Part 1), 75.

41. Man Ray, "The Age of Light," in *Classic Essays on Photography*, ed. Alan Trachtenberg (New Haven, Conn.: Leete's Island Books, 1980), 167.

42. Steve Edwards, "Gizmo Surrealism," (review of *L'Amour Fou: Photography and Surrealism*), *Art History* 10, no. 4 (Dec. 1987): 509–16.

43. Man Ray, "Photography is Not an Art," in *Surrealists on Art*, ed. Lucy Lippard (Englewood Cliffs, N.J.: Prentice-Hall, 1970).

44. Neil Baldwin, *Man Ray: American Artist* (New York: Da Capo Press, 1988), 158.

45. André Breton, *Les Pas perdus* (Paris: Gallimard, 1924), 101; also, André Breton, *The Lost Steps*, trans. Mark Polizzotti (Lincoln: University of Nebraska Press, 1996), 60.

46. Ann Banfield, "*L'Imparfait de l'Objectif*: The Imperfect of the Object Glass," *Camera Obscura* 24 (Sept. 1990): 85.

47. Krauss, "Notes on the Index" (Part 1), 81 and 77.

48. Man Ray, "Deceiving Appearances," in Christopher Phillips, ed., *Photography in the Modern Era* (New York: Metropolitan Museum of Art and Aperture, 1989), 12.

49. The precise formula is Hollier's. See Hollier, "Surrealist Precipitates," 124. He quotes Breton in the footnote: "The invention of photography has delivered a mortal blow to the old forms of expression, painting as well as poetry for which automatic writing, appearing at the end of the nineteenth century, is the true photography of thought." ("Max Ernst" [1921], in Breton, *Les Pas perdus*, 101; "Max Ernst," Breton, *The Lost Steps*, 60).

50. In fact, Derrida's conception of writing implies a good deal of involuntariness, but this aspect is not stressed by Krauss.

51. Charles Sanders Peirce, *Photometric Researches (Made in the Years 1872–1875)* (Leipzig: W. Engelmann, 1878). Other titles are *Note on the Sensation of Color* (New Haven, 1871) and *Gravity Research: Effect of the Flexure of a Pendulum upon its Period of Oscillation* (Washington, D.C.: Government Printing Office, 1885).

52. Krauss, "Reinventing the Medium," *Critical Inquiry* 25 (winter 1999): 295.

53. Laura Mulvey, "The Index and the Uncanny," in *Time and the Image*, ed. Carolyn Gill (Manchester: Manchester University Press, 2001).

Eros and the Readymade

Helen Molesworth

The now standard reception of Marcel Duchamp's readymades is that they ushered the forces of mass production into the realm of art, permitting seriality to become a dominant mode of practice for many twentieth-century artists. Further, the readymade, chosen with what Duchamp called "aesthetic indifference," is understood to be an antiart gesture designed to counter the fetishism of the visual, particularly the visuality of painting. Duchamp repeatedly used the word "antiretinal" to signal this tendency of the readymade. The strong axis of mass production and the antiretinal have combined to form a genealogy of art that can be loosely called conceptual, inasmuch as the idea behind the art is seen to be as important, if not more so, than its visual manifestation. This narrative generally offers us pop art and minimalism, followed quickly by conceptual art and institutional critique, as the rightful inheritors of the implications of the readymade.[1] I would like to take some small steps toward articulating an alternative genealogy, both in this paper and in a forthcoming exhibition entitled *Part Object Part Sculpture*.[2] I think the American reception of Duchamp's readymades may have unwittingly and unwisely unhooked Duchamp's erotic concerns—which find themselves in the *Large Glass,* the erotic objects, and *Etant donnés*—from the readymades. To untether the readymade from the erotic in Duchamp is to neglect other versions of art and the commodity, sculptures and viewers, subjects and objects.

One of Baudelaire's many complaints against sculpture was that it had too many vantage points from which to apprehend it.[3] Perhaps no artist relished in this putative failing of sculpture more than Duchamp, who was often looking for a way out of the trap of a precisely controlled viewing situation. In 1913 he invented the readymade by conceiving of the commodity object as an engine for making sculpture. During the teens the mechanics of this operation largely comprised choice, purchase, and display; Duchamp allowed his artistic process to mime the relations and logic of the commodity world. As he strolled the markets of Paris and the streets of New York looking for commodities to transform into art, he performed another of Baudelaire's complaints against sculpture: that it "suffers because it too easily becomes indistinguishable from a luxury object."[4] While one would be hard pressed to view the array of mundane and domestic objects chosen by

Duchamp as luxury items (a hat rack, a coatrack, a bottle rack, a comb), the problem of indistinguishability was acute, and, consequently, most of the original readymades were lost, discarded, or simply went unnoticed. And although Duchamp had publicly abandoned art-making for a life of chess by the 1920s, the postwar reception of his work was one of steady interest, and the lost readymades—now known almost exclusively through photographs—were in increasing demand.

It is well documented, but not much discussed, that the Swedish curator Ulf Linde and the Italian dealer Arturo Schwarz came to Duchamp's aid in the early 1960s by making handmade versions of the readymades.[5] Linde first made copies of *Bicycle Wheel* and *Fresh Widow* for a gallery exhibition of Duchamp's work in Stockholm. Later, the Museum of Modern Art in Sweden (the Moderna Museet) commissioned Linde to make a copy of *The Large Glass* as well as a complete set of readymades. Linde fabricated some of the objects himself, some (*Paris Air*, for instance) were produced by local craftspeople, and the Linde version of *Fountain* was purchased directly from a restaurant. In 1961 Duchamp journeyed to Stockholm to review Linde's work, and while there signed the objects with both his signature and the phrase "copie conforme," and further requested that all of the works be donated to the permanent collection of the museum. In an ironic turn of events, many of Linde's copies were sent to Milan to Arturo Schwarz's gallery for an exhibition held there in 1963, precisely at the moment Schwarz was beginning to work on his own newly fabricated readymades. The set Schwarz made in 1964 was overseen by Duchamp at every turn, and accuracy was of the essence, as Schwarz hired professional engineers to make blueprints of the readymades based on the photographs and professional craftsmen to make the objects.[6] The dominant art historical reception of the readymade sees it as the agent which introduced the forces of mass production into the realm of art, yet this account too easily neglects this wrinkle in the story. That Duchamp turned commodity production into a cottage industry staffed by Swedish and Italian craftsmen comes with all the requisite Duchamp irony. Yet if the meaning of objects (art and otherwise) derives as much from their function as their production, the handmade quality of the readymades and Duchamp's explicit decision to have them refabricated in editions is a knot worth trying to untie.

It may be that we need to take a step back. Despite Duchamp's alleged abandonment of art, during the early 1950s he produced three small enigmatic and erotic sculptures. In time, they were understood to be preambles to Duchamp's last and most inscrutable work, *Etant donnés*. The simultaneously phallic and scatological *Objet-Dard* (fig. 1) is a remainder from the process of breaking the mold for the woman's

body in *Etant donnés,* specifically the part of
the mold that supported an area under her
breast. Similarly, *Female Fig Leaf* (fig. 2) is
cast from the figure's particularly mysterious
genitals. *Wedge of Chastity* (fig. 3), a wedding
gift to Duchamp's bride, Teeny Matisse, came
a few years later. Comprising two pieces that
fit snugly together, hand in glove, the wedge
is fashioned of galvanized plaster and the base
is made from a handful of the material used
to make dental impressions. The interior of
the object has never been photographed (al-
though it bears a strong resemblance to a
photograph of *Female Fig Leaf* that appeared
on the cover of André Breton's magazine *Le
Surréalisme meme*); it is a shocking pink and

Fig. 1. Marcel Duchamp, (American, born France, 1887–1968), *Objet-Dard (Dart-Object)*, 1951. Galvanized plaster with inset lead rib, 2 ¹⁵/₁₆ × 7 ¹⁵/₁₆ × 2 ³/₈ in. (7.5 × 20.1 × 6 cm). © Succession Marcel Duchamp, 2004. Artists Rights Society (ARS), New York/ADAGP, Paris

is an intensely intimate, loving, and erotic depiction of a pussy.[7] Relatively soon after
these works were made, Duchamp authorized their replication into cast editions of
eight. Even the intimate wedding present was reproduced.

 The objects share a domestic scale: they are things to fit on tables and man-
tles rather than floors and pedestals. Their modest scale gives them a migratory quality
that Duchamp acknowledged when discussing *Wedge of Chastity:* "We still have it on

Fig. 2. Marcel Duchamp, *Feuille de Vigne Femelle (Female Fig Leaf)*, 1950. Galvanized plaster, 3 ⁹/₁₆ × 5 ¹/₂ × 4 ¹⁵/₁₆ in. (9 × 14 × 12.5 cm). © Succession Marcel Duchamp, 2004. Artists Rights Society (ARS), New York/ADAGP, Paris

our table. We usually take it with us, like a
wedding ring, no?"[8] I find the quickness of
this elision telling, to think that an object as
curious and oblique as *Wedge of Chastity* could
so easily be held in relation to a readymade
(or luxury object!) like a wedding ring. It is
precisely the relation between the erotic ob-
jects and the readymades that I would like to
explore, especially given the fact that by the
late 1950s editions of the erotic objects had
already begun to circulate. Schwarz exhibited
them in Milan, where they were almost cer-
tainly seen by Lucio Fontana and Piero
Manzoni. Manzoni, in turn, showed *Female*

Fig. 3. Marcel Duchamp, *Coin de Chasteté (Wedge of Chastity)*, 1954. Galvanized plaster and dental plastic, 2 3/16 × 3 3/8 × 1 5/8 in. (5.6 × 8.6 × 4.2 cm). © Succession Marcel Duchamp, 2004. Artists Rights Society (ARS), New York/ADAGP, Paris

Fig Leaf to Marcel Broodthaers; it was the first work by Duchamp he had seen.[9] By 1960 it appears that Jasper Johns owned a version of all three objects, thus the reception of Duchamp came as much through these objects as through the readymades. Importantly, it was only after these intimate cast objects were reproduced and circulated that Duchamp authorized Arturo Schwarz to fabricate a set of the then mostly lost readymades.

So why simply purchase more readymades? After all, Duchamp had done just that when he first arrived in New York after leaving the original *Bicycle Wheel* in Paris. Schwarz maintained that making the readymades by hand to the specifications of the photographs was to keep them as much like those out-of-date looking originals as possible, not like their more modern available substitutes. According to Schwarz, "He wanted a perfect reproduction of the original. The only way to do it perfectly was to do it by hand. There was no other way. How could he reproduce something that was manufactured over half a century before?"[10] Duchamp never quite addressed the issue head-on, although he certainly maintained that readymades were chosen with "visual indifference." When asked by an interviewer in 1967 how a readymade should be looked at, Duchamp responded: "Ultimately, it should not be looked at. Through our eyes we get the notion that it exists. But we don't look at it the way we look at a painting. The idea of contemplation disappears completely. One simply notes that it's a bottle rack, or that it was a bottle rack and has changed direction."[11] But if that's the case, then why go through all the trouble of having them remade by hand? Of course Duchamp had been going through the trouble of reproducing his oeuvre for quite some time, as the *Boite en Valise* will attest. It seems to go without saying that he was an artist deeply interested in the problem of reproduction. But making readymades by hand? What's that about?

I only have some provisional answers, but I think that the historical proximity of the intimately scaled and handmade erotic sculptures and the 1964 handmade edition of the readymades suggests connections between the erotics of the body and the allure of the commodity object and that Duchamp's sculptural practice is

partially made up of the relays between such different stagings of desire. Perhaps the reproductions of the erotic objects created a sense of permission, or a field of possibility, for the production of handmade readymades. Handmade readymades offer a model of repetition that is more analogous with erotic or bodily modes of repetition, rather than the repetition of the assembly line. The erotic casts and the crafted readymades maintain a productive and structuring tension between the forces of reproduction that make commodities and the forces that make art. Rather than collapsing these modes of production and reproduction, the handmade ready-made of 1964, like the erotic editions of the late 1950s, stage the problem of the art/commodity object anew.

I want to return to the temporal proximity of these two sets of objects. If the readymades were a conundrum, objects that resided in an uneasy place of legibility, inasmuch as they could not be registered as art by those who first encountered them, then the cast objects are memory molds, fossils of psychic states; *Objet-Dard* is a remnant of a work of art—or better yet of the process of making a work of art. *Female Fig Leaf* is the memory of a body—albeit a fictional one. And the last of the triumvirate, *Wedge of Chastity* memorializes the ineffable quality of the erotic encounter and is a mnemonic for intimacy and fidelity, "like a wedding ring." Perhaps Duchamp's desire to have *Wedge of Chastity* function "like a wedding ring" was a desire for it to be read along standard social conventions, for it to be legible, as well as portable.[12] The problem with the original readymades was that their legibility, their ability to be construed or understood as art, was compromised with every move—from Paris to New York, from the halls of the Independents Exhibition to Stieglitz's studio—in each instance they were discarded or misplaced, no longer available to perform the role of art. One of the foremost roles of art is to make things visible. Art gives public form to thoughts and feelings, to ideas and bodies, to history and memory. One of the most important things the readymade continues to do is give this legibility to the eccentricities and vagaries of the commodity, to the deep peculiarity of objects, to the ways in which commodities trip us up or act as a trap, or precede us. One of the ways readymades make the commodity legible is by making the body legible. Bodies become legible in their encounters with readymades because they are either called into humorous action (go ahead, hang up your hat) or stymied by their inability to use a previously functional thing (the inverted urinal).[13] As we trip over *Trébuchet* in Duchamp's studio or spin the *Bicycle Wheel* or puzzle over what to do with *In Advance of a Broken Arm,* Duchamp's readymades of the teens set into motion an intense relay between bodies and things,

each making the other visible. Perhaps it is no mistake that the little girl of *Apolinère Enameled* is painting her bedpost, marking it so both she and it can be seen. In turn, however, no matter how newly animated bodies might have become in the face of the readymades installed in Duchamp's studio (little machines for slapstick), the objects were routinely thrown away, forgotten, or destroyed; the readymades were commodities that ceased to be legible either as art or as a commodity worth saving. In many ways the readymades didn't become truly visible until after the war, when people wanted to include them in exhibitions, and when Duchamp allowed others (such as Sidney Janis) to purchase them for him.[14] Yet it is precisely during this period that Duchamp began to make his erotic sculptures by hand, and when he was secretly involved with the beginnings of *Etant donnés*. And it was at this time that he began to imagine a series or edition of readymades made by hand, to the exact—or as exact as possible—specifications of the originals. As handmade objects, they became legible as art—finally. No one will ever lose or misplace or discard or destroy a 1964 handmade readymade. They have migrated off the floor, they have come down from the ceiling, and sit properly on pedestals—like art—and as such, they are as legible as a wedding ring.

But perhaps there is one other intermediary step. When Duchamp "installed" the first replication of the readymades in the *Boite en Valise* he positioned them in league with the *Large Glass,* where they hang like a vertical predella explicating, and being explicated, by the stalled machine of desire that is *The Bride Stripped Bare by Her Bachelors, Even.* (This installation was staged again by curator Walter Hopps in the 1963 Pasadena exhibition of Duchamp's work.) This pointed co-presentation is a way that Duchamp might have had of talking about the possible relationships between the readymades and the *Large Glass*—between a set of objects that call the body into new ways of being, a set of objects at a liminal threshold between being a commodity and being something else—a readymade (if not a full blown art object) and the kind of transformative but stymied erotic encounter imaged by the *Large Glass*. In other words, it was a way of talking about the effect of things on the body, and the bodiliness of things.

This installation of the readymades helps to show us something about the corporeality of art and the potential reciprocity between the eroticism of the body and the sensuality of objects—art and otherwise. Here the commodity is shown to be a profoundly psychic object with erotic dimensions, as the readymades mirror the sexual division and frustration of the *Large Glass*—with *Paris Air* as an archetypal sinuous female form; *Traveler's Folding Item* a simultaneous chaste pro-

tector and striptease waiting to happen; and finally *Fountain,* here turned upright—as if to offer at least some form of male release. And, just as there are three migratory commodities held in relation to the *Large Glass,* so the three erotic objects are clues to the as yet unveiled *Etant donnés,* snapshots of a picture not yet seen. If the 1964 set of readymades is the past reincarnated, then the three erotic objects are (or were) artifacts of the future.

In closing I would like to offer the following hypothesis: Duchamp repeatedly stated that one aim of the readymade was to be antiretinal, but I don't think he ever meant for them to be antibodily. Indeed, Duchamp's claims for the antiretinal can here be seen as having more to do with bodily modes of apprehension, memory, and legibility than ideas about art in the service of the mind. This suggests that Duchamp was a purveyor of object relations that are in keeping with those of Melanie Klein, in which parts are taken for whole and objects are apprehended through a wide range of bodily modes that often supercede the visual as such, where an intense cathexis onto objects is manifested in a manner that is quite demonstrably bodily and tactile. Duchamp doesn't offer us the *Large Glass* and *Etant donnés* as static objects to be puzzled over visually. Rather, their accompanying set of objects suggests that there is no adequate way to stage the problem of either vision or desire without recourse to a tactile relationship with the object world. This is precisely because our psychic lives become intricately bound up in things (commodities or art), and sculpture and its repetitions offer the most charged course to untie the knot of eroticism, repetition, and commodities that governs our daily lives.

1. While this is a generally accepted genealogy, its most articulate forms are found in: Benjamin Buchloh, "Conceptual Art 1962–1969," *October* 55 (winter 1990), and Martha Buskirk and Mignon Nixon, eds., *The Duchamp Effect* (Cambridge: MIT Press, 1996), especially Hal Foster, "What's Neo about the Neo-Avant-Garde?" and a roundtable featuring Buchloh, Rosalind Krauss, Alexander Alberro, Thierry de Duve, Buskirk, and Yves-Alain Bois, "Conceptual Art and the Reception of Duchamp."

2. In the fall of 2005 the Wexner Center for the Arts at the Ohio State University will mount *Part Object Part Sculpture,* dedicated to such an alternative genealogy of postwar sculpture. For some time, postwar sculpture has been dominated by the powerful concerns and legacies of minimalism. As such, seriality, industrial processes and materials, and phenomenology have fueled the reigning discourse for much of the past thirty years. This is not to suggest that other modes of working and other forms

of sculpture were either absent or without their own prominence—we need only think of Robert Rauschenberg and Eva Hesse. Yet the dramatic, even shocking, nature of such artists' oeuvres has often been seen as a rupture or punctuation in an otherwise tidier story. *Part Object Part Sculpture* offers a counternarrative in which the impulse to repetition is sparked by the body and not the machine, where repetition itself is organic and evolving rather than identically machined in its seriality. This is work that resonates physically and psychically, both consciously and not. Suspended between the everyday allure of the commodity and the autonomous realm of art, the artwork in the exhibition demonstrates a sustained exploration of both the limits and porous boundaries between the dual realms of object and sculpture.

3. See Charles Baudelaire, *Art in Paris 1845–1862,* trans. and ed. Jonathan Mayne (London: Phaidon, 1965), 111, especially on the Salon of 1846: "Why Sculpture is Tiresome."

4. As quoted in Alex Potts, *The Sculptural Imagination: Figurative, Modernist, Minimalist* (New Haven: Yale University Press, 2001), 63.

5. The two notable exceptions are William Camfield, *Marcel Duchamp/Fountain* (Houston: Houston Fine Art Press, 1989), and the unpublished lecture by David Joselit, "The Belated Career of the Readymade."

6. Ulf Linde asserts that the blueprints were actually made from his replicas. Conversation with the author, 19 Apr. 2004, Stockholm.

7. I was able to view the interior of *Wedge of Chastity* at the Marcel Duchamp Archive at Villiers-sous-Grez, 19 Dec. 2003.

8. Pierre Cabanne, *Dialogues with Marcel Duchamp* (New York: Da Capo Press, 1979), 88.

9. On the relations between Broodthaers and Manzoni, see Rachel Haidu, "Marcel Broodthaers 1963–1972 or The Absence of Work" (Ph.D. diss., Columbia University, 2003).

10. Conversation with the author, 16 Dec. 2003.

11. "Marcel Duchamp Talking about Readymades: Interview by Philippe Collin, Galerie Givaudan, Paris, 21 June, 1967," in *Marcel Duchamp,* ed. Museum Jean Tinguely, Basel (Ostfildern-Ruit: Hatje Cantz, 2002), 38.

12. On notions of transportability and Duchamp see T. J. Demos, "Duchamp Homeless? The Avant-Garde and Post-Nationalism" (Ph.D. diss., Columbia University, 2000).

13. On the physicality of the readymades, see Helen Molesworth, "Slapstick and Laziness: The Everyday Life of Marcel Duchamp's Ready-mades," *Art Journal* (Jan. 1999): 50–61.

14. On the belatedness of the reception of Duchamp see Foster, "What's Neo about the Neo-Avant-Garde?"

CONFERENCE RESPONSES

Responding to Allure

Martha Buskirk

Why "the lure of the object" now? The title indicates both an urge to reconsider the significance of the object—within the field of art history, or indeed more widely—and perhaps also a bit of a justification: we just couldn't help ourselves, the object continues to attract, to exert its seductive allure.

In fact, the talks we've heard over the two days of the conference run the gamut, from addressing the work of art as synonymous with a physical object, which in turn carries inherent material evidence of its status, to, at another extreme, considering works that may comprise no more than a declaration. There are many points between, of course, occupied by works based on strategies of designation or fabrication, as well as the myriad variations of the ephemeral. Furthermore, an experience based on a physical presence, particularly one that is jarringly recontextualized, does not necessarily equal a secure identification of the work with a particular manifestation. I am referring to the difference, in other words, between a work that could survive a sojourn in a flea market and return as a major find, and those other physical forms (bathroom fixtures, provisional arrangements of material) that would simply lose their status and slip away when unmoored from a certain type of context and provenance.

The relationship between the object and the photographic document is also a key concern. In fact, photographs have been avidly collected by connoisseurs to aid in the comparative study of the physical object, even as they may also be implicated in a lack of attention to materiality. By extension, there is the role of the photograph in systems of classification by which the imaginary museum of the reproduction exerts its influence over the collection of objects within the museum's walls. And finally, in this movement around materiality, there is photography's wedge, contributing to the undoing of medium divisions as a way of thinking, or perhaps assuming, the relationship between effect and material support.

It was therefore telling how the first and last talks bracketed the subjects under discussion—the conference opening with John Brewer's account of the controversy created by Duveen's dismissal of a purported Leonardo and concluding with Helen Molesworth's consideration of Duchamp's late work. What I found suggestive here was the opposition between, in the case of the disputed Leonardo,

a painting that was physically unchanged yet susceptible to a radical alteration in status depending on the plausibility of its attribution and, with the Duchamp readymades, a series of works whose identity as idea had a certain continuity, even as their physical embodiment was subject to numerous detours and delays. But of course Molesworth's talk was not just about the unfolding history of the readymades, since she made a telling connection between the readymade editions of the sixties and the erotic objects that immediately preceded them. Molesworth's emphasis on this aspect of Duchamp's production, in turn, suggested an interesting point of comparison to Emily Apter's consideration of the link between the commodity and the sexual fetish in Warhol's work. Yet another affinity is the play with the artist's name as a form of brand, with the deployment of authorship as a way of transforming the status of an object—including, of course, having a tremendous impact on its market value.

Such declarations of authorship are at once an outgrowth of the classification system upheld by connoisseurship and, at the same time, a concerted challenge to the desire to find inherent evidence of authorship, though with the final twist, in the Duchamp readymade editions, that we now are most likely to experience these works through specially made, essentially sculptural objects standing in for the lost products of mass production. There are also suggestive echoes, if accompanied by sharp differences, in Warhol's collecting and the much earlier cabinet of curiosities that was the subject of Mark Meadow's paper. Meadow's own experiment with trying to understand the impact of the cabinet through an exhibition of recently used objects supports this comparison, even if the parallel begins to break down around the issue of order (or lack thereof) in Warhol's obsessive hoarding.

Another of the interesting threads running through several papers linked the different ways that objects may be represented in conjunction with procedures of ordering and categorization. In papers presented on the first day, Edward Sullivan drew our attention to the cultural specificity of the goods and produce depicted within a series of Mexican paintings that of course also function as objects in their own right, whereas Martha Ward examined René Huyghe's work as editor and curator, considering the nature and use of photographic reproduction at a crucial moment for its theorization during the thirties. Intertwined with the issue of reproduction, a related strand is the question of how knowledge about the object is obtained, and, of course, its impact on interpretation. This was clearly an important question in a cluster of papers from the second day, where we had a juxtaposition of Karen Lang's consideration of the "eye" of the connoisseur, Malcolm Baker's call

for a critical reinvestment in the analysis of technique, and Ewa Lajer-Burcharth's interrogation of a kind of "cost" to the artist in an approach to painting that she introduced with an X-ray view of aspects of the work not accessible in the surface presented to the viewer.

It is around these issues that we also need to look back to Christian Scheidemann's description of the conservation challenges posed by the remarkable array of materials taken up by contemporary artists. One of the striking features of Scheidemann's account is how an analysis of the evidence that might be inherent in the object has been supplemented, perhaps at times even supplanted, by a more collaborative process of working directly with the artist. In this process the conservator's interpretation of the artist's declared intent forms a basis for decisions about the work's ongoing physical constitution.

One paradox of this incredible material specificity is how it follows upon the dissolution of earlier medium divisions as operative categories, and more specifically, upon a final demise linked to the intervention of conceptual practices of the sixties and seventies. We have indeed witnessed, in recent works, the fracturing of materials, forms, and effects into increasingly separable elements, where precise decisions are often difficult to generalize into broader categories, and the artist is faced with the question not only of how, but indeed whether, the work might be realized as a physical object. The various photographies that George Baker mapped onto Rosalind Krauss's expanded field demonstrated this fracturing of the photographic, already present in the quotation of cinematic or other effects in the context of traditionally produced photographs, and far more dramatically broken asunder in the digital era. And it is therefore telling that Margaret Iversen ended her paper with the speculation that the interest in the indexical is an effect of photography's current dissolution as a medium.

I have a couple of final observations, generated by the intersections of these many papers. One point concerns the suspicions about the return to the object (the "I don't work on" or "I don't make objects" recounted by Stephen Melville in his introductory remarks). In this respect, the idea of a certain seductive lure can be connected to the discussions of a return to beauty so in vogue a few years ago— which could be cynically viewed as a market subterfuge masquerading as a more disinterested form of appreciation. There can be little doubt of the link between connoisseurship and market imperatives (Brewer and Lang certainly dispelled any), but related forces are also present in Duchamp's participation in the limited editions discussed by Molesworth, or the works that occupy the different diagram

points in Baker's expanded field of photography, which are nonetheless closely linked by their status as works made for an exhibition context (rather than for some of the alternate distribution systems deployed in the earlier play with the photographic document in the context of conceptual art).

My other thought is more in the form of an open-ended speculation: it concerns what we may be trying to access through the object—with, for example, the idea of a direct connection to the artist mystified by the connoisseurs cited by Brewer (the marketing of an experience rather than a commodity), in comparison to something of the opposite in the works of Dan Graham cited by Apter, where there is a cut to the chase, with the physical object removed from the equation. What the conference leaves us with, then, is not the resolution of these issues, but evidence of an ongoing process of exchange between renewed attention to earlier formations and consideration of the shifting relation to the object in contemporary practices.

The Lure of the Object

Marcia Pointon

We have heard a compelling but fissiparous set of papers. As a respondent, I have felt like an archaeologist before a collection of ceramic shards to be stuck together to form the semblance of an amphora. As with such a reconstruction, so with this response, the gray area of paste may, I'm afraid, sadly exceed the beautifully colored pieces.

I turn first to the word *object,* as rich as any in the English language; the use of the word to describe an artwork comes very late—the first recorded use is 1862. John Brewer reminds us, as do also (in different ways) Helen Molesworth and Emily Apter, of the centrality of art-object/object-art to the history of capitalism and commodification, while Mark Meadow argues for an a priori moment of collecting things that are not reducible to art as formative to the political and cultural shift from modernism to postmodernism with which so many speakers have been concerned.

The metaphorical use of the word *object* as a "thing or being of which one thinks or has cognition, as correlative to the thinking or knowing subject" (OED), which is a much earlier application (dating back at least to 1513), underpins many of the papers we have heard insofar as they implicitly or explicitly presuppose a viewer. And yet as early as 1398 an object was understood to be (merely) what is seen or perceived, as well as what is admired. We should, however, note that the thing before our eyes in this instance is a material thing—whether in actuality, as with Malcolm Baker's examples of sculpture, and the work of Matthew Barney, as cited by Christian Scheidemann; or in representation, as the fruit and vegetables painted by Mexican artists discussed in Edward Sullivan's paper. I will return to this question of materiality. Hovering over this conference there have been, however, other connotations of *object:* an intention (through medium and technique), as with George Baker's paper; or the notion of something that might stand in the way, as with "money is no object," or "objectionable," as some objects discussed might arouse disgust rather than pleasure. Especially problematic because of where we are speaking from in 2004 is the use of object in "objective"; Karen Lang's discussion and analysis of the objectivity of art history's own history casts invaluable light on this troubled area, while Brewer's case points up a politics as well as a history of competing claims for objective versus subjective in the diad which, as Apter remarked, we keep slipping into. However, I suggest there is a further political

dimension to this: the term *objective* is problematic precisely because in the West we no longer believe in the desirability or possibility of objectivity. Just as *disinterested* is now widely used to mean "uninterested"—a shift reflecting the fact that we can perhaps no longer believe in the idea of a disinterested human subject— so *objective*, whether in science or politics, no longer carries conviction.

Academics in general write for a small circle of other academics who share their preoccupations. Therefore, I would like to tie things up by broadening them out, with an eye to the history in art history. In his introduction, Stephen Melville told us the conference was not to be about images, not about representation, not about material culture. Yet, the speakers he has so magnificently assembled for us have, it seems to me, brought all these things into the arena. And in discussion today, in particular, it has been rewarding to witness the identification of what Karen Lang rightly calls aporias between vision and writing, the optical and the haptic. Objects are, to use Nicholas Thomas's formulation, entangled in discourse[1] but they are not, in my view, eradicated by that entanglement. It seems that one of the things we have witnessed at this conference is a struggle between language and material, between plasticity and metaphoricity.

Sight is central to notions of trust, truth, and reliance. If the eye requires objects on which to focus or, to put it the other way around in a relationship that is by no means clear, if the object attracts the eye, that object attains—as Margaret Iversen puts it—the status of authenticating the real or, as others have expressed it, the object is overdetermined by social and representational structures. Yet, as Malcolm Baker demonstrates, materiality is not a static matter. What is seen is also historically conditional. Nonetheless, the idea of authentication is powerful and widespread. The word *evidence* comes from *videre* and, as Derrida pointed out, before doubt ever became a system, "skepsis" has to do with the eyes.[2] Thus, on the one hand Scheidemann proposes here that the materiality of the object offers access to the artist's intentions while, on the other, in Apter's meditation on fetishism, it permits "mobile semiosis between thing and living subject."

We have heard little of the other senses, at least until today's discussion. And yet, historically, seeing is not perhaps so preeminent in the engagement with the object. Doubting Thomas needed to touch Christ's wounds in order to be convinced, and Medea's terrible revenge against Jason's new wife only became effective with the touching of the dreadful poisoned dress she had sent as a gift. Smell and hearing may play their part, but the tactile has been largely rinsed clean by the dominant discourses and practices of the modern museum and its heirs (where sculpture is more

likely to be used as a repository for empty wine glasses at corporate receptions than touched in a spirit of discovery), and by the photo-technologies of contemporary art. Nonetheless tactility was until relatively recently an effective means of luring the subject. Jamnitzer's box demands to be opened to fully reveal its taxonomic and object: rich plenitude. Here, in a slightly later example, is the eighteenth-century collector Horace Walpole, who owned flat art in profusion, on his prized possession, a complex artifact known as the Lennox jewel that he has been asked to lend for the purposes of engraving: "it is so complex and intricate; it opens in so many places, and the springs and hinges are so very small and delicate, that when I do show it, which is very rarely indeed, I never let it go out of my own hands."[3]

As Malcolm Baker points out, because of the slippage between the dimensional image and its reproduction, questions of facture have been easy to avoid. It is, however, not only with sculpture that this is hardly a possibility. I would go further and suggest that discussions of questions of uniqueness and value that have been significant in this conference—whether through the work of Dan Graham, Marcel Duchamp, or Chardin—would benefit by reference to a preindustrial era when artifacts were unique and value-laden through a relationship of subject to object that was either explicitly tactile (as with boxes that have to be opened) or implicitly so (as with relics within a reliquary or a shrine). Some of us remember the game "animal, vegetable, mineral" played on boring car journeys before SUVs with DVDs existed. This is not a game that could be played easily with digitalized art. Moreover, as Iversen and Apter indicate, artists have begun to challenge and break down the distinctiveness of human as subject, not object, as had prevailed in museums other than those of medicine and anthropology, with their collections of body parts that continue to pose curatorial problems.

Historically, the plasticity of objects juxtaposed to the warmth and limpidity of flesh has involved the tomb and a degree of magic or spirituality. I was forcefully reminded of this in Ewa Lajer-Burcharth's analysis of Chardin. I have said nothing yet of the "lure" in "the lure of the object," but I have found it difficult not to associate this exclusively with sinister situations. One is not lured to a friendly family picnic; one is lured to the evils of Vanity Fair, as described by John Bunyan in *Pilgrim's Progress* (1684), and thus to perdition.

It is therefore proper to remind ourselves that the first objects known to have been associated with human life have been generally found at burial sites and associated with the need to bridge distances between subject and states, living or dead. Capitalism and commodification, far from eliminating, actually heighten

that relationship between the object and what is deathly. I will conclude, therefore, with what I hope to be a fitting epilogue, the personal record of one person's encounter with an object in a context characterized by commercialism and museology, but an encounter that took place over two hundred years ago.

In 1786 Sophie von la Roche, an educated and passionate German traveler, visited the recently established British Museum. Crucial to her experience is touch: handling objects triggers her desire to empathize and her ability to imagine the past. "With what sensations one handles a Carthaginian helmet excavated near Capua," she declares, and she wishes that a noble-minded young Englishman could survey the standards of the Roman legion called "Victrix." Attracted by the mirrors that once belonged to Roman matrons, she picks one up and, with it in her hand she says:

> I looked amongst the urns, thinking meanwhile, "Maybe chance has preserved amongst these remains some part of the dust from the fine eyes of a Greek or Roman lady, who so many centuries ago surveyed herself in this mirror, trying to discover whether the earrings and necklet before me suited her or not." Nor could I restrain my desire to touch the ashes of an urn on which a female figure was being mourned. I felt it gently, with great feeling, between my fingers, but found much earth mixed with it. The thought, "Thou divided, I integral dust am still," moved me greatly, and in the end I thought it must be sympathy which had caused me to pick this one from so many urns to whose ashes a good, sensitive soul had once given life. This idea affected me, and again I pressed the grain of dust between my fingers tenderly, just as her best friend might once have grasped her hand, complaining that she had but ill reward for her kindness, or that her best intentions were misread. And gently I returned the particle I had taken to the rest of the dust, murmuring to myself, "Forgive Hamilton and me for breaking in on your peace." I had become quite attached to that ash and would have liked to bury it somewhere, so as to prevent its being shaken up and fingered again; but how was I to shield that which had been taken from its mother's womb one thousand years ago?[4]

1. Nicholas Thomas, *Entangled Objects: Exchange, Material Culture, and Colonialism in the Pacific* (Cambridge: Harvard University Press), 1991.

2. Jacques Derrida, *Memoirs of the Blind: The Self Portrait and Other Ruins* (1990), trans. P.-A. Brault and M. Naas (Chicago and London: University of Chicago Press, 1993).

3. Horace Walpole to the earl of Buchan, 29 Nov. 1792, in *The Yale Edition of Horace Walpole's Correspondence,* ed. W. S. Lewis (New Haven and London: Yale University Press, 1955), 15:233–34.

4. Sophie von la Roche, *Sophie in London 1786, Being the Diary of Sophie von la Roche,* trans. C. Williams (London: Jonathan Cape, 1933), 107–8.

Afterword

Stephen Melville

"The Lure of the Object" was, unusually perhaps, a conference aimed at producing or transforming questions rather than answering them, and so it was probably inevitable that the bulk of the conference's actual work happened above all in the discussions this volume cannot reproduce. What the volume does provide is the grounds for renewal or prolongation of the conversations that animated the two days at the Clark, and in doing that, it asks for readings focused less on the individual papers than on the various strands of relation among them that mark the various ways that close encounters with particular objects offer possibilities for thinking again about what "objectivity" might mean in art history.

The conference's discrete sessions offer one guide to where and how such readings might unfold—the first session, for example, brought together meditations on the inner workings of the modern construal of subjectivity and objectivity in marked contrast with circumstances in which things are organized and construed in fundamentally different terms, such that the things we are used to calling "subjects" show themselves as more peculiarly implicated in a field of objects that are not simply, epistemologically or proprietarily, theirs. At the same time, this session also offered starting places for readings that cut through the whole of the conference at various angles. There is, for example, a thread of possible reading balanced on a complex series of questions about what it is to exhibit an object—about conditions of exhibition but also about where exhibition starts and stops, and how it is continued—that finds its center straightforwardly enough in curatorial concerns but is interestingly extended across issues of both conservation and reproduction. And there's another path of reading marked by repeated questions about the difference psychoanalysis makes in how we understand an object—a question that is always also about the economies in which we and it participate. Both these lines of question are interrupted or traversed by another track in which our predisposition, at once casual and oddly deep, to hear "object" as carrying strong implications of mass and dimensionality finds itself played off against our increasing willingness to imagine art history as a discipline of the image—as if the relation between sculpture and photography were now a place of complex disciplinary decision. Other tracks are more shadowy: criticism, perhaps obliquely

figured in the discussion of the contemporary work's determination in conservation, abruptly surfaced as a key term in the closing panel discussion and made one wish it had been more deeply plotted into the program.

Did "The Lure of the Object" succeed in producing the kinds of questions it aimed at? Here's a handful of questions that might arise from the kinds of reading I've sketched that can perhaps crystallize elements of the discussions at the Clark:

- How far is the interplay of object and image integral to the history of art? Are we really clear of the grand haptic/optic dialectics of Riegl and Wölfflin, or do they still run deep inside our engagements of particular objects and continue to shape from within the outer limits of the discipline?
- Is such dividedness more generally a deep feature of any art historical object, such that in its absence the art historian finds him or herself abandoned to mere anthropology?
- How far do we or ought we imagine art history as essentially involved with the representation of essentially distant or absent objects? What is art history when we take it instead to be the consequence of our continuing attachment to objects? Is this equivalent to understanding its work as "writing" more or less over and against "research"?
- What does it mean for the shape of the discipline as a whole that questions of this order emerge most directly and pointedly out of encounters with "modern" art? And what then are the disciplinary stakes in the claim to some passage beyond such modernity?
- How does "theory" figure for or matter to art history? What modes of attachment and detachment underwrite our various appeals to method, principle, objectivity?

Questions of this order sound odd within the current practice of art history, and in trying to sustain their asking, we may find ourselves reaching out to resources that sometimes appear new and that sometimes are to be discovered or rediscovered in places we have come to think of as historically exhausted. Hegel, for example, wrote in his *Lectures on Fine Art:* "Philosophy has to consider an object in its necessity, not merely according to subjective necessity or external ordering, classification, etc.; it has to unfold and prove the object, according to the necessity of its own inner nature. It is only this unfolding which constitutes the scientific element in the treatment of a subject."[1]

In fitting itself to the modern research university, art history worked hard to purge itself of its Hegelian residues and establish itself as a field of scholarly research underwritten by a particular range of methodological protocols. But recent

years have seen an extraordinary questioning of the discreteness and specificity of its claimed object. This is often cast in terms of a critique of the "aesthetic"—and such critiques clearly have played an important role in raising questions about art and art history—but perhaps the most direct form of the question arises from the observation that nothing in standard art historical method allows any distinction between the visual works and objects it evidently finds worthy of study and those it does not, and if that is the case, then art history may as well give over to the broader field of visual culture or visual study, fields that have no need of such distinction and are content to work at whatever presents itself to them.

It is then perhaps not a bad moment to look again at the ways a discipline might compellingly imagine itself as the ongoing proof of its object. The formulation itself is strange: we normally expect the object of the verb "to prove" to be a proposition, and even when we think we have some feel for what it might mean to "unfold an object in its necessity" (it evidently means something about showing how a claimed object holds together, or perhaps fails to do so), we're likely to continue to be uncomfortable with the thought that this is a form of "proof." For Hegel proof is never far from disproof, the moment of an object's unfolding, as it were, beyond itself. Proof in this sense evidently entails a certain movement toward the object's limit, happening at that limit. This may not yield us any greater comfort with Hegel's way of talking about proof, but it may nonetheless seem to offer a general way of thinking about the kinds of division and limitation—instabilities of desire and exhibition, time and writing—that animated so much of the conference discussion.

Jacques Lacan, for whom psychoanalysis is essentially a Hegelian and post-Hegelian discipline, remarked somewhere that we have no way of knowing that the unconscious exists outside of psychoanalysis and, exploiting the ambiguities of the sentence's grammar, he offers this not as a way of admitting the justice of positivist critiques of psychoanalysis but as a way of insisting on the conditions under which psychoanalysis has both its object and the only objectivity it can properly claim. Is this how we might learn to think of the history of art as well? If there is no way of knowing that art exists outside of art history, we are obliged to a discipline both continuously propped upon its particular objects and continuously responsible for their showing. Can we chance such exposure to the lure of the object? Have we ever done anything else?

1. G. W. F. Hegel, *Aesthetics: Lectures on Fine Art,* trans. T. M. Knox (Oxford: Oxford University Press, 1975), 11.

Contributors

Emily Apter is Professor of French at New York University. She is the author of *Continental Drift: From National Characters to Virtual Subjects*; *Feminizing the Fetish: Psychoanalysis and Narrative Obsession in Turn-of-the Century France*; and co-editor with William Pietz of *Fetishism as Cultural Discourse*. A book near completion is titled *The Translation Zone: Language Wars and Literary Politics*. She also edits a book series *Translation/Transnation* for Princeton University Press

George Baker is Assistant Professor of Modern and Contemporary Art at UCLA and an editor of *October* magazine and October Books. His recent publications include the essay "Film Beyond its Limits" for the first retrospective of Anthony McCall's work (Mead Gallery, University of Warwick, 2004), the essay "Fraser's Form" for the first retrospective of Andrea Fraser's work (Hamburg Kunstverein, 2003), and the book *Gerard Byrne: Books, Magazines, and Newspapers*. He is at work on a book entitled *The Artwork Caught by the Tail: Francis Picabia and Dada in Paris*.

Malcolm Baker is Professor of Art History at the University of Southern California, where he directs the USC-Getty Program in the History of Collecting and Display. Formerly Head of the Medieval and Renaissance Galleries Project at the Victoria and Albert Museum, London, he has written widely on the history of sculpture, the decorative arts, and the history of collecting. His books include *Roubiliac and the Eighteenth-Century Monument Sculpture as Theatre* (co-authored with David Bindman and awarded the 1996 Mitchell Prize for the History of Art) and *Figured in Marble: The Making and Viewing of Eighteenth-Century Sculpture*.

John Brewer is Eli and Edye Broad Professor in the Humanities and Social Sciences at the California Institute of Technology. His books include *The Pleasures of the Imagination: English Culture in the 18th Century* and, most recently, *A Sentimental Murder*.

Martha Buskirk is Associate Professor of Art History at Montserrat College of Art in Beverly, Mass. She is author of *The Contingent Object of Contemporary Art* and co-editor of *The Duchamp Effect* and *The Destruction of Tilted Arc: Documents.* She is currently pursuing work on an upcoming book tentatively entitled *Now and Then: Tradition as Subject and Method in Contemporary Art.*

Margaret Iversen is Professor in the Department of Art History and Theory at the University of Essex, England. Her work on the historiography of art history includes *Alois Riegl: Art History and Theory* and *Retrieving Warburg's Tradition.* More recently she has turned her attention to issues around the linked topics of psychoanalysis, feminism, photography, and contemporary art. Publications in this area include *Mary Kelly* (with Home Bhabha and Douglas Crimp) and a special issue of *Art History* called "Psychoanalysis in Art History." She recently edited a volume of essays called *Art and Thought,* and a book called *Art and Theory Beyond the Pleasure Principle* is forthcoming.

Ewa Lajer-Burcharth is Harvard College Professor and Professor of History of Art and Architecture at Harvard University. She is the author of *Necklines: The Art of Jacques-Louis David after the Terror* and numerous essays on eighteenth- and nineteenth-century French art and contemporary art. Her forthcoming book is titled *A Touch of Self: Painting and Individuality in Eighteenth-Century Europe.*

Karen Lang is Assistant Professor of Modern European Art at the University of Southern California, specializing in eighteenth- and nineteenth-century German art and aesthetic theory. She has published on German monuments and issues of national identity, Kantian aesthetic theory and its relation to art history, and the spectator of the eighteenth-century English garden. Her book *Chaos and Cosmos: Critical Reflections on the Image, Aesthetics, and Art History* is forthcoming.

Mark A. Meadow is Associate Professor of Northern Renaissance Art at the University of California Santa Barbara and Co-Director of the Microcosms Project, a special humanities project of the University of California Office of the President. He has

published on Pieter Bruegel the Elder, Pieter Aertsen, and Albrecht Dürer, as well as the histories of collecting, of rhetoric, of proverbs, and of the university.

Stephen Melville is Professor of the History of Art at the Ohio State University, specializing in contemporary art, theory, and historiography. He has served as resident faculty at the Getty Summer Institute in Visual and Cultural Studies and as co-curator of *As Painting: Division and Displacement,* a major exhibition of contemporary painting. His publications include *Seams: Art as a Philosophical Context; Vision and Textuality;* and *Philosophy beside Itself: On Deconstruction and Modernism.*

Helen Molesworth is Chief Curator of Exhibitions at the Wexner Center for the Arts at the Ohio State University. She is currently working on *Part Object Part Sculpture,* an exhibition that tracks postwar sculpture through the lens of Marcel Duchamp's erotic objects. Her primary research areas are contemporary art, feminism, and the reception of Duchamp. Her writings have appeared in publications such as *Art Journal, Documents,* and *October.*

Marcia Pointon was formerly Pilkington Professor of History of Art at the University of Manchester, United Kingdom. She is now Professor Emerita at Manchester and Visiting Research Fellow at the Courtauld Institute of Art. Her most recent books are *Hanging the Head: Portraiture and Social Formation in Eighteenth-Century England* and *Strategies for Showing: Women, Possession and Representation in English Visual Culture 1665–1800.* Her book *Brilliant Effects: Jewelry and Its Images* is forthcoming.

Christian Scheidemann is an independent conservator based in New York. His studio has specialized in the conservation of modern and contemporary works of art since the early 1980s, when artists from his generation, such as Robert Gober, Jeff Koons, and Paul McCarthy emerged into the art world. He is a consultant to artists, museums, and collections, and has lectured and published on the conservation and the significance of new materials in contemporary art in both Europe and the United States.

Edward J. Sullivan is Professor of Fine Arts at New York University and Dean of Humanities of the Faculty of Arts and Science. He is the author and editor of numerous books and exhibition catalogues on Latin American art, including *Latin American Art in the Twentieth Century* and *Brazil: Body & Soul.* His book on the history and theory of the object in Latin America is forthcoming.

Martha Ward is Associate Professor of Art History at the University of Chicago. She works in nineteenth and twentieth century French art history, especially on the history of exhibitions, criticism, and museums. Her publications include *Pissarro, Neo-impressionism, and the Spaces of the Avant-Garde,* and she is currently preparing an anthology of historical debates about museum practice.

Photography Credits

Permission to reproduce illustrations is provided by courtesy of the owners as listed in the captions. Additional photography credits are as follows:

Courtesy Acconci Studio (pp. 25, 26 top); © The Andy Warhol Foundation, Inc./Art Resource, NY (p. 22); © Bildarchiv Preussischer Kulturbesitz/Art Resource, NY: photo Joerg P. Anders (p. 163); courtesy Paula Cooper (p. 82); courtesy Eric Fischl (p. 147); © Giraudon/Art Resource, NY (p. 5); courtesy Barbara Gladstone (pp. 80 top, 81); courtesy Barbara Gladstone Gallery, New York (pp. 110, 111 bottom); Jay Jopling/White Cube, London (p. 113); courtesy Rosalind Krauss (p. 106); Archive of the Kunsthistorisches Museum, Vienna (pp. 46, 53); Peter Lauri, Bern (p. 79 top); © Erich Lessing/Art Resource, NY (pp. 26 bottom, 167, 174); © Magnum Photos (p. 135); courtesy Mark A. Meadow (pp. 43–45, 50–52); The Menil Collection: photo Hickey-Robertson, Houston (p. 27 top); © Museum of Fine Arts, Boston (pp. 158–59, 164 bottom); courtesy *October* Magazine (p. 109 bottom); © Photothèque des musées de la ville de Paris: cliché Pierrain (p. 172 bottom); © Reunion des Musées Nationaux/Art Resource, NY (p. 171); © SCALA/Art Resource, NY (p. 187); courtesy Christian Scheidemann (pp. 75 top, 80 bottom); Statens Konstmuseer, Stockholm (p. 173 top); © Sterling and Francine Clark Art Institute: photo Michael Agee (p. 4); Trustees of the Victoria and Albert Museum (pp. 121–28); courtesy of Video Data Bank, *www.vdb.org* (p. 27 bottom); courtesy David Zwirner (p. 79 bottom)